From iMovie to Final Cut Pro X

From iMovie to Final Cut Pro X offers an accessible, introductory guide to those taking up video editing using Final Cut Pro X, especially users making the transition from iMovie, Apple's free video software, helping aspirational and mobile filmmakers develop the skills needed to take their career to the next stage. Written by award-winning former Apple Education trainer and Final Cut Pro expert Tom Wolsky, this full-color book illuminates the key differences between these two applications and teaches users how to produce first-class results using the professional application. Wolsky also covers best practices for those working with iMovie on an iPhone or iPad and looking to move to a more advanced desktop program. Downloadable Final Cut Pro X project libraries included with the book offer readers hands-on examples of the techniques and practices discussed. Covers Final Cut Pro X 10.3.1.

Tom Wolsky is a founding director of the Digital Media Academy, where he taught Final Cut Pro for many years. Tom is the author of several Final Cut and video production instructional books as well as DVDs for FCP, Final Cut Studio, and Mac OS X for Class on Demand, where his training has won multiple Telly and Horizon Interactive awards. Before teaching, he worked in the film and television industry for more than 40 years.

From iMovie to Final Cut Pro X

Making the Creative Leap

Tom Wolsky

Routledge
Taylor & Francis Group

NEW YORK AND LONDON

First published 2017
by Routledge
711 Third Avenue, New York, NY 10017

and by Routledge
2 Park Square, Milton Park, Abingdon, Oxon OX14 4RN

Routledge is an imprint of the Taylor & Francis Group, an informa business

Library of Congress Cataloging-in-Publication Data
A catalog record for this title has been requested

ISBN: 978-1-138-20995-4 (hbk)
ISBN: 978-1-138-20997-8 (pbk)
ISBN: 978-1-315-45629-4 (ebk)

Typeset in Minion Pro
by Apex CoVantage, LLC

Printed in Canada

For B.T.
With Endless Love and Gratitude

Contents

Acknowledgments

First, as always, my gratitude to all of the people at Focal Press/ Routledge who make this book writing process relatively painless, particularly Simon Jacobs, Editor for Film and Video, for his thoughtful advice and guidance, and for bringing this project to life; also John Makowski, editorial assistant, who shepherded me through the process, and Jonathan Merrett and Kate Reeves, for their insightful editorial questions. My thanks also to Abigail Stanley, Production Editor, for her work; also to Gareth Toye for his wonderful design for the cover. Any errors in text or substance are of course mine alone.

My thanks go to Rich Lipner of Finca Dos Jefes and Café de la Luna for his gracious cooperation for allowing us to shoot his coffee tour, with special thanks to Lazario and Hermione for their assistance. I have to thank Travis Schlafmann, who continues to be one of the outstanding instructors at Digital Media Academy, for letting me use the snowboarding and skiing video that accompanies the book. Though it's been quite a few years since we first shot at CoHo, my grateful thanks to the musicians and organizers of the Stanford Summer Jazz Workshop for allowing us to tape their performance, especially Ambrose Akinmusire, trumpet; Patrick Wolff, tenor sax; Ryan Snow, trombone; Sam Grobe-Heintz, piano; Josh Thurston-Milgrom, bass; and Adam Coopersmith, drums. Thanks as always to our friends in Damine, Japan. A great many thanks are due to my partner, B. T. Corwin, for her insights, her endless encouragement, her engineering technical support, and her patience with me. Without her, none of this would have been possible. If any errors are brought to my attention I shall post corrections on my web site (http://fcpxbook.com) as well as changes that are made to the application as it moves forward.

Introduction

WHO SHOULD READ THIS BOOK?

This book is intended for all Final Cut Pro users, especially those new to the application and those moving up from iMovie. While FCP is directed to the professional video and film production market, its price point and ease of use makes it appealing to consumers, prosumers, and professionals; really anyone making video or film from any format for any market should find this application fits their needs. Its affordability will particularly benefit the prosumer market, event producers, and even small companies with video production requirements. I think it's a truly great video application for education—fully featured, able to go beyond the limitations that frustrate many students who use iMovie, at a price that makes it accessible even to school budgets in these penny-pinching times. Final Cut Pro is a complex application. It requires learning your way around the interface, its tools, and its enormous capabilities.

If you're looking to make the transition from iMovie to FCP, you're probably doing it because you've reached the limits of iMovie's capabilities and are becoming frustrated with its limitations. For you, Final Cut Pro has a huge number of features to enhance your creativity and open up a whole world of new possibilities for your productions. What makes FCP appealing to many iMovie users is its inherent simplicity and similarity to the application they're used to. It has a clean, simple application interface based on iMovie.

Here are some of the great features in FCP that take the application far beyond iMovie:

- Unlimited multiple layers of video that can be composited together and unlimited layers of audio that can be mixed to add sound effects and music and narration

- Multicam editing
- Combining groups of clips into secondary storylines
- Combining clips into compound clips
- Combine multiple clips in a single Audition clip container
- Powerful color grading with color masks and shape masks for unlimited secondary color adjustments
- 3D titles with cinematic quality with animation and textures
- Content auto analysis
- Incredible performance that uses all the power of macOS together with both the CPU and GPU for effects processing
- Great control on speed changes, with speed ramps and transitions in speed segments in a single clip
- Customizable keyboard

> **NOTE**
>
> **iMovie 11 or earlier**: If you're using iMovie 11 (version 9.0.9 or similar) or even the older iMovie HD you'll need to update to the current version. iMovie 11 uses a quite different folder structure and needs to have its projects and events updated from inside the current version of iMovie using the **File>Update Projects and Events** function to bring these into line with the current version. Earlier versions of iMovie will not even run in on OS X El Capitan and macOS Sierra and need to be updated. The current version of FCP, version 10.3.1 at the time of this writing, requires El Capitan 10.11.4 or later.

WHAT'S IN THE BOOK?

This book is not intended as a complete reference manual for all aspects of Final Cut Pro. For that you would really need to consult the manual in the Help files that accompanies the application. Nor does this book cover any ancillary applications that may be used with FCP, such as those bundled with earlier versions of Final Cut Pro, for example Compressor or Motion or Color or DVD Studio

Pro. Rather this book is intended as a course to give you a good grounding and understanding for practical use of the application. If there is something specific you'd like to learn how to do, I would suggest looking first in the Index to see if it's covered in the book.

There are many different ways of doing things in FCP, different ways to edit and to trim, but there are clearly more efficient ways. There are many ways to do things in Final Cut because no one way is correct in every situation. Working cleanly and efficiently will improve your editing by allowing you to edit more smoothly and in a steady rhythm, concentrating on content rather than on the mechanics of the application.

The book is organized as a series of tutorials and lessons that I hope have been written logically to guide the reader from one topic to a more advanced topic. The nature of your work with Final Cut Pro, however, may require that you have the information in Lesson 10, for example, right away. You can read that lesson by itself. There may, however, be elements in Lesson 10 that presuppose that you know something about using the Viewer in conjunction with the Inspector.

WHY DO I GET TO WRITE THIS BOOK?

I have been working in film and video production for longer than I like to admit (okay, more than 40 years). I worked at ABC News for many years as an operations manager and producer, first in London and then in New York. I went on to teach video production at a small high school in rural northern California. I wrote the first step-by-step tutorial book with projects files and media for Final Cut Pro in 2001. Since then I have written many FCP and FCE books as well as made training DVDs for Final Cut Pro, Final Cut Studio, Final Cut Express, iLife, and Mac OS X. I also have written a curriculum for Apple's Video Journalism program and taught training sessions for them, and during the summer, I have had the pleasure of teaching Final Cut for the Digital Media Academy on the beautiful Stanford University campus.

WHERE'S THE MEDIA?

The libraries and media for this book are kindly stored by Focal Press on the Routledge website. To download the media go to www.routledge.com/products/9781138209978. In the middle of the page click on eResources, which will take you the page with the zipped files. These contain the libraries we'll be using. These ZIP files are all fairly large and will not download instantly. If you want you can download them all at once or as you need them. With the exception of the file called *NONAME,* they are numbered sequentially as you use them in the book. I would suggest keeping the original ZIP files after you download them so that you can go back to the original media whenever you need to.

You're going to need the media to get started so the sooner you can start downloading the better. You may want to substitute your own material—clips you want to work with or are more familiar with, but I would suggest starting with the supplied materials.

Though you cannot contact me through the Focal website, if you have any questions or problems with the media, you can contact me through my website at www.fcpxbook.com. Also, be sure to check my website whenever the application updates for a look at the changes in the new version.

I hope you find this book useful, informative, and fun. I think it's a great way to learn this kind of application.

Getting Started

WHERE IS EVERYTHING?

There are many similarities between iMovie and Final Cut Pro X as many like to point out, but few mention that there are enough differences between the two to confuse someone moving between the applications. The first question that most iMovie users ask is: Where is everything? To answer that, we'll look at the components of Final Cut Pro's interface and its panes, and to do that we'll need to have a library with media to look at.

Loading the Lesson

To start you'll need to download the library from the book's website. Go to www.routledge.com/products/9781138209978 and then click on eResources. On the page there are a number of ZIP files, each of which contains a library that we will work with. You will probably need to download all of them over the course of the book, but for now we simply need the first ZIP file called *FCPX1.zip.* This is a fairly large file, about 675MB in size so it will take some time. The other ZIP files in the website contain other libraries and media.

Though you cannot contact me through the Focal website, if you have any questions or problems with the media, you can contact me through my website at www.fcpxbook.com. Also, be sure to check my website whenever the application updates for a look at the changes in the new version. This book is based on version 10.3.1, and

by the time you read it there will be newer versions available, with new or changed features.

Once you have downloaded the ZIP file from the website you should double-click it to unzip the file. Next you should move the *FCPX1* library to your media drive before opening it. See the note on media drives below. By copying or moving the library to the media drive the contents will play from that drive. Once you have the library on your media drive, double-click it to launch the application and open the library. Normally when you launch FCP it will open any previously open libraries, however, if you double-click an individual library to start the application only that library will open.

The media files that accompany this book are mostly heavily compressed H.264 files. Playing back this media requires a fast computer processor, though any recent Mac should handle the files without problem. If you have difficulty playing back the media, you should transcode it to proxy media.

1. To convert all the media, select the event in the Event Browser, right-click on it and choose **Transcode Media**.
2. In the dialog that appears check on **Create proxy media**.
3. Next you have to switch to proxy playback. Go to upper right of the Viewer and from the **View** popup select **Proxy** under the Media section.

NOTE

Media Drive: In addition to your internal system drive, I recommend you should have at least one other hard drive that's both large and fast. This drive should carry only your media. A separate drive is much more efficient at moving large amounts of data at high speed. The drive should be either USB3 or Thunderbolt at least. USB2 and FireWire are not adequate for HD video and modern applications.

> **TIP**
>
> **Library Version:** These libraries were created in FCP version 10.3.1. You will probably be using a newer version. In which case you will get a dialog telling you that the library will be updated. Once the library is updated older versions of the application will not be able to open it.

> **NOTE**
>
> **Right-click:** In this book I will use the term "right-click" to activate the shortcut menu. By default Mac mice are still set to work in single click mode, which is quite ridiculous. Go to **System Preferences** and in **Mouse** controls check on secondary click to activate right-clicking if you have not done so already. If you're using a laptop without a mouse, use **Control**-click to access the shortcut menus.

The Interface

The FCP interface will look vaguely familiar to iMovie users, but daunting at the same time because of its complexity (see Figure 1.1). Many of the same functions are in iMovie and FCP applications, but they're often in different places in the interface or have different icons. For instance, in iMovie there's a button on the left of the top bar to completely close the Browser, leaving just the Viewer. The button for this is in the first of the cluster at the right end of the top bar (see Figure 1.2). It can also be closed by deselecting **Browser** in the **Window** menu under the **Show in Workspace** submenu or by using the keyboard shortcut **Control-Command-1**.

Let's take a quick look at that top bar, which has some resemblance to the similar iMovie bar, but has some other functions. The section on the left holds the **Import** button, which you probably recognize from iMovie and other applications (see Figure 1.3). Once you get into the FCP Import window it's very similar to iMovie Import window. We'll look at importing in the next lesson. Next to Import is the **Keyword** button, which opens the Keyword Editor (**Command-K**),

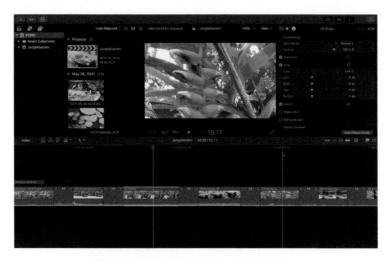

Figure 1.1 Final Cut Pro X Interface

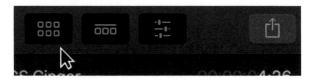

Figure 1.2 Top Right Buttons

which we'll work with in Lesson 3 on Organization, and next to that is the **Background Task** button, which will show a clock action as a background task is happening. On the right end of the bar are four buttons: the **Show/Hide Browser** button that we saw, the **Show/Hide Project** button, which is new to this version of FCP and closes the Timeline pane, and the **Show/Hide Inspector** button. At the end of the bar is the familiar **Share** button. This is actually a popup menu and brings up the Sharing options (see Figure 1.4). There are options for creating a basic DVD, sending to Apple devices to sync through iTunes, and to Facebook, Vimeo, and YouTube. There is also a master file export option, which we'll look at in detail in the last lesson. One of the important items you'll notice that's missing in FCP is the Theater. There simply isn't one. Sorry. The two other items that appear to be missing are sharing an image and sharing to email. These are actually both available in FCP, as we'll see in the last lesson.

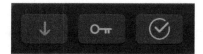

Figure 1.3 Top Left Buttons

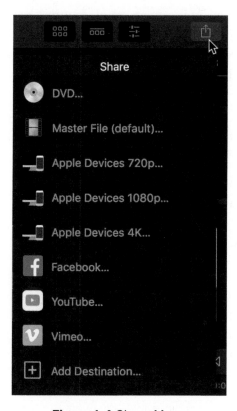

Figure 1.4 Share Menu

The first puzzle for many iMovie users is: Where are my projects? It's a little difficult to tell in iMovie that your projects are actually inside a library, but they are. The Project window in iMovie shows you all the projects that are available in any open libraries. There is no corresponding window in FCP. Here projects are inside events, which are inside a library. The projects inside an event appear at the top of the list in the event. You can have as many projects in as many events as you like, and you can edit media from any event in a library

into any project in the same library. Smart Collections in a library will show you all the projects available in that library, but there is no project window that shows you all the available projects in any open libraries. In iMovie, each project is a separate folder inside the library bundle, apart from the event folders. In FCP, the project folder in the library bundle is always inside an event. Figure 1.5 shows the contents of the *FCPX1* library with one event inside it called *JungleGarden*, and inside the event folder another folder called *JungleGarden*, which is the project folder.

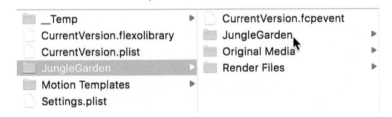

Figure 1.5 Library Package Contents

Libraries in FCP have preset Smart Collections that show you video, audio, stills, projects, and favorites across all the events in the library. You can make your own library Smart Collections and add them in. We'll look at Smart Collections in Lesson 3.

> **TIP**
>
> **Panes:** FCP has four primary panes: the Event Browser, the Viewer, the Timeline, and the Inspector. You click in one of them to make it the active pane, and a blue line appears above it. You can also switch quickly between the panes with the handy shortcuts **Command-1** for the Event Browser, **Command-2** for the Timeline, **Command-3** for the Viewer, and **Command-4** for the Inspector.

Browser Controls

In iMovie the **Show/Hide Libraries** button is at the top of the Browser; in FCP it's in the top left of the Libraries and has the blue

clapperboard icon (see Figure 1.6). You can also do this by using the **Window** menu and deselecting **Sidebar** in the **Show in Workspace** submenu or with the keyboard shortcut **Command-`** (the grave/tilde key in the upper left of the keyboard). Like iMovie, which gives you access to photos and music in the Browser, so does FCP. Next to the **Show/Hide Libraries** button is the **Show/Hide Photos and Audio** button (see Figure 1.7). This accesses your Photos, Aperture, or iPhoto libraries as well as your music in iTunes and Sound Effects. iLife Sound Effects including Jingles and Theme Music is accessible from the the popup menu in the upper right of the Audio Browser. Next to Photos and Audio is the **Titles and Generators** button to access all the 2D and 3D titles in the application, which we'll be using in Lesson 8.

Figure 1.6 Buttons at the Top of the Libraries Sidebar

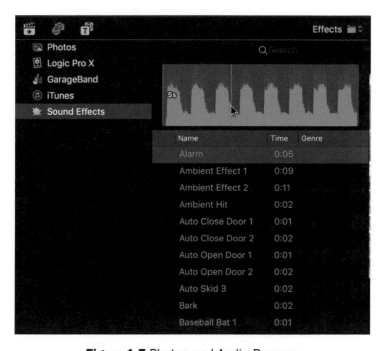

Figure 1.7 Photos and Audio Browser

The Browser sort functions that are in the **View** menu in iMovie are also in the **View** menu in FCP, but are also more easily accessible from the Clip Appearance popup, the small filmstrip icon at the top of the Browser (see Figure 1.8). Notice that there is both a **Group By** and a **Sort By** option, depending on whether the Browser is in the Filmstrip view used in iMovie or in List view. As in iMovie the way the clips are displayed is controlled by the Clip Appearance popup. Notice also in this popup the two checkboxes for Waveforms and Continuous Playback. Continuous Playback emulates the iMovie behavior that lets the user play continuously from one clip to another without having to do anything.

The button to toggle between List view and Filmstrip is to the left of the Clip Appearance popup and uses the keyboard shortcut **Option-Command-2**. Switching between these can also be done using **View> Browser** and setting either **List** or **Filmstrip**.

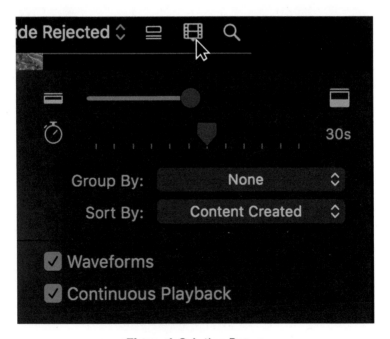

Figure 1.8 Action Popup

Filmstrip View

When you switch to Filmstrip view two items are available in the Clip Appearance popup, which are dimmed when in List view. There's a slider to adjust the clip height and a slider that lets you change the view of the clips. It controls how many thumbnails are used to represent your clip. When it's set to the left, to **All**, each thumbnail in the Browser represents a single clip. As you move the slider to the right, the display changes to show the clips with filmstrips, first one thumbnail for 30 seconds, then 10 seconds, then five, two, one, down to one thumbnail for half a second of video.

> **TIP**
>
> **Switch to All:** If the Browser is the active pane the keyboard shortcut **Shift-Z**, which in the Viewer and the Timeline is zoom to fit the pane, will in the Browser switch the filmstrip display to All.

At the top of the Browser are two other controls. The Clip Filter popup on the left, which defaults to Hide Rejected, similar to iMovie, lets you select what clips you see in the pane (see Figure 1.9). There are keyboard shortcuts for each of these for easy switching.

On the right is a search box that lets you looks for clips in the browser based on text and other clip criteria. This is also the basis for creating Smart Collections, which we'll see in detail in Lesson 3.

There is no Record Voiceover button in FCP as there is in the bottom of Viewer in iMovie, but there is a voiceover tool that is opened from the **Window** menu or **Option-Command-8**.

Though you cannot create a movie with a theme in FCP, you can do something similar. When you create a new project in FCP you don't have the option to create a project with a specific theme. You can however use thematic based titles and transitions similar to what you can do in iMovie. The Stylized category in the Transitions Browser

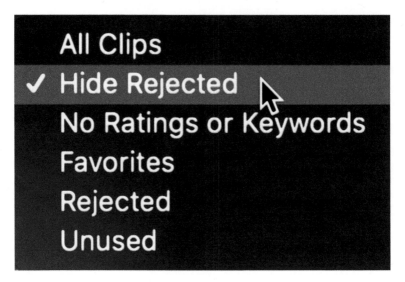

Figure 1.9 Clip Filter Popup

has groups of thematic transitions, while many of the title categories like Lower Third have groups of thematic titles that correspond to the transition themes.

While much of the Browser functions in FCP as it does in iMovie, FCP has many more organizational tools, which we'll look at in the chapter on Organization. Though there are features in FCP that aren't in iMovie, there is one thing that appears to be missing in FCP. What often puzzles iMovie users is the apparent lack of image correction in the Browser. In iMovie it's easy enough to select a clip in the Browser and apply any video or audio correction effects to the clip, either auto correction or manual correction. In FCP there is very little automatic color correction except for the Enhancement functions at the bottom of the Viewer that give you **Balance Color** and **Auto Enhance Audio** (see Figure 1.10).

To access other effects, you have to put the clip onto the Timeline. You can either do this after the clip has been edited into a project, or by right-clicking on the clip and selecting the **Open Clip** option. Here you can select either the video or audio tracks and apply any of

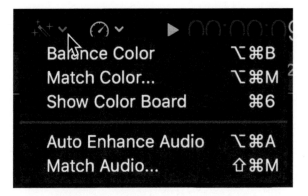

Figure 1.10 Enhancements Menu

the effects including Color Correction, which we'll look at in detail in a later chapter. Though you've opened the clip into the Timeline pane and are working in the Timeline, this is not a project. *Do not,* I cannot emphasize this strongly enough, *do not* edit anything into the clip. I have seen too many users proceed to edit into the Timeline and then close the application. When they reopen their library they have no idea where the "project" they did all that work could be. Please do not fall into this trap.

List View

Use the View menu or the List view button or press **Option-Command-2** to switch the Browser to List view (see Figure 1.11). Here you see the clips as a list of names, with a filmstrip view of the selected clip at the top of the window. Audio files would show a waveform in the preview area.

In the Browser you can change the names of your clips, as I have done for most of these clips. Clips often come in with camera assigned names which are often not helpful. You can assign the clip's date/time stamp, as I've done here to some of the clips, or you can give them descriptive names. To rename a clip, select the clip and press the **Return** key.

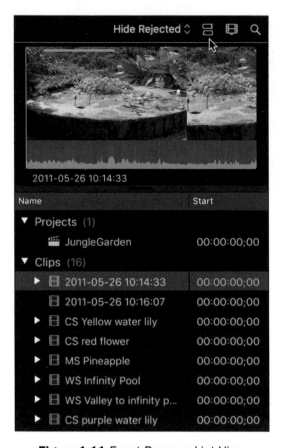

Figure 1.11 Event Browser List View

1. Select the first clip by clicking on the name line as in Figure 1.11.

2. Press the **Return** key to select the name.

3. Type in *Small pool push to fountain*

4. Select the second clip and name it *Lily pond tilt down and up*

5. Click the Name header at the top of the list to reorder the clips alphanumerically based on their name.

Renaming the clips only changes their name in the Browser and does not affect the name of the media on your hard drive. To see this, either right-click on the clip name in the list (or on the preview at the top if you prefer) and select **Reveal in Finder** from the menu.

You can also use the keyboard shortcut **Shift-Command-R**. This will take you to the media file on your hard drive, which is in the *Original Media* folder inside the *JungleGarden* event folder.

Viewing Clips

Let's look at our clips. You can view the clips almost exactly as you can in iMovie. In List view selecting a name loads the filmstrip. You can skim the filmstrip and play forward and backward with **JKL** just like iMovie, and like iMovie there is a playhead separate from the skimmer. You can of course play forward with the **spacebar** and backwards with **Shift-spacebar**. All the controls are identical.

Sometimes you might want to skim video without hearing the audio, and as in iMovie, you can toggle this on and off from the **View** menu **Audio Skimming** or use the keyboard shortcut **Shift-S**. There is also a button for this on the right side of the Toolbar, which we shall see in a moment. In FCP you can also toggle the skimmer itself off and on with the **S** key.

A list of important keyboard play controls shortcuts is in Table 1.1, pretty much all identical to iMovie.

Browser Details

If the Library pane is open, close it with the blue clapperboard button in the upper left of the pane or **Command-'**, giving your Browser more space. With the Browser in List view, stretch out the Browser window to the right, and you will see just some of the many things the Browser displays in List view. If you right-click in the Browser list header you will get further options that are available (see Figure 1.12).

TIP

Ordering: You can arrange the order in which clips are shown in List view by selecting the column header. By clicking the little triangle that appears in the header, you can change the order from descending to ascending (see Figure 1.13).

Table 1.1 Some of the principal keyboard shortcuts

Play	L (spacebar)
Pause	K (spacebar)
Play backward	J (Shift-spacebar)
Fast forward	Repeat L
Slow forward	K and L or hold Right arrow
Fast backwards	Repeat J
Slow backwards	K and J or hold Left arrow
Forward one frame	Right arrow
Backward one frame	Left arrow
Forward 10 frames	Shift-Right arrow
Backward 10 frames	Shift-Left arrow
Previous Clip	Up arrow
Next Clip	Down arrow
Go to beginning of clip	;
Go to end of clip	'
Go to the first clip in List view	Home key
Go to the last clip in List view	End
Mark selection start (In point)	I
Mark selection end (Out point)	O
Go to In point	Shift-I
Go to Out point	Shift-O
Play selection	/
Select clip	X

The Browser shows the duration of clips and the Start and End times. You also should see a box of Notes, as well as technical information, though this is best viewed in the Inspector as we shall see.

In addition to adding more column information to the Browser, you can move any of the columns by grabbing the header at the top of the column and pulling it to wherever you want the column to

Figure 1.12 Browser Lists

Figure 1.13 Ascending/Descending List

appear. So, for instance, you could drag your Notes column next to your Name column. Only the name column cannot be moved. It stays displayed on the left side of the pane. The Notes column allows you to add descriptions and other information about your clip.

> **TIP**
>
> **Tab Key:** If you have a clip selected the **Tab** key will, like the **Return** key, select the clip name to change it; if you press **Tab** again, the cursor will move to the Notes column, where you can enter information about your clip, such as a few words about an interview. If you select sections of a clip using keywords, each keyword or favorite selection will have its own Notes box.

You can create a new project at any time by:

- Using **File>New Project**
- The keyboard shortcut **Command-N** or
- Right-clicking in the Libraries pane and selecting **New Project**

The project appears at the top of the event whether in Filmstrip or in List view.

Viewer

The Viewer in FCP is your window on your video and shows whatever clips you're playing back, whether skimming or playing in the Browser or in the Timeline. It switches to whichever is the active pane. The controls centered under the Viewer are very simple and similar to iMovie. Like iMovie, the button in the lower right displays the Viewer in full screen mode, which can also be evoked with the keyboard shortcut **Shift-Command-F**. While in full screen mode all your standard keyboard shortcuts work, **Spacebar, JKL, I** and **O**, and so on. To get out of full screen mode press the **Escape** key.

The name displayed in the center above the Viewer is the name of the clip or project that the Viewer is playing back (see Figure 1.14). The icon next to it indicates whether the item playing is an event, a star icon, or is a project, with the clapperboard icon. In the upper left is very basic information about the clip or project, frame resolution, frame rate, and audio information.

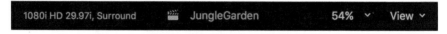

Figure 1.14 Top of the Viewer

In the upper right of the Viewer are two important controls. The one on the left is the Zoom popup (see Figure 1.15) that lets you set the display size of the video in the viewer. It's normally set to Fit, which can be evoked with the shortcut **Shift-Z**.

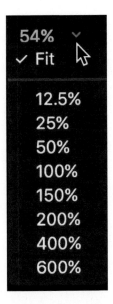

Figure 1.15 Zoom Popup

Next to the Zoom popup is the View popup (see Figure 1.16). It's divided into sections for Display, Quality, Media, Channels, Overlays, and Range Check. Display gives you access to the scopes and multicam angle viewer as well as **Show Both Fields**, which will display any interlacing in your video. Quality defaults to **Better Performance**, which gives smooth playback but sacrifices quality, especially for media that needs to be rendered. You can set the media to Original or Proxy if you've created proxy files. We'll look at this in the next lesson. You can also display various video channels, **All**, or just specific red, green, and blue channels rendered in grayscale values, or the alpha (transparency) channel. You can turn on title and action safe areas, which we'll look at when we do titling in Lesson 7. Finally, the popup menu gives you access to Range Check, which will display diagonal stripes across portions of your image that are out of broadcast standard gamut for luminance or saturation.

In addition to seeing the Viewer within the FCP window and viewing its contents in full screen the Viewer can also be placed on a second computer monitor using **Window>Show in Secondary Display**.

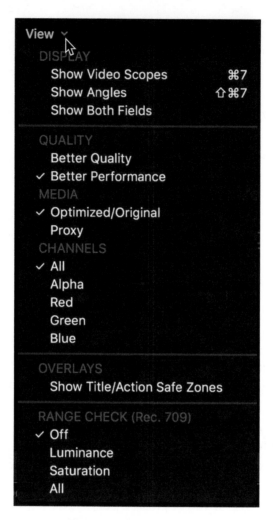

Figure 1.16 View Popup

You can choose to put the Browser, the Viewers, or the Timeline onto the secondary monitor. Putting the Viewers on the secondary monitor will give you more space for Browser columns and for the Inspector, which we will see in a moment. Many people prefer to put their Browser on the external monitor, leaving the primary FCP window for the Viewer and the Timeline.

In the lower left of the Viewer is a popup for image manipulation: transformation, cropping, and distorting (see Figure 1.17). We'll look

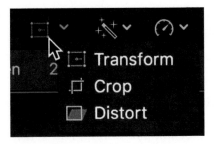

Figure 1.17 Bottom Left of the Viewer

at these controls in later lessons in the book. Next to the Transform popup menus are the popups for Enhancements and for Retiming, which we'll look at in Lesson 9 on effects.

The Dashboard

Under the Viewer in the middle is the Dashboard (see Figure 1.18). This consists of a play button, together with the Timecode display, and next to that a small set of audio meters that give you a rough idea of your playback levels.

Figure 1.18 Dashboard

The Dashboard shows the timecode for whatever clip is being played back in the Browser or project in the Timeline. The Dashboard is also a tool. It can be used to numerically move clips and edits, and by clicking the timecode or pressing **Control-P** moving the playhead itself. It can also be used to change the duration of a clip by double-clicking the timecode or pressing **Control-D**.

On the right of the timecode display are the tiny audio meters. They're not much use as meters except as a confidence check, but by clicking on them or pressing **Shift-Command-8** you can bring

up a full set of meters that can display either two bars for stereo audio, or the six bars for 5.1 Surround if your project is set to that specification.

THE INSPECTOR

One of the most important panes in FCP is new to iMovie users and is to the right of the Viewer. This is the Inspector. You can call it up from the **Window** menu or using the keyboard shortcut **Command-4** or by clicking the slider button for the Inspector in the top right of the interface next to Share. The Inspector is contextual and will change to display information and controls for whatever is selected. It can provide information about a selected clip as well as giving controls for video and audio effects, transitions, titling tools, generators. It also gives information and allows changes of properties for clips, projects, and libraries.

If you have a clip selected in the Browser, the Inspector usually has four buttons at the top. There is a Video inspector, which has limited controls until the clip is placed in the Timeline. The Audio inspector gives you Volume control, Pan control, access to Audio Enhancements and Channel Configuration. Changing these prior to editing the clip into the Timeline will set these parameters for every instance of the clip you use. Of course they can be changed again in the Timeline whenever you like. The Info inspector (see Figure 1.19) provides extensive information about the media specifications, as well as providing multiple types of information, much more comprehensive than in any other application. At the bottom left you can use the **Basic** popup menu to select more extensive information displays. Notice the information at the bottom about where the media is located and what types of media are available for the file, original, proxy, and optimized. In addition, with the **Apply Custom Name** popup menu in the lower right corner of the Inspector you can add custom metadata and customize your naming conventions for clips. Information and

organization are key components of FCP, as we shall see. Finally, the Share inspector lets you set title, description, creator, and tags for an exported item, either a clip or a project.

The further we go into the book, the more important the Inspector will become.

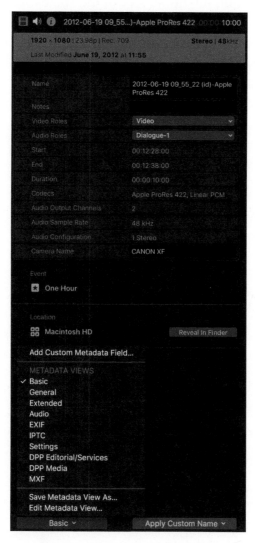

Figure 1.19 Info Inspector Pane

THE TOOLBAR

Across the middle of the FCP window, dividing the Browser and Viewer from the Timeline, is the Toolbar, which is divided into three sections, with buttons on the left and right and project information in the center.

The group of buttons on the left side of the Toolbar are mostly tools. The first button is the **Index** button, which gives you information about and access to the project's content (see Figure 1.20). You can either use the button to open and close the list or the shortcut **Shift-Command-2**.

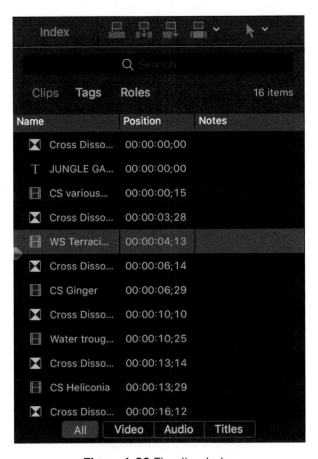

Figure 1.20 Timeline Index

To the right of Index are four edit buttons (see Figure 1.21), which allow you to do Connect, Insert, Append, and Overwrite edits, similar to iMovie.

Figure 1.21 Edit Buttons

To the right of that is the Select tool popup (see Figure 1.22). The Selection tool can be evoked with the **A** key and the other trimming and control tools that appear in the popup beneath it can all be called up with single letter shortcuts.

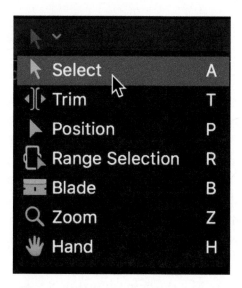

Figure 1.22 Select and Other Tools

In the center of the Toolbar is project information (see Figure 1.23). You see the name of project you're working in together with the

< JungleGarden 03;04 / 22;11 >

Figure 1.23 Center of the Toolbar

overall duration of the project. If a clip or clips are selected in the project their duration will appear there as well, highlighted in yellow.

The arrow buttons to the left and right of the name and project information let you move between recently opened projects, just like the back and forward buttons in a web browser, and like a web browser they use the same keyboard shortcuts **Command**-[for back and **Command**-] for forward. If you've opened a lot of projects, you can mouse down on the forward and back buttons to see lists of recent opened projects.

The buttons on the right side of the Toolbar are primarily controls for the Timeline pane (see Figure 1.24).

Figure 1.24 Right Side Buttons

The first button switches the skimmer off and on. You can also toggle it off and on with the shortcut **S**. When the button is blue it's on, when gray it's off. That's consistent throughout the application. LED and checkboxes that are blue are on and active, gray or dimmed are off. The button with the waveform to the right switches audio skimming off and on. The shortcut is **Shift-S**. Note that when the video skimmer is off, audio skimming is off as well. Without the skimmer, dragging the playhead to scrub will produce no audio scrubbing.

The next button is soloing, which solos a single clip or selected clips so that's all you hear. The shortcut is **Option-S**.

In FCP, as in iMovie, Snapping can be toggled off and on, which is very useful. You can toggle it with the button to the right of Soloing or with the shortcut **N**, just as in iMovie.

The Clip Appearance popup next to that controls the Timeline appearance (see Figure 1.25).

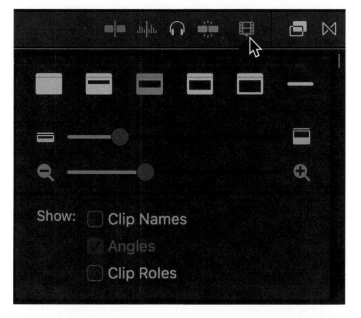

Figure 1.25 Clip Appearance Popup Menu

The slider in the middle with magnifying glasses at each end adjusts the scale of the pane's content, allowing you zoom in and out of the pane. You can also do this with the keyboard shortcuts **Command- =** (think of it as +) to zoom into the Timeline and **Command- –** (that's minus) to zoom out of the Timeline. Above that is a slider that adjusts the clip height, and below are checkboxes that give you additional display options for clips in the Timeline. Normally the clip names are displayed, but you can add in Roles or Angle Names if you're working in a multicam project, which we'll look at in Lesson 7.

At the top of the popup are six display options from left to right (see Figures 1.26–1.31). These allow you to change the appearance from seeing only the audio waveforms, to only seeing the filmstrips, or just the clip naming information.

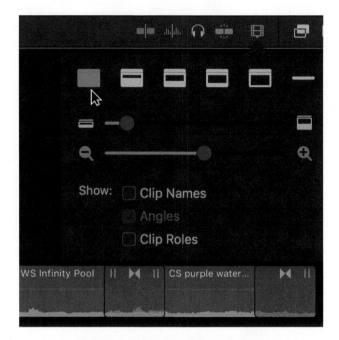

Figure 1.26 Audio Waveforms Only

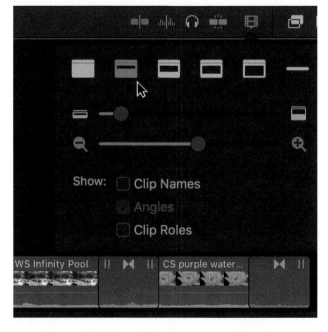

Figure 1.27 Small Filmstrip Large Waveform

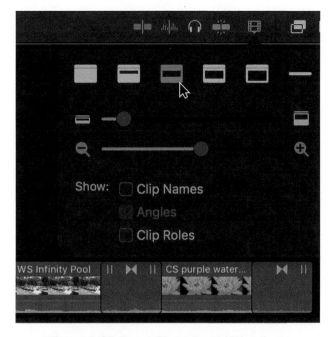

Figure 1.28 Equal Filmstrip and Waveform

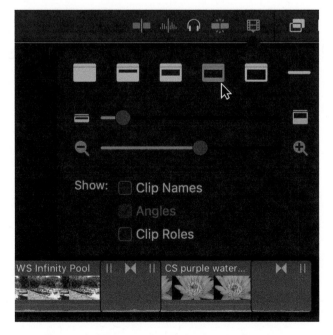

Figure 1.29 Large Filmstrip Small Waveform

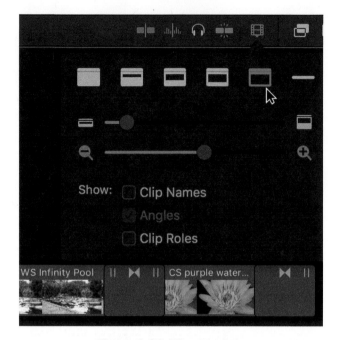

Figure 1.30 Filmstrip Only

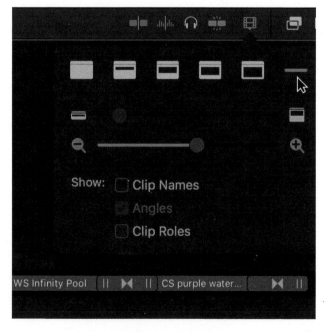

Figure 1.31 Clip Names Only

There are two buttons beyond the Timeline pane controls buttons. The first accesses the **Effects Browser**, where all FCP's 233 built-in video and audio effects are stored, as well as any third party effects. The final button opens the **Transition Browser**, where the transitions are stored in categories. We'll look at working with transitions in Lesson 4 on editing.

The Timeline

If you've not already done so open the *JungleGarden* project to fill the Timeline pane. To open a project, you can either double-click the project in the Browser, or select it and press the **Return** key.

As in iMovie, each project in the library is a separate sequence. If you need to make multiple projects for a production, for backup, to try different versions, you work with multiple projects. You can duplicate a project or duplicate a project as a snapshot. A snapshot is a completely separate project, while a duplicate may contain elements that change across multiple copies.

One of the first things you'll notice in the *JungleGarden* project in the Timeline is that each of the clips isn't represented by a single icon. In an iMovie project a single icon often represents one shot, regardless of the length of the shot. This is never the case in FCP. Also, as you play the project, the playhead moves at a constant speed, not slowing down or speeding up based on the length of the clip under the playhead as it sometimes does in iMovie.

One of the great limitations of iMovie is its inability to have multiple layers of video in the Timeline. While you can stack an image in iMovie to create a picture in picture effect or a split screen or to add B-roll, you're limited to this additional layer. In FCP you can have an unlimited number of video as well as audio layers, all of which are connected to something on the primary storyline. There is no free floating music layer as in iMovie; all the layers are connected, even if only to a piece of filler called a Gap Clip in FCP.

Movie settings in iMovie are accessed with a button in the upper right of the Timeline. In FCP you access **Project Properties**, from the **Window** menu or the shortcut **Command-J**. The properties appear in the Inspector, and you can change the properties of the project by clipping the **Modify** button (see Figure 1.32). Notice also the box that allows you to add notes to the project, which can be useful when transferring projects between editors.

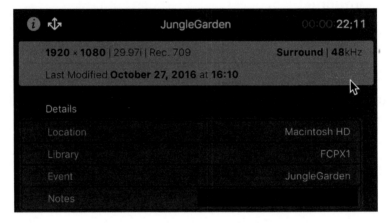

Figure 1.32 Modifying Project Properties

Let's take a look at the Timeline pane.

In the center, running through the middle of the project pane, is the primary storyline with the clips on it. The clips contain both the video and the audio, and in this case have transitions, simple cross dissolves between them, and a title connected to the first clip in the storyline.

At the top of the pane is the timecode displayed as a ruler, beginning at 0:00:00:00. The Timeline Ruler and the current time display will show time in whatever frame rate you're using in Hours:Minutes:Seconds:Frames.

Workspaces

A recent feature of FCP is the ability to create and save custom Workspaces and to quickly switch between them. There are three basic

workspaces which can be selected from the **Window>Workspaces** menu. The original Default layout can be switched to with the keyboard shortcut **Command-0 (zero)**; the Organize layout, with a long Browser, central Viewer, and full length Inspector can be accessed with **Shift-Control-1** (see Figure 1.33); and Color & Effects, which has scopes open, Viewer, Inspector, Timeline and Effects Browser, which is called up with **Shift-Control-2** (see Figure 1.34).

Figure 1.33 Organize Workspace

Figure 1.34 Color & Effects Workspace

In the **Window** menu there is a **Show in Workspace** function which lets you select what you want open, including the option to have a full height Inspector. Workspaces can be saved in the menu and can be called up from there. In addition, you can resize panes in the FCP window dynamically by grabbing the edges where the mouse pointer changes to a Resizing tool (see Figure 1.35). This can be tricky because the boundaries between the panes can be difficult to discern. When you pull with the Resizing tool, the panes will move, expanding and contracting as needed to fill the available space. The Timeline can be dragged vertically. The Viewer, the Browser, and the Libraries can be resized horizontally.

Figure 1.35 Resizing Panes

> **TIP**
>
> **Full Height Inspector:** You can also toggle the Inspector full height by simply double-clicking the name at the top of the Inspector. It'll shoot down to the bottom of the screen or collapse to the top of the Timeline pane.

> **TIP**
>
> **Help:** If you have problems with Final Cut Pro, help is available in a number of places: the Apple Support Communities Final Cut Pro discussion forum, which you can access at https://discussions.apple.com/community/professional_applications/final_cut_pro_x. You can also get help at the fcp.co website forum at www.fcp.co/forum/4-final-cut-pro-x-fcpx, or through my website at www.fcpxbook.com.

SUMMARY

You should now be familiar with the interface used in Final Cut Pro and have seen some of the similarities and differences between iMovie and FCP. I'm sure at this point that you have many questions, and I hope to answer as many of them as possible over the course of these lessons so you can work smoothly and efficiently with the application. Spend some time clicking around in the Final Cut Pro window. You can't hurt anything. And remember to try right-clicking to bring up shortcut menus. In the next lesson, you'll take a look how FCP preferences work, and how to get media into your system so you can start making your own projects. We'll look at importing from a camera and from a hard drive, and also how to go from iMovie in iOS through iMovie in macOS and then into FCP.

Preferences and Importing

Importing your media into FCP is a crucial part of working with the application. The libraries used by FCP allow great flexibility, much more than in iMovie. Though media can be moved and your operational workflow can be changed while you work, doing so requires time, care, and patience. Generally it's better to set up importing correctly to start with so your library structure and media are organized for your productions. There is no one true and certain method for all productions and all situations. There are quite a few variables, and I will try to explain some of them in this chapter and the next.

Before you import your media, you should set up your application for the way you like to work and also so that it's set up for importing. In Final Cut Pro, as in most professional programs, that means setting up your preferences. After setting preferences, we'll move on to importing media. We'll start with the process of going from iMovie in iOS to iMovie on the Mac and then bringing your iMovie content into FCP, before we look at importing from cameras and hard drives.

For this chapter you can use your own media, but if you want to follow along I will be working with a little AVCHD media that you can download from www.routledge.com/products/9781138209978 and clicking on the eResources tab. On this page there are a number of ZIP files, most of which contain an FCP library. For this chapter

we'll use the ZIP file called *NO_NAME.zip*, which is the disk image of an AVCHD camera card, and is about 300MB in size.

PREFERENCES

Before you work with FCP, especially before you import, it's important to set up your preferences, which are accessed from the **Final Cut Pro** menu, or using the standard preferences shortcut **Command-,** (comma). There are five preference tabs in FCPX. We'll look at the last tab, **Destinations**, in the final lesson on Sharing.

General and Editing Preferences

The **General** preferences tab is pretty simple (see Figure 2.1). This tab only has three minor preferences. Here you can change the Timeline display from H:M:S:F to include subframe amounts or to frames only or to seconds. There's also a button to reset warning dialogs as well a button to validate Audio Units plugins, which can be a problem on some systems and should be run when new audio plugins are added.

The **Editing** preferences are pretty straight forward, and I usually leave them at the default settings (see Figure 2.2). I'm not sure who wouldn't want the first two checked on.

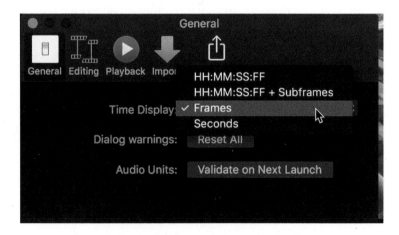

Figure 2.1 General Preferences

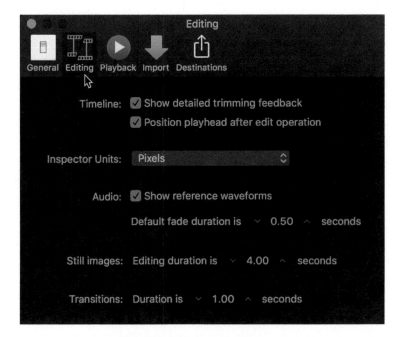

Figure 2.2 Editing Preferences

Inspector Units can be in pixels or percentages. I prefer pixels, but percentages can be useful when you're doing motion graphics animation.

In **Audio**, Show Reference Waveform can be useful also, but I'd leave it off for now, as it clutters the Timeline a little. When we get to audio editing, you can turn it on. There is also an audio fade duration preference. The default is a quick fade, which is great for adding quick ramps to the audio, eliminating clicks and pops that sometimes appear on cut points. You can apply or remove the fades using the **Modify>Adjust Audio** submenu.

For **Still Images**, you can set the edit selection duration to whatever you prefer. Four seconds is the default. Notice you cannot set seconds and frames, but you can set seconds and a decimal value. This is NOT the import duration of a still image, but the default duration of a still image when it is selected in the Browser. The import duration is always 10 seconds.

Like the Still Images preference, the **Transition** preference, which defaults to one second, uses seconds and decimals, not seconds and frames. For instance, 0.20 is a fifth of a second, or six frames at the NTSC frame rate, or five frames at the PAL frame rate. This is done because users often work on multiple projects with very different frame rates. An eight frame transition means two completely different things in a 24fps project and in a 60fps project. On the other hand 0.25 second transition means a quarter of a second regardless of the frame rate.

Playback

The **Playback** tab lets you switch off Background Rendering, which I think is the generally recommended procedure (see Figure 2.3). Some people suggest leaving it on but setting the start time for when it kicks in to something like 600 seconds, or 10 minutes. So after 10 minutes of idle time, while you're talking on the phone or going off to lunch, the application will start rendering in the background. You can force rendering by making a selection and using **Control-R** or rendering everything with **Shift-Control-R**.

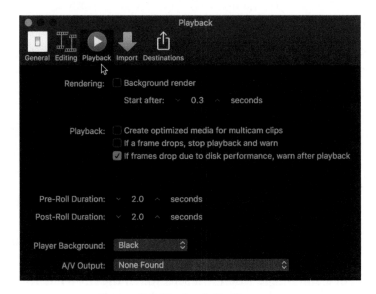

Figure 2.3 Playback Preferences

Because multicam editing requires a great deal of processor power, there is a default preference to optimize material used in multicam clips. I would recommend switching this off. If you have a decent computer, from the last three years or so, I generally don't recommend this. It makes huge files and requires very fast drives as there's a lot of data to pump through your system. I would have rather there was a preference to create proxy media for multicam, which is very much more useful, and using proxies is what I would strongly recommend if you're having trouble playing back a multicam project.

Player Background can be set to Black, White, or Checkerboard. This means the Viewer background display. The default is black, but the background actually is transparent. As a result, text over an empty background is text on transparency, so you might prefer to use checkerboard as the background to show that, although checkerboard during playback does look strange.

A/V Output lets you select third party hardware like Black Magic or AJA to output to a broadcast monitor. Once the device is selected here you can turn the function off and on in the **Window** menu.

> **NOTE**
>
> **Background Rendering:** Apple marketing calls what FCP does background rendering, but the truth is that it's not. It's seamless rendering or automatic rendering. It renders when it has time, when you're not doing anything. It will pause when you start to do something in the application and resume when it can. It does not actually render while you're doing other things in the application.

Import

The **Import** tab (see Figure 2.4) sets your default importing behavior and is used as the import setting whenever you drag and drop to import something into your library or into a project. On the other hand, unless you're dragging and dropping, the import tab is just

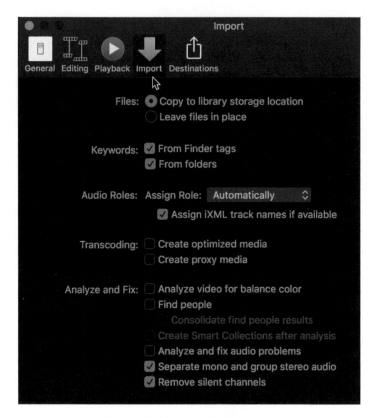

Figure 2.4 Import Preferences

a default and can be changed at any time for any media that you're importing directly in the Import window.

There are two checkboxes for transcoding that allow you to immediately make duplicates of your original media in high resolution ProRes 422 or in small, highly compressed ProRes Proxy files. Generally I think it's best to leave these off. Transcoding can always be done at a later time as needed, and transcoding on import, especially when importing a great deal of media, can really slow down the process.

There has been much discussion about what is the best practice for handling your media. Though the general recommendation is that when you're importing compressed formats such as H.264, it's best to optimize the media, in my view this is not really necessary with

recent computers and graphics card capabilities. If your computer is fast enough and has a good, fast graphics card, I suggest working with H.264 is not a problem and should be used, saving yourself a great deal of processing time and hard drive space. Some formats such as DV and HDV and XDCAM cannot be optimized in FCP, as the application handles them in their native codec. At any time in the editing process, you can transcode specific files or even all your files to standard ProRes 422 or ProRes Proxy files.

You can import items applying keywords based on their Finder tags, if you use those, or based on folder names, whose clips get added into a Keyword Collection based on the name of the tag or the folder name. This is a useful feature and it's probably a good idea to leave this on as your import preference. You can always switch it off during the actual import process. We'll look at keywords and collections in the next lesson.

A new feature in FCP is the ability to assign Roles and Subroles in the Import window, either the default Roles or custom Roles created by you. Generally for preferences it's best to leave these set to automatic, and set the Roles you want in the Import window sidebar itself as we shall see in a moment.

Another useful feature in FCP is its ability to analyze and correct media on import. There are separate sections for video and for audio analysis. Color balance analysis doesn't get applied, but the analysis does slow down the background task functions. Again, this is something I would leave off. I do the same with Find People, which we'll look at in the next chapter. Usually I recommend checking on the group and silence audio options. These are done very quickly in the background process and are helpful to be done with, rather than having to do it manually.

When you drag and drop from the Finder or from iTunes, to a project, no dialog appears, and library preferences will be applied. The exception to this is when your item is in the Photos or iPhoto library. In this case it will always be copied into your dedicated media folder or into the library itself. The application will not access

them from inside these library bundles. This applies to iTunes music as well in some instances. Some formats will remain in the iTunes folder structure. As iTunes music is usually in a heavily compressed format, I recommend compressed audio always be converted to an uncompressed format, either AIFF or WAV. We'll look at how to do that in a moment.

> **NOTE**
>
> **Drag and Drop from Camera Card:** Though you can often drag files to import from a camera card structure, such as DSLR cards, make sure you do NOT have the **Leave In Place** option selected in Import preferences. This will leave the file in the camera card structure, and you may end up not being able to export your project because the camera is still being referenced.

> **TIP**
>
> **Changing Drag and Drop:** When you drag and drop from the Finder, the import function will be guided by the Import preferences. You can override these options while you drag. If the drag indicates a copy function with the green + circle, you can change this to leave in place by holding **Option-Command** while you drag. If the drag is indicating a symlink that leaves the file in place and you want to copy it into the library just hold the **Option** key to copy, just as in the Finder.

> **TIP**
>
> **Importing into Keyword Collection:** You can import directly into an existing Keyword Collection by either having the clips in a folder with the same name as the Keyword Collection and having **Import folders as Keyword Collection** checked on; or if you right-click on the Keyword Collection in the event and select **Import Media** the imported media will be added directly into the collection. You can also drag and drop to import of course, and if you drag and drop to the Keyword Collection the files are not only imported into the event but also keyworded.

Managed Media

The concept of managed media and external media is foreign
to iMovie users and is an important difference between the two
applications. Where media is stored in FCP is assigned on a library
by library basis. This is done in Library Properties in the Inspector.
If you select a library in the Libraries pane the Inspector will show
its properties (see Figure 2.5). If you click on the **Modify Settings**

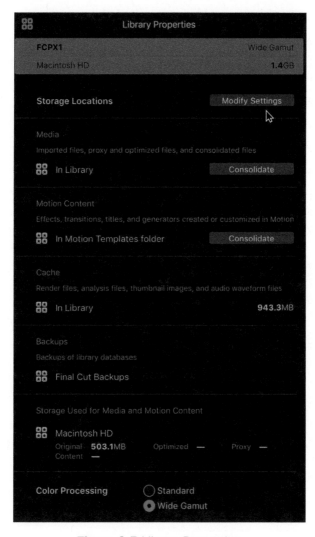

Figure 2.5 Library Properties

button opposite **Storage Locations** you will get a drop down sheet that lets you assign the location for the media. This will be the import preference for the library (see Figure 2.6). The default Storage Settings is **In Library**, which creates what's called *managed media*. These are files, video files, still images, audio files, that get copied into an event in your library when you import. This is the standard operational procedure for a great many users, and there is absolutely nothing wrong with it. iMovie users are familiar with this, and like still image libraries, many users may only have a single library of managed media.

However, video files are substantially larger than still images, and when media files need to be rendered they are rendered into high data rate, large ProRes QuickTime format files or even larger. So if you have all your media files in a library, it isn't long before the library becomes very large and too large for your hard drive.

Keeping your media inside the library, using managed media, is a simple way to work, and a very good way to work for many types of productions. Who should use managed media? Hobbyists and small production companies where a production is edited on a single system. Wedding and event production can easily use managed

Figure 2.6 Storage Settings

media for their work. Also those who collaborate by physically moving a hard drive from place to place will find managed media within the library very useful. Basically anyone who is producing video on one system using only one application, Final Cut Pro from ingest to delivery. Who should not use managed media? Those working on productions in a collaborative environment. Those working in situations where multiple users need to access the same media. Those working with multiple applications, for instance, those who need to access the media in Motion or After Effects. This is not easily done with managed media.

Notice also in Storage settings that you can assign where Motion content is stored. The default location is the *~/Movies/Motion Templates* folder, which is great for most users. However, if you need to share your projects with other users, you also have the option to store created Motion content inside the library itself.

> **NOTE**
>
> **Library Media Location:** Once you set the media location, either in the library or an external folder, those library properties will be used for each subsequent library that's created, until you change the properties; so it's always a good idea to check the properties whenever you make a new library to be certain they're the way you want them.

External Media

For those who need to not copy media into the library bundle when you import, you have the option to leave your media in place or move it to a selected location. The location for your media is a preference you should set for each library as you create it. I do not recommend leaving files where they are, because files then get scattered all over your drives, though you can consolidate your media later, which we'll look at in a moment.

My recommendation is to have a separate folder on your media drive that holds all the media for your production. This folder

should be on some kind of backup routine using software like Carbon Copy Cloner or SuperDuper! Everything goes in there—all your video, your audio, your still images, your Motion projects and exports, your multi-layer Photoshop compositions—everything gets imported into this location. When you create a new library you set Storage settings for Media to a specific location by using the **Choose** option, and creating a new folder on one of your dedicated media drives. When you import something into your event in the library you can then immediately send it to the dedicated media folder. The folder can be anywhere, on any directly connected drive, or SAN, or network storage. Performance of course is entirely dependent on the speed of the connection and the number of users accessing the network simultaneously. The media location selected in Storage settings includes not only your Original Media but also your transcoded media. The folder that contains your media has separate folders called *Final Cut Optimized Media, Final Cut Original Media,* and *Final Cut Proxy Media.* These are all stored in your media location and not inside the library bundle. You can also store your Cache files here so your media location might look something like Figure 2.7.

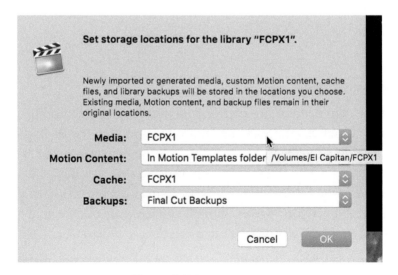

Figure 2.7 Media Folder

You also have the option to select where your Cache files are saved. The default is to save them in the library, but you can also select a separate location such as any external folder, either where your media is stored or some other separate location. The Cache creates another FCP bundle, a library cache bundle, which stores all the cache files for the library, all the thumbnail files, and peak data, as well as your render files. So this bundle can get quite large.

When you use the import function, the button at the head of the top bar or **Command-I**, you can select the files you want, and how they are handled. Though your media is external to your library and very easy, some would say too easy, to access by anybody, you need to make sure that files are never moved from the folder or renamed or altered in such a way that changes the media's fundamental properties, such as video frame rate. Media at the Finder level should not be fundamentally changed, or FCP will lose the connection to it. You can alter stills and other media, change colors, modify and enhance the images, and FCP will update the changes in the application, but media properties should never be altered.

Consolidate

Though you have essentially two options for working with your media, either managed media within the library, or external media outside of the library, you do have a way to switch from one condition to the other at any time using either the **Consolidate Library Files** or **Consolidate Event Files** or **Consolidate Motion Content** functions from the **File** menu. As the names imply, Consolidate Library means you affect the entire library, while Consolidate Event means you affect only that one event in the library. So what does Consolidate do? Simply put it moves files in and out of your library. It's a two way street. It will either move all your media that's in the library out of the library, or it will copy (not move) all the media that's outside of the library into the library.

If your media is external to the library, change your Library Properties for the media to **In Library**. When you select **Consolidate**

Figure 2.8 Consolidate Library Files

Library Files you will get a simple dialog that asks if you want to consolidate in addition to your original media your transcoded and proxy media as well (see Figure 2.8). This will copy the media into the library. If your media is in the library bundle and you want to move it out of the bundle, change the Storage settings in Library Properties. Now when you select **Consolidate Library** or **Consolidate Event** or **Consolidate Motion Content** you will get the same dialog except it will be set to the location designated in the Library Properties. If the setting is for an external location, the files will be moved out of the library bundle into the appropriate *Original Media, Optimized Media,* or *Proxy Media* folders and replaced with symlinks. These symlink connections can be broken by moving the files or renaming or changed their basic properties in the Finder. Don't do that.

Library Backups

You definitely want library backups, and you get to choose where they're stored. This preference is part of Library Properties. You can select any location, and set a separate location for each library, or have all the libraries use a common location. The default is the Movies folder, which is pretty good place for them, especially if your system drive is on a Time Machine routine. You want to keep your

library backups separate from your active libraries. As your working libraries and your media are usually on dedicated media drives, saving the backups in the internal drive is a good strategy.

These backups are not the entire library thankfully, just the metadata needed to reconstitute the projects and events. The backups can be as little as a few kilobits but are more usually around 25 or 50MB. Backups are created about every 15 minutes in which there is activity in the library. They are stored in folders with the library name. You can access a backup directly from the folder, which might look something like Figure 2.9. To open a backup you can double-click it, which will launch FCP if it's not open, and the library will appear with the library name together with the time stamp. You can also open a backup directly from inside the application. Select the library and from the **File** menu choose **Open**

Figure 2.9 Library Backups

Library>From Backup, which opens a dialog that lets you select the backup you want. If it doesn't appear, you can click **Other** in the same dialog (see Figure 2.10) to select any backup for any library that has been saved.

Because the backups are for emergency situations for the most part, it's probably a good idea to go into whatever folder you're storing them in and trash the backups for old and obsolete productions. Though the files are relatively small, they can add up and chew up a good deal of space.

Figure 2.10 Backup Dialog

Preferences Files

All the preferences you make are stored in preference files in the user's home Library folder. These files are updated when the application is closed, that is when it's closed normally with the **Quit** function. They are not saved when the application is forced to quit or when it crashes. When that happens the preferences refer to the application in a different state, which may no longer be possible, so basically the files have become corrupted. Because of this, if you have problems with FCP, one of the first remedies anyone will suggest is to trash your preferences file, which resets the application to its default state, as if you're opening it for the very first time. It will create a new *Untitled* library in your Movies folder so you may as well keep an *Untitled* library there.

The simplest way to reset your preferences, which you should always do after any non-standard shut down, is to hold the **Option-Command** keys as you launch the application. A dialog will appear asking if you want to delete your preferences.

TIP

Opening Specific Library: If you want to trash your preferences and reopen a specific library rather than *Untitled*, you can do that. Hold **Option-Command** as you double-click the library you want to open. You'll trash your preferences and access the library you want.

Customizing the Keyboard

Technically the keyboard isn't part of preferences. For the custom keyboard layout you use **Option-Command-K**. Like preferences it's in the **Final Cut Pro** menu. Once the Command Editor, as it's called, opens, the first step you want to take is to duplicate the current layout using the popup in the upper left.

Changing the layout is pretty straightforward. If there's a function you want to add search for it in the search box in the upper right. To see what's used by a particular modifier key, just hold it down or click the modifier or combination of modifier keys at the top. To see what's used by a particular key, just click on it. To see what's under **W** click it and the Key Detail pane in the lower right will display what's there (see Figure 2.11). There is no keyboard shortcut to add a chapter

Figure 2.11 Command Editor

marker to a clip. To create a custom keyboard shortcut to add a chapter marker, do this:

1. Search for *chapter*.

2. At the top of the Command Editor click a modifier combination like **Control-Command**.

3. Drag the function *Add Chapter Marker* and drop it on the **M** key.

4. Click the **Save** button in the lower right and when you're done click the **Close** button.

That's it. **Control-Command-M** will now add a chapter marker to a clip in the Timeline.

Once you've set up the keyboard the way you want it and saved it, you probably want to back it up or save it on a flash or jump drive. With the Command Editor open to the layout you want to save, from the popup in the upper right select **Export**, and save the file onto the drive. You can now carry your preferred keyboard layout wherever you go to any FCPX system. When you get to the other system, mount your jump drive, and in the Command Editor select **Import** from the same popup and point it to the file on the jump drive. The keyboard layout is saved in your home Library. In the Finder hold the **Option** key and use the **Go** menu to select **Library**. The saved keyboards are in *~/Library/Application Support/Final Cut Pro/Command Sets*.

> **TIP**
>
> **Updating Your Keyboard Layout:** When Apple makes a major update, or sometimes even when not a major update, they change or add keyboard shortcuts. These, of course, won't be in your custom keyboard layout. So whenever the application is updated be sure to check if there are new shortcuts added or changed shortcuts and to update your custom commands.

IMPORT FROM iMOVIE

Let's look at going from iMovie to FCP. Many users are now shooting videos on mobile devices, iPhones and iPads, doing some basic

assembling in iOS and then going on from there; so let's see the process from phone to Final Cut. Unfortunately, you can't go directly from iOS iMovie to FCP, but you can go from iOS iMovie to macOS iMovie and from there to FCP.

After you've shot and edited your material on iOS, you're ready to get it onto the other platform.

1. If you open the edited project from the projects list, at the bottom of the screen is a Share button (see Figure 2.12). Tap the button.

Figure 2.12 Sharing from the iOS iMovie Project

2. In the sheet that pops up tap the iTunes button (see Figure 2.13). You can also use iCloud Drive, but this can take a great amount of time to both upload the material and then to download back to your computer. It's much simpler to go to iTunes.

Figure 2.13 Sharing from iOS to iTunes

3. A screen appears asking what you want to share to iTunes, either the Video File, which is the finished movie, or iMovie Project, which is the timeline together with the media (see Figure 2.14).

Figure 2.14 Selecting the iMovie Project to Share to iTunes

4. When you tap iMovie Project, the material will be prepared and ready to load into iTunes. This will take a little time, but is much faster than uploading to the cloud.

5. Next sync your mobile device to iTunes. When sync is complete, select the device and its Apps section. Find iMovie the File Sharing section and select it to see your transferred iMovie project (see Figure 2.15).

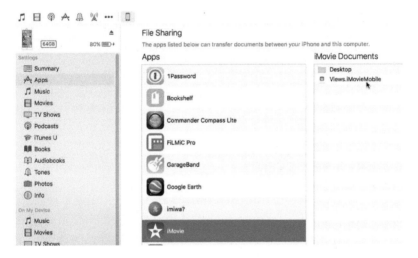

Figure 2.15 iTunes File Sharing

6. Drag the .iMovieMobile project from the iTunes File Sharing window to your Desktop to copy it there.

7. Launch iMovie on your Mac and go to **File>Import iMovie iOS Projects** pointing the application to the file on your Desktop you want to bring into iMovie.

The media appears in the Timeline and the clips appear in the iMovie library. If you wish you can add iMovie functions, like sound effects or a map generator, and when you're ready you can send the project to FCP. With the Timeline active, select **File>Send Movie to Final Cut Pro**. If FCP isn't open it will launch the application. The

material will appear as a new iMovie Library together with an event with the name of the project and the project itself inside it. All the title and generators you may have added in iMovie are brought over to FCP. In addition you can now also select and send an entire iMovie library to FCP, though of course trailers will not appear.

You cannot send trailers from iMovie to FCP, but if you convert the trailer to a movie in iMovie, you can send the converted movie to FCP including all the titles, generators, music, and effects exactly as it was in iMovie.

You might want to copy the project to an existing FCP library. This is simple to do, just make a new event in the FCP library for it and drag the project from the iMovie Library to the event you want to put it in. This will bring over the project of course, but it will bring over all the media as clips in the Browser in the FCP library, which is very useful.

CREATING A NEW EVENT

Now that we have set up our preferences and everything is ready, we can start bringing our own material into the application. So let's begin by creating a new event. As in iMovie every library must have at least one event. Events are bins or folders inside a library, so when importing think about what event you want to import your media into. We'll look at organization in more detail in the next lesson, but importing into the correct event in the correct library is the first step. You can assign the event or create a new event in the right hand sidebar in the Import window, just as you can with the popup in the iMovie Import window.

1. Select the library in which you want to create your new event and go up to **File>New Event** or use **Option-N** or right-click and select **New Event**.
2. The event is created and its name is highlighted ready to be renamed. Let's call the event *Importing*.

A new event without any media gives you a helpful button to start you importing your media. The event will hold any media you import into it: video clips, audio files, and still images.

IMPORTING

Whenever you're importing, whether from a camera, camera archive, or our hard drive, it all uses a single Import window. Whenever you import media, it gets put into an event folder, either as digital files or as symlinks to the digital files.

The import process in FCP is as simple and straightforward as it could possibly be, and not dissimilar to iMovie.

From FCP's import window (**Command-I**) you can access any connected camera, or drive, or archive that's available to your computer. If the camera or camera card is detected, you simply select it in the sidebar of the import window (see Figure 2.16).

Figure 2.16 Cameras in Sidebar

If you don't have file-based media of your own and you want to follow along, you can download and unzip the *NO_NAME*.zip from www.routledge.com/products/9781138209978. Go to eResources and download the file. Double-click the disk image from the ZIP file to mount it. It appears as a camera card.

1. In the Import window, select the memory card called *NO_NAME* under Cameras on the left, which will fill the Import window with the clips.

2. You can click the Import All button in the lower right if you wish.

3. You can also select clips by clicking on them and then using the Import button, which has now changed to **Import Selected**. You can also simply press the **Return** key.

4. You can play your clips with **spacebar** as well as **JKL** and mark a selection with the **I** and **O** keys.

5. You can also drag a selection on the clip with the pointer.

6. You can also mark additional selections on a clip by pressing **Shift-Command-I** and **Shift-Command-O**.

All these selections are persistent. If you press **Command-A** to Select All, all the selections that you have made will be honored. Any clips without selections will be imported in their entirety. This effectively allows you to log your media before you import the footage.

Do not use selections in the Import window as an editing function. Import more than you need. It's better to import too much than too little. Most people simply import everything except for shots that are completely messed up, such as when the camera's recording inside the trunk of your car or pointed at the ground as you walk around.

When importing from a camera, camera card, or camera archive, in the lower right of the Import window you have a button that gives you the option to switch between Filmstrip view and List view. **Option-Command-2** toggles between the two just as in the Browser. Also notice next to that button the Clip Appearances popup which controls how the clips are seen in the Import window just as in the Browser. It also has a checkbox to allow you to hide any clips, or portions of clips you've already imported. The Filmstrip view function does not appear when importing from hard drives, nor does selective importing of sections of media. More about that in the section called Trimming.

You can also import a file by dragging and dropping from a Finder window. You can drag into the Libraries pane onto the event icon, or directly into a Keyword Collection, which will apply the keyword to the clips, or even directly into a project. If you have an event selected, you can also drag and drop directly into the Browser, which is much easier than trying to hit the small event icon. The media will be imported based on your import preferences. If copy is checked off in the preferences, symlinks will be created pointing to the media. If copy is checked on, the files will be copied into the *Original Media* folder in the event folder. If you drag directly to the Timeline pane, the media is also placed in your designated default event for the project. If you drag audio from a CD to import, which you can do, the audio will follow your preferences, so be very careful. If you have the copy function switched off, the imported track will simply be an alias pointing to the track on the disc. It's always a good idea to convert the media from a CD or from compressed audio before importing it. We'll see how to do this later in the lesson.

Sidebars

In the Import window the sidebar on the left is pretty self-explanatory. It gives you access to Cameras, Devices (usually hard drives), and Favorites. Anything, such as a folder, can be made a Favorite simply by dragging it from the central pane of the window onto the word Favorites as in Figure 2.17.

Figure 2.17 Making Favorites

The sidebar on the right reflects the choices that you have set in Import preferences (see Figure 2.18).

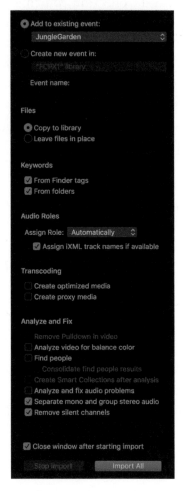

Figure 2.18 Right Sidebar Import Window

Here you can override the preference settings. You do want to set a few things:

1. Select the event you want the clips to appear in. The event can be in any open library, or you can can create a new event in a library.

2. Choose whether to copy the files into the designate library location, whether it's in the library or outside it; or to leave the

files in place in their current location. ANY time you import from a camera, camera card, camera archive, or folder that contains camera content, you must copy the files. FCP will not allow files to remain in place that are in a camera file or folder structure. You cannot change this.

3. If you have Finder tags or folders that you want to use as keywords, check those on.

4. Assign Roles for clips. The default Role for audio is Dialogue-1. For the clips on the *NO_NAME* camera, you'll want to change the Roles to Effects. You can use the Role Editor to create custom Roles before you import. You can do that from **Edit Roles** in the **Modify** menu. We look at this in more detail in later lessons.

5. If you need to create optimized media, or especially if you want to work with proxy files, check them on.

6. Turn on whatever video and audio analysis you want. I often check on the audio analysis, but usually not the video.

> **NOTE**
>
> **Hard Drive Suddenly Appears Under Cameras:** This can happen when there is a folder or files at the root level of an external drive that makes the application think the volume is a camera drive. It can be something like a folder called PRIVATE or the contents of an AVCHD bundle. Generally the simplest way around this is to enclose problem material in an appropriately named folder to hide it from the application.

Creating Camera Archives

Most video media is now recorded as files on a SDHC card, a CF card, a P2 card, or a hard drive. All of these are camera media, which are designed to be reused, not stored. Before you import your media, back up the media from the card or hard drive. The first step you should always take with file-based media is to archive it. The tiny memory card is the only recording of your production or of a

precious, never to be repeated, moment in life. Make another copy before you do anything else. It's really simple to do in FCP. When the application detects the media it opens the import window and populates it with the card's contents.

1. Select the card, which is usually called *NO NAME,* in the camera list.
2. At the lower left of the camera import window click the **Create Archive** button.
3. A dialog sheet drops down that lets you specify which drive you want to archive the media onto. Select the drive.
4. Name the archive something useful such as the event and the date or the name of the production followed by a number.

The drive used for archiving should not be your media drive. It should be a separate drive, not necessarily a fast drive, but it should be large. This becomes your archive storage. Keep it safe.

You can also archive your media manually. Here's the simple way to do this:

1. Create a new folder and name it something useful.
2. Select the *entire* contents of the memory card including *all* its sub-folders. Do *not* drill down into the folder structure to find the video. FCP must have the whole folder structure.
3. Drag the entire contents of the card into the archive folder.

One of these methods should always be used to archive media from a memory card.

Reimporting Files

Sometimes clips aren't properly imported in the Browser because the card was ejected before the process finished, especially if transcoded media is being generated, or other interruptions require you to reimport the media. Sometimes you'll see a filmstrip in the browser with a camera icon on it. This indicates that the clip is still accessing a camera card or camera archive. You will need to reimport the clips before you can export the project.

Select the clips in the event, and then use **File>Import>Reimport from Camera/Archive**. Simply click the **Continue** button in the dialog that appears and if the archive is mounted and available the application will immediately reimport the clips into the appropriate event and reconnect the clips in the project. This function only works for camera media and camera archives, which makes it even more imperative that you backup and archive your camera originals and save them on a secure drive, separate from your media drive. It is the only way to re-access media that has been misplaced or moved.

Relinking

You can relink files either for clips in an event by selecting them, or for a project by selecting it in the event. Simply use **File>Relink Files** and a dialog appears (see Figure 2.19). Generally it's better to relink

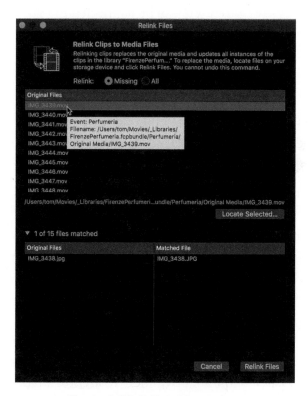

Figure 2.19 Relink Files Dialog

the browser clips, because this will automatically relink clips that are in a project.

Note the radio buttons at the top that let you relink either missing files or all files. If you're looking for missing file, hold the pointer over a file and a tooltip will appear with the expected file location.

The clips names that appear in the list are not browser or project names, but the original file names. Select the files you want to relink and click **Locate Selected**. Navigate to the file you want to relink to and select it; the file will be moved to lower half of the dialog. When you've found all the files you want, click the **Relink Files** button at the bottom.

Importing from Tape-based Cameras

FCP can import from tape via FireWire, so only cameras or decks that have FireWire output and can be connected to your computer via FireWire will work, unless you use third party hardware from companies such as Black Magic or AJA. For most people, importing via FireWire means importing either from DV or HDV tape. FCPX has a very simplified import function.

When you connect the camera in playback mode the application will usually detect it and immediately open the camera import window. Here you get a viewer with controls to play and rewind your tape.

To start import, click the **Start Import** button, and to stop importing you can either click the **Stop Import** button or press the **Escape** key.

When you import from tape the application automatically splits the material into clips when it detects a shot change caused by a break in the date/time stamp. It's important for DV tape cameras that the internal clock be set, not necessarily to the right time, but that it be set to some time.

You can also archive a tape, though most people use the tape itself as the archive. However, a camera archive can be used to reconnect media if necessary, while a tape cannot. To archive a tape, click the **Create Archive** button in the lower left corner of the window. The

application will seize control of the tape, rewind it to the start, and starting playing it back to import the clips, which all get put in the locked camera archive. DV and HDV files are around 13G per hour of media.

> **NOTE**
>
> **Importing with QuickTime:** FCP can be very difficult to use to import from tape: it will not import analog material in pass through; it will not import media with timecode breaks; and it will not import media through some adaptor connections. If you're having problems importing tape based media, I'd recommend using the QuickTime player to import. It will import media in DV or HDV, it will import in pass through when using a camera or deck to digitize, and generally is very forgiving. The digital media can then be imported from your hard drive into FCP for editing.

Importing from Photos

To access stills from Photos or iPhoto or Aperture click the camera/music icon at the top of the Libraries pane. You can also use **View>Sidebar>Photos and Audio** or the shortcut **Shift-Command-1**. Here you can access your libraries, events, albums, and projects. To bring the stills into your Final Cut project simply drag the image into your project from the Photos and Audio Browser. Images dragged directly into the project are stored in the event in which the project is stored. You can also drag images into the Event Browser. Select the images you want and drag them to the sidebar on the left, which will immediately change from the Photos and Albums Browser into the Libraries pane and let you drop the images into any of the events. Still images that are dragged into the application are always copied into your event folder rather than symlinked.

When still images are placed in a project they will be conformed to fit the window by default, scaled down if the image is larger than the screen, scaled up if the image is smaller than your frame size. This can be controlled in the Inspector as we'll see in the lesson on animation.

> **NOTE**
>
> **Adding Stills:** Be careful about adding stills to the project as the first item in a project. Projects by default set the project properties based on the first item. If you add a still image first, FCP will select 23.98 (actually 23.976) as the frame rate. Always put a video clip into the project first to allow the project to set the frame size and frame rate. Once there are clips in the project the frame rate can no longer be changed, and you can add stills without problem. You can delete the clip once you've put it in the project, but do so by actively deleting, not by simply undoing, because that will undo setting the project properties.

You can import both video and stills from Photos. However, I would strongly advise that you import your videos directly into Final Cut, and your stills into the photo applications. You should not use the photo applications to import video. FCP performs certain routines, such as rewrapping the media to a production format which is done during the import process, but this is not done in Photos or other applications, and not done when a file is dragged and dropped from the Photos and Audio Browser.

Importing Music

The simplest way to import music is to use the Photos and Audio Browser. This will allow you access to the audio content that comes with FCP, as well as your own iTunes library. To bring the music into your project, simply drag it from the media browser into the Timeline. You can also drag directly to an event by dragging left to bring up the Libraries pane. This is all well and good in theory, but the fact is that a great deal of iTunes music is in heavily compressed formats like MP3 and, while they will work in FCP, they are not really suitable for professional production work and really should be converted to high-quality AIFF or WAV files—even AIFF files such as those imported directly into iTunes without conversion are not in the best possible format. Audio CDs use an audio sample rate of 44.1kHz. This is not the sampling rate used by digital video, which is

most commonly 48kHz. These compressed and audio CD standard files should be converted while being resampled and having their compression removed. There are a number of ways you can convert audio files—with Compressor, MPEG Streamclip, or even directly in iTunes, by changing the iTunes import preferences.

To do a batch conversion in Compressor:

1. Drag the files you want to convert either from the iTunes application or from the Finder into the Compressor batch pane. You can also use the + popup menu at the bottom of the pane or press **Command-I**.

2. Under **Audio Formats** in the Settings pane, find **AIFF** or **WAV**, right-click on it and use **Duplicate**.

3. Select the copied preset and in the Audio pane of the Inspector change the **Sample rate** to **48 kHz** and the **sample size** to **16** or **24 bit** (see Figure 2.20). This forces the application to change these parameters rather than keeping the original.

Figure 2.20 AIFF Preset

4. With all the items selected in the batch pane drag the modified preset onto one of them to apply the preset to all of them.

5. With all the batch items selected from the Locations pane drag your preferred destination onto them. This can be your library's assigned external media folder.

6. Click the **Batch** button to begin converting your files.

7. Import your converted music into FCP. If the media is already in the correct location you can simply leave it in place.

SUMMARY

With this lesson, you have set up your preferences for editing, for playback, and for importing. We looked at importing from cameras and converting media and importing still images from Photos and audio from iTunes. In the next chapter we'll look at organization and workflow and different scenarios for different types of production.

Organization

In this lesson we'll look at working in the Browser to organize your footage using FCP's tools for working with metadata, the extra information attached to a piece a media that either comes from the camera itself or that you add to it.

LOADING THE LESSON

If you skipped directly to this lesson, first you'll need to download the material from www.routledge.com/products/9781138209978 and use the eResources tab. For this lesson we'll need the ZIP file called *FCPX2.zip*

1. Download the file and double-click the ZIP file to open it.
2. Drag the *FCPX2* library to your dedicated media drive.
3. Double-click the library to launch the application if it's not already open.

The library contains one event called *Organize* with 13 clips but without any project.

The media files that accompany this book are heavily compressed H.264 files. Playing back this media requires a fast computer. If you have difficulty playing back the media, you should transcode it to proxy media.

1. To convert all the media, select the event in the library, right-click on it and choose **Transcode Media**.
2. In the dialog that appears check on **Create proxy media**.

3. Next you have to switch to proxy playback. Click on the **View** popup in the upper right of the Viewer and select **Proxy**. If you haven't created proxy files, everything will go offline.

ORGANIZING THE CLIPS

There are no firm rules about how you organize your media, and each production or series tends to dictate its own organizational structure. Usually, I begin with one library that holds all of the media for the production, video, audio, and stills, so they're all collected into one place and are easy to back up. I prefer to use external media rather than managed media as it allows more flexibility for working with other applications like Motion. Even though the media is external, the library remains a self-contained unit which links everything involved in the production.

With the library selected in the Libraries pane you can see all the content of all the library's events in the Browser in List view by switching to it with the button at the top of the Browser or toggling between Filmstrip view with **Option-Command-2** (see Figure 3.1). If there are multiple events in the library the clips will be grouped by event name in the Browser. With the library selected you'll see at the bottom of the Browser the total number of items in all events; with one event selected just the number of clips in that event. Once you have the library selected like this you can close the Libraries pane with **Command-`**.

The purpose of events is primarily an organizational tool. These are the equivalent of top-level folders within your production. In *FCPX2* there is only one event, but if you have many more you can close and open the ones you want to work with using the disclosure triangles, while still seeing them all at once. If you want to see the contents of multiple events you can **Command**-click the events to see the contents at one time. Of course if you want to focus on any one event, you can simply select it in the Libraries pane. You can use the **Tab** key to move between the Libraries pane and the Browser and **Shift-Tab** to move backwards, and the arrow keys to move around

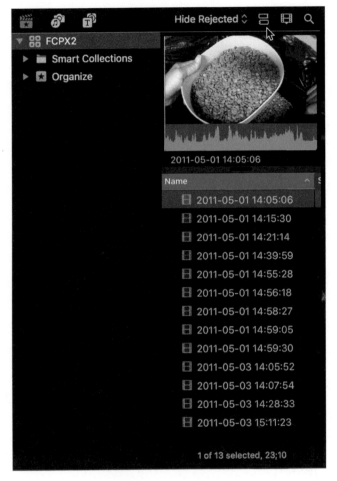

Figure 3.1 Clip Browser

the Browser, up and down arrows to move through the list, right arrow to open a disclosure triangle and left arrow to close it.

From the library, you start breaking down your material to organize it. If you ingest everything into one event, you can make new events and start moving clips around by dragging them from one to another. This is the same as moving files between folders, unless you hold down the **Option** key while you drag to make a duplicate. This does not duplicate the media or move the media. The media, whether it's managed media within the library, or external media, remains where it

was first imported. By copying from one event to another you're only making another pointer to the same media. Making copies of clips for organizing in the library does not take up more space.

You can also merge events by dragging one event on top of another in the Libraries pane or use **File>Merge Events**. All the clips and Keyword Collections and Smart Collections and folders will be combined into a single event.

Naming Clips

Because of the extensive use of metadata in FCP, clip names are not that important. Nonetheless, a cluster of date/time stamps like *2011-05-01 14:05:06* or *Clip #12* isn't very appealing or informative. Though you can rename your clips whatever you like, this does not change the name of the media file on your hard drive that it refers to.

You can rename a clip in the Browser in either Filmstrip view or in List view. To change the name in Filmstrip view, just click the name and it will be selected for renaming. In List view, select the name and press **Return** to highlight the name and allow you to change it.

You can also change the name of a clip in the Info inspector.

Let's start by renaming a few of the clips, first in Filmstrip view.

1. Change to Filmstrip view by clicking the icon at the top of the Browser or press **Option-Command-2**.
2. To see the clips as single icons, change the slider in the Clip Appearance popup at the top to All or press **Shift-Z** for Zoom to Fit, which sets the slider to the left.
3. Click the name of the first clip, the shot of a bucket of green coffee beans, to select it and rename it *green beans*.
4. Let's switch to List view by clicking the view icon at the top or pressing **Option-Command-2**.
5. Select the next clip in the list, the shot of the coffee cherries on the tree, press **Return** to highlight the name and rename it *cherries on tree*.

6. In whichever view you prefer rename the next clip *bananas & coffee*.

7. Select the clip *2011-05-01 14:39:59* and open the Inspector to the Info inspector.

8. In Basic view triple click or drag select the clip's name and change it to *green beans on tray* and press the **Tab** key.

9. Skip a clip and the last clip we'll rename is *2011-05-01 14:56:18*. This is a two minute shot at the end of the coffee roasting process. Just call it *roasting*.

TIP

Close the Timeline: To give yourself more space while you're organizing your clips you can close the Timeline pane by going to the **Window** menu and deselecting **Show in Workspsace>Timeline** or by pressing **Control-Command-2**, which will close and open it.

If the Name column is selected at the top of the list view as in Figure 3.2 the named clips will be at the bottom of the list. To reverse the sort order, just as in the Finder, click the Name header to toggle the triangle direction and reverse the order. If you want to keep the clips in shot order, regardless of the name, click the Content Created column header. This is sometimes useful for shoots like this that are a sequential process. You can drag the column headers to reposition the order in which the columns appear.

NOTE

Project Clips: Clips in the Timeline can also be renamed in the Info inspector, or by right-clicking on the Timeline clip and selecting **Rename Clip** (see Figure 3.3). Changing the name of a clip in the project timeline does not rename the clip in the Browser. The two are quite separate, two individual instances of the same piece of media. However within the Browser any instance of a clip in any collection or Smart Collection has to share the same name.

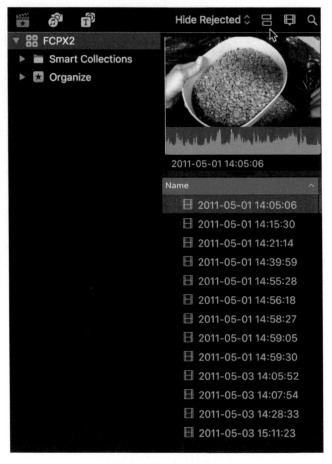

Figure 3.2 Name Order

Deleting Clips

In FCP, selecting a clip and pressing **Delete** simply marks it as rejected, as we shall see in a minute. Because the library you're working with actually contains your media, the clips in the Browser are very much your media. You can delete a whole clip from your event and remove it from your hard drive by pressing **Command-Delete**. Fortunately you get a warning message when you do this, and if you click OK, it's gone, but if you have sudden second thoughts **Command-Z** undoes this action, removing the clip from the Trash and restoring it to the Browser.

Figure 3.3 Rename Clip in Timeline

If the library contains the actual media, as it does here in the *FCPX2,*
the clip is gone to the system trash. If the event is only holding
symlink pointers to the media in an external folder, the alias is
deleted from the event, but the media remains wherever it was.

KEYWORDS

Collections are types of folders that are stored in events and created by
metadata, information assigned to clips or generated by cameras when
the material is recorded. Collections can be made by using keywords or
by creating Smart Collections. You can select an entire clip or a portion
of a clip to be added to a collection. A shot can be long or short, but
you'll usually want to use only part of it, perhaps cutting out the bit at
the beginning where the camera's not steady or a section where someone
steps in front of the lens. You can do this in a couple ways in FCP:

1. Select the *cherries on tree* clip. (It's Content Created time is May 1st
 at 2:15:30 PM.)

2. Switch to List view if you are not in it and slide the pointer across the preview filmstrip. Make sure the preview is not selected and is not bounded by a yellow selection box. (If it is selected press **Option-X** to deselect the filmstrip.)

3. Skim across the clip to look at the video. Around the 54 second mark mouse down and drag a selection of about six seconds of the clip. As you do this, a tool tip will show you the length as in Figure 3.4.

4. Once you have the selection made you can drag the handles on either end to adjust it.

5. Let's drop the selection. You can do this by pressing the **X** key to select the whole clip.

6. Play the clip using the **JKL** keys and find 54:04. Obviously on a clip like this that's over a minute long this gives you much greater precision.

7. Press the **I** key to mark an In point at 54:04. The **left** and **right** arrow keys will let you move forward and backward in one frame increments. **Shift** and the **left** and **right** arrow keys will move forward and backward in 10 frame increments.

8. Play through the clip until 1:00:22 and use the **O** key to mark an Out point. This makes a selection, and the selected duration 6:17 appears at the bottom of the browser.

The best way to mark this section of the shot is to make it a favorite or to apply a keyword to it.

TIP

Going to an Exact Frame: You can use the Dashboard to go to an exact frame. Click the timecode in the Dashboard once or press **Control-P** for playhead and type in a number such as *5404* for 54:04 (see Figure 3.5). You don't need to type in the colon. Press **Return** and the playhead will leap to that position.

Figure 3.4 Dragging a Selection

Figure 3.5 Playhead Position

> **TIP**
>
> **Playing a Selection:** To play just a selection that you've made from beginning to end press the **/** (forward slash) key.

Anything that happens in the Browser is tracked by a database that's filed in the event folder inside the library. This keeps track of all the metadata applied to all the clips. The whole organizational structure of FCP is based on the application of metadata to clips. Much of it is already there, from the camera and the QuickTime file or other file format that is your media, the rest you have to provide. One way you can do this is by adding keywords.

Keywords can be added to clips either in list view or in filmstrip, regardless of how the selection is made either of part of a clip, as here, or of an entire clip. To add a keyword to a clip or section of a clip:

1. With the area you just marked selected click the **Keyword** button at the top left of the FCP window or press the keyboard shortcut **Command-K**. Either way will open the Keyword HUD (Heads Up Display). **Command-K** will also close it.

2. Enter the word *cherries* in the HUD and press **Return**. An animation will appear that shows the keyword is applied to that segment of clip, and a blue bar will appear on it. Also in the *Organize* event a new Keyword Collection called *cherries* has been created, and the keyword has been added to the clip, which can be seen in list view when the disclosure triangle is open as in Figure 3.6.

3. Twirl open the disclosure triangle to see the rest of the HUD as in Figure 3.7. Notice that the keyword as had a keyboard shortcut, **Control-1**, applied to it.

4. Click on the *cherries* Keyword Collection in the event and you will see that it contains just one clip, the section of the *cherries on tree* clip.

Figure 3.6 Keyword in List View

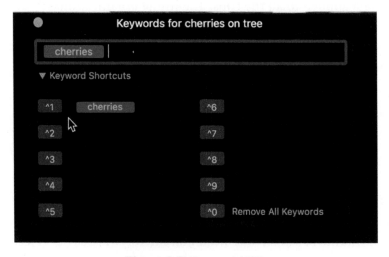

Figure 3.7 Keyword HUD

You can have up to nine keyboard shortcuts for keywords at a time using **Control-1** through **9**. The last shortcut **Control-0** (zero) is reserved to allow you to select a clip and remove all the applied keywords. You can also type in a keyword in HUD to add it to the list. This is useful if there are commonly used keywords that you want to apply. You can enter them even before you have imported your media. After you've made the keywords, as soon as you want to apply one, you just press the keyboard shortcut. If it's the first time the keyword is applied to a segment or a clip, a new Keyword Collection will be created in the event.

If you like clicking buttons, you can also click the shortcut button in HUD to apply a keyword to a selection.

Once you've made the Keyword Collection by adding a keyword to a clip, it becomes easy to apply the same keyword to other clips or to other segments of the same clip:

1. Click back on the *Organize* event in the Library pane so you see the whole list of clips.

2. Start playing the *cherries on tree* clip from the beginning and mark an In point around 17:07, after the camera has moved into the green cherries.

3. Play forward through the push in and mark an out point at 23:08, then press **Control-1** to apply the *cherries* keyword.

4. Let's add another keyword. Play forward to 43:21 and mark an In point. Mark an Out point after the push at 50:27.

5. Put the pointer over the selection till you see the helping hand, grab the selection and drop it on the *cherries* Keyword Collection in the event. The keyword is applied to that section.

6. In List view, with the disclosure triangle open, click on the first *cherries* keyword in the list view. Notice the selection area you made and labeled shows in the preview.

7. Click the second blue keyword bar in the preview and that section is immediately selected.

Essentially marking keywords is making multiple In and Out points in a single clip and holding those for any time you need them. In the *cherries* Keyword Collection each keyworded section behaves as if it were a separate clip. Although making a keyworded clip, or a favorite, which we'll see in a moment, does not create a separate QuickTime file, the clip in the Keyword Collection is treated as a separate clip, even though it really isn't.

Let's see how to remove a keyword:

1. In the preview in list view of *cherries on tree* skim down to about 1:06:15 and drag a selection that's about eight seconds long.

2. Press **Control-1** to add the *cherries* keyword. Oops. Those aren't coffee cherries; they're papayas.

3. If you dropped the selection, click the last blue bar on the clip or click the last *cherries* keyword in the list.

4. If the keyword HUD isn't open press **Command-K**, which will also close it by the way.

5. Select the word *cherries* in the HUD as in Figure 3.8 and press the **Delete** key. The keyword is removed and disappears in a little puff of smoke. The section is of course also removed from the Keyword Collection.

Figure 3.8 Deleting Keyword

You can also create a Keyword Collection and import directly into it.

1. To create a new Keyword Collection you can use **File>New Keyword Collection** or the shortcut **Shift-Command-K** or you can right-click on the event in the library and select **New Keyword Collection**.

2. Choose your preferred method to make a new Keyword Collection and call it *roasting.*

With the empty Keyword Collection selected you can if you wish use the Import window to bring in media from a camera or hard drive directly into that Keyword Collection. You can also, if you wish, drag and drop clips, video, audio, or stills directly from the Finder into a Keyword Collection. The items become keyworded and are added to the event the collection is in.

TIP

Option Drag to Select: If you have a whole clip selected and want to drag a smaller selection, hold the **Option** key to begin a new selection on the clip.

NOTE

Keyword Collections from Folders and Tags: It also can be very useful to organize your media into folders in the Finder, and to use the macOS tagging function to identify files. When you import these files FCP can use the folders and tags you create to make Keyword Collections.

FAVORITES AND REJECTS

FCP has a very useful ability to rate clips, mark them as Favorites or Reject them. You can also Unrate a clip or clip segment so it's no longer marked as a Favorite or Rejected. The ratings can be applied from the **Mark** menu or with the same keyboard shortcuts as iMovie: **F** for Favorites, **U** for Unrated, and the **Delete** key for Rejected.

1. Play the two-minute *roasting* clip from the beginning and mark an In point at 4:10, then mark an Out point at 18:08 after the words "a medium roast."
2. To mark it a favorite press the **F** key. A green bar appears in the preview and the section is tagged a Favorite.

3. Mark another In point at 22:06 and an out at 34:26 after the words "from here to here."

4. Mark this segment as a Favorite with the **F** key.

Notice that no collection is being created for Favorites, but we can fix that so you can have a collection for Favorites. To see just your Favorites use the Clip Filtering popup menu at the top of the Browser (see Figure 3.9). You can also use the keyboard shortcut **Control-F** and only the two favorite sections will appear. Press **Control-H** to return to **Hide Rejected** in the Browser. A list of the Clip Filtering shortcuts is in Table 3.1. With the Browser in list view, let's rename the Favorites.

1. Twirl open the disclosure triangle for *roasting* and select the first Favorite in the list and press the **Return** key to rename it.

2. Type in *medium roast* and press the **Return** key to close the name.

3. Press the **Down** arrow to select the second Favorite, then press **Return** to rename it.

4. Type in the word *darker* and press **Return** again to confirm it.

Figure 3.9 Clip Filtering Popup Menu

Table 3.1 Clip Filtering Shortcuts

All Clips	Control-C
Hide Rejected	Control-H
No Ratings or Keywords	Control-X
Favorites	Control-F
Rejected	Control-Delete
Unused	Control-U

Because you can't name the sections of the clip separately, naming the Favorites is a way to make a note of the section that you have marked as a Favorite.

Let's mark some sections of the clip as rejected.

1. Select the *roasting* clip so that you can see the preview and click the first of the two green bars to select the first Favorite segment.

2. Press **Shift-I** to move the playhead in the preview to the beginning of the marked selection and step one frame earlier with the left arrow.

3. Press **O** to mark an Out point. This will make a selection from the beginning of the clip to the beginning of the first Favorite.

4. Press the **Delete** key to mark the section as rejected and the section will disappear.

5. Click the second green Favorite bar to select the region and press **Shift-O** to move the playhead to the Out point.

6. Go forward one frame with the right arrow and press **I** to mark an In point.

7. Play to around 41:18 and mark an Out point.

8. Press the **Delete** key to reject this segment as well.

With rejects hidden, *roasting* appears as two separate clips, one with two Favorites, and one without any Favorites. These are not two separate clips that can be renamed. These are still one clip shown as two separate sections.

1. Switch to view all the clips by pressing **Control-C** or use the popup at the top of Browser. The *roasting* clip will now appear as a single clip with the red reject bars at the top.

2. To remove a Favorite or a Reject click the green or red bar to select the region.

3. Press the **U** key for unrated. The green or red designation disappears.

4. Undo that so that you still have two Favorite sections and two Reject sections in *roasting*.

Switch to **Hide Rejected** by pressing **Control-H** and check out the other functions available in the Browser filter menu.

SEARCH FILTER

In addition to keywords and ratings, it's often useful to include notes about clips or segments on the clips themselves, a few words about a soundbite, a note about fixes like color correction that need to be made.

1. If you're in Filmstrip view switch back to List view by pressing **Option-Command-2**.

2. Make sure the *Organize* event is selected and click on the clip named *green beans on tray* and press the **Tab** key, which is another way to select the name for renaming.

3. Repeat pressing **Tab** until the selection has moved across the list to the Note column.

4. Type in the word *sample*. This is now a searchable piece of information that can be found easily and used as a tag for creating a collection.

To search the Browser, click the magnifying glass icon in the upper right for the Browser and type a word like *sample* in the search box that appears. This is a search filter so you will now only see the clip *green beans on tray*. If you select the Keyword Collection *cherries* the browser will be empty because there is nothing in that collection that includes the word *sample*. To remove the text filter delete the word or click the little X circle on the right edge of the search box.

You can call up a more robust filter window by clicking on the Filter HUD icon to the right of the search box or pressing, just like in the Finder, **Command-F** to bring up the Filter HUD. Here you can enter a text search such as *sample* and add multiple criteria by clicking the + popup in the upper right. Notice the button allowing you to create a **New Smart Collection**.

NOTE

Notes on Keywords and Favorites: You can also add notes to specific favorites and keyword sections (see Figure 3.10). You can add the notes to favorites in the Browser, and to keywords either in the Browser or in the Keyword Collection.

Figure 3.10 Notes in Browser

SMART COLLECTIONS

Metatagging is tagging media with metadata, such as we do when we create keywords or mark favorites or add notes to clips. This metatagging is used to create what Apple calls rules for Smart Collections. A Smart Collection is like a Smart Album in Photos or a Smart Playlist in iTunes. Basically you set up criteria that the collection uses to add material to it. There are different types of Smart Collection: ones you produce, which we'll see in a moment, and ones produced by the application. Every library comes with a Smart Collection

folder, which includes library wide Smart Collections for things like stills, audio, favorites, and projects. In addition, the application can produce Smart Collections from analysis. FCP has some automated tools that divide material into shot types and shots with people. While this sounds good in theory, for large projects it's not really of great benefit, and you have to impose an organizational structure that suits your project and your needs. Some Smart Collections can be created automatically on import when running analysis for people in the right sidebar of the Import window (see Figure 3.11).

Figure 3.11 Smart Collection in Import Window

You can also have FCP analyze your video after the media is imported by using **Modify>Analyze and Fix** or by right-clicking on a clip or selected clips and choosing **Analyze and Fix** from the shortcut menu.

1. Select the clip *2011-05-03 15:11:23* and rename it *removing parchment from beans*, because pounding the green coffee beans is done to remove the outer parchment-like skin that surrounds them.

2. With the clip selected right-click and run **Analyze and Fix**. In the sheet that drops down check on **Analyze for balance color**, **Find People**, and finally check on **Create Smart Collections after analysis**.

This may take quite some time, depending on the speed of your computer and what else you're doing on it. To see the progress of your analysis watch the dial with checkmark in the top left of the

FCP window or click it to bring up the Background Tasks HUD (see Figure 3.12). You can also bring up this HUD with the keyboard shortcut **Command-9**, which also will close it.

Figure 3.12 Background Tasks HUD

Once the analysis is complete you will have a number of new collections with the purple gear icon called Smart Collections, two grouped in a folder for *People*, one for *Close Up Shot* and another for *One Person*.

> **NOTE**
>
> **Renaming Collections:** While Keyword Collections can be renamed, thus changing the keyword itself, automatic Smart Collections cannot be renamed, as they take their name from the analysis that was performed. Renamed Keyword Collections will change every instance of the keyword used in the Browser. It will not change keywords that have already been edited into a project. On the other hand *manually* created Smart Collections can be named whatever you want, and renaming them will not change the criteria.

You could make an empty Smart Collection by using **File>New Smart Collection** or the shortcut **Option-Command-N**, and then click the icon to open the Filter HUD. You can create a Smart

Collection for an entire library, by selecting the library, and using **File>New>Library Smart Collection**, or you can make a Smart Collection for a single event by selecting the event and using the menu. The keyboard shortcut is the same for both, it just depends what you have selected, the library or the event. The library Smart Collection will appear inside the Library Smart Collections folder.

Let's use another way to create a Smart Collection:

1. Select the *Organize* event in the Libraries pane so you'll be searching all the clips in the event and creating the Smart Collection in the event.
2. Click the magnifying glass to open the search box and click the Filter HUD icon.
3. Type the word *sample* in the Text search box. If you entered the word *sample* in the Note column earlier, the filter will reveal the three clips in the Browser that had *sample* added to the Notes.
4. Next click the + button in the upper right of the Search Filter HUD and select Ratings. The default is Favorite, and of course the Browser.
5. In the lower right click the button for **New Smart Collection.** The criteria you used to make the smart search filter is used to make a new Smart Collection that appears in the event as *Untitled*.
6. Name the Smart Collection *sample+fav*. Now every time you make a Favorite and add the note *sample* to a clip, it will immediately be added to the Smart Collection.

While there is a Favorites Smart Collection in the Library Smart Collections folder, you can create a Favorites Smart Collection for an event. You could go through the process we just did, or simply drag the Favorites Smart Collection from the Library Smart Collections folder into the event in which you want to have a Favorites Smart Collection. This will only show the Favorite clips in that event.

Search filters are based on Boolean selections so, for instance, you can search for text that Includes, or Does Not Include, or Is, or Is Not. You can search by a great many custom settings including

keyword groups, all of which can be saved as Smart Collections. Figure 3.13 shows the default available options.

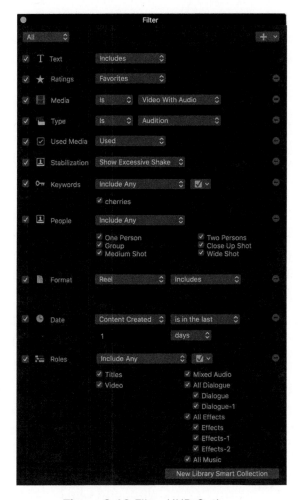

Figure 3.13 Filter HUD Options

OTHER TOOLS

Just as the analysis of Smart Collections such as *Close Up Shots* and *One Person* are grouped into a folder, so you can group your own collections into folders by right-clicking on the event and selecting **New Folder**, or with the event selected use **File>New>Folder** or press **Shift-Command-N**.

You can also consolidate events by dragging one event on top of another in the Libraries pane. This will move all the media into one event folder. You can also copy or move an event from one library to another library by selecting the event and using **File>Copy Event to** or **Move Event to.** You will not have the option to move an event if it's the only event in the library. Every library must have at least one event.

Compound Clips and Auditions

Compound Clips and Auditions are some advanced tools that we'll look at later in other situations, but many FCP users have found them useful as organizational tools so I've included them here as well. Often editors like to look at string outs of clips, to play through multiple clips, maybe all the clips in a scene, continuously. You can mark the clips as favorites or give them keywords and play through the collections using continuous playback. Another way is to put them into a Compound Clip.

1. Select the *Organize* event and make sure nothing is selected in the Browser.

2. Holding the **Command** key randomly select three or four non-contiguous clips.

3. Then press either right-click on one of the clips to select **New Compound Clip** or use the keyboard shortcut **Option-G.**

4. A new Compound Clip drop down sheet appears. Name the compound *coffee.* The new Compound Clip will appear in the Browser. In Filmstrip view a Compound Clip badge will appear in the upper right corner of the filmstrip.

5. Double-click the compound to open it into the Timeline. Here are the selected clips laid out in the order in which they were shot for you to see. Press **Shift-Command-F** for full screen and sit back and watch your video play.

The compound is actually a separate sequence inside your event. You can edit it just as we'll see in the next lesson: you can add music and

titles and effects; you can cut and paste from it into a project; you can place the entire Compound Clip if you wish into a project.

It's important to note, though, that Compound Clips are recursive. That means that if you make a Compound Clip in the Browser and put that Compound Clip into a project, if you open the compound from the Browser and make changes those changes will be reflected in the project.

You can also make an empty Compound Clip from the **File** menu or with the keyboard shortcut. This can be opened into the Timeline and have clips added to it for viewing.

Auditions are slightly different. These allow you to combine multiple clips into a container from which you can select the clip you want to view and use. When you edit the Audition into the Timeline all the clips go together and in the Timeline you can switch between them. We'll look at working with Auditions in the Timeline in later lessons, but let's look at creating them here.

1. In the *Organize* event select the three clips *cherries on tree, bananas & coffee,* and *green beans on tray.*

2. To make the Audition you can either right-click on the clips and select **Create Audition** from the shortcut menu or use **Command-Y**. A new item will appear in the Browser with a spotlight icon, which can also be seen as a badge in the upper left corner of the preview, just as the Compound Clip badge.

3. Click the badge in the upper left corner of the preview to open the Audition container or select the Audition and press **Y** (see Figure 3.14). Because there were multiple selections made in the *cherries on tree* clip, more than three clips appear in the Audition container.

You can switch between the Audition clips in the container by clicking on the clip you want and the preview will update. You can also move between the items using the **Left** and **Right** arrows. To close the Audition you can click **Done** or press the **Y** key. The Audition is a complete unit, separate from all the clips, and contains

Figure 3.14 Audition Container

the clips you want in it. This is a handy way to group clips together, which can be edited and switched as you like. It's a great tool for prevaricators or those suffering from a serious case of indecision.

You can edit the Audition into the Timeline where you can continue to switch between items. Once the Audition is in the Timeline, more clips can be added to it or clips can be removed from it.

SUMMARY

In this lesson, we looked at the importance of organizing our material. We looked at naming our clips and deleting clips. We created keywords, and made Keyword Collections, made Favorites and Rejects, and organized our event in collections and folders. We used the search filter to make Smart Collections. We also looked at Smart Collections created by analysis. We even worked with some advanced editing tools—Compound Clips and Auditions—and used them for grouping and organizing our media. In the next lesson, we will look at putting our shots together in a sequence. We'll look at precise ways of editing our clips into a project, as well some trimming and rearranging functions.

Editing Basics

Now that you've organized your material in the Final Cut Pro Browser, it's time to edit your clips into the Timeline to assemble your project. FCP has several different ways to do most of the editing functions, some of which will be familiar to iMovie users. You can edit directly into your project Timeline with the mouse or with keyboard shortcuts, which is probably the most efficient way to edit in most instances.

LOADING THE LESSON

If you skipped directly to this lesson, then first you must download the tutorial material from the www.routledge.com/products/9781138209978 web page and going to the eResources tab. For this lesson we'll need the ZIP file called *FCPX3.zip*

1. Download the ZIP file and double-click it to open it.

2. Copy or move the *FCPX3* library to your dedicated media drive.

3. Double-click the library to open it and launch the application.

The library contains a single event called *Edit* that has 14 clips that we're going to work with in this lesson.

EDITING CLIPS

When you first launch iMovie, you are taken to a window to create a project, either a movie or a trailer, which opens into the Media pane with an empty project at the bottom. When you first open FCP, there

is no project, just an empty Timeline pane, because, as we've seen, there is so much work to do before your project is ready to start being edited.

1. To make the new project click the **New Project** button in the empty Timeline, or use **File>New Project** or the almost universal keyboard shortcut for a new document or whatever your application calls it, use **Command-N**.

2. In the drop down sheet name the project *Edit*, which will be created in the *Edit* event. If you click **OK**, the project will be created using the default settings.

3. Click **Use Custom Settings** to see your options (see Figure 4.1). Notice the option to set the Color Space. It's set to Rec. 709 unless the Library has been changed to Wide Gamut color processing in Library Properties. Then the Rec. 2020 option will be available.

4. Switch back to Automatic Settings and leave the Starting Timecode at zeros unless you have a reason to change it.

5. Usually the best choice, unless you have specific reason to use custom settings, is to have the video properties **Set based on first video clip properties**.

6. Unless you're working in 5.1 surround, you should use the default Stereo 48K audio settings.

Figure 4.1 New Project Settings

Figure 4.2 Start of the Primary Storyline

The new project will appear in the *Edit* event and open in the Timeline pane. Like iMovie FCP has a storyline, here it's marked by a barely discernible dotted rectangle on the left edge (see Figure 4.2). This marks the start of your *primary storyline*. We'll start by editing some shots into this project, onto the primary storyline. For most types of edits there are up to four ways to edit into the Timeline:

- By dragging the clip into the Timeline
- By using the **Edit** menu
- By using keyboard shortcuts
- By clicking one of the edit buttons.

You can execute the edit any way you like. Many people like to drag to the Timeline, but I personally prefer the accuracy and speed of using keyboard shortcuts.

Append

Many of the basic edit functions are the same in iMovie as in FCP, such as Append, Insert, and Connect, so we'll go through this pretty quickly. Let's start with the shot called *man standing at counter.* You could skim the shot to view it, which is fine when you're organizing your media and applying keywords; but when you're editing, to get the correct pace and timing of a shot, it's best to simply play it in real time.

1. Play the shot with the spacebar. Wait for the camera to settle at around 3:05 and enter an In point with the **I** key to mark the beginning of the selection.
2. Play forward in the clip for around six seconds to around 9:10.
3. Enter an Out point by pressing the **O** key to mark the end of the selection.

The little + button that appears on clips in the Browser in iMovie and acts as an Append button is not available in FCP.

When you have the clip marked the way you want, about six seconds long, you're ready to put it into the Timeline:

1. The first way is to drag it there. Grab the image from the filmstrip in the Browser and drag it into the Timeline. Drop it anywhere in the Timeline pane, and the clip will move to the beginning of the storyline.

This is an **Append** edit, just as in iMovie. If you drop the clips beyond any in the Timeline, it always adds the clip to the end of the project.

Let's edit a few more shots into the Timeline using other methods.

1. Let's put in the next shot, *man handed bag.* Mark a selection from where the camera pushes in and settles around 2:19 to where the man gets his groceries around 16:00.
2. You could append the clip into the Timeline using **Edit>Append to Storyline**, but rather than that use the **E** key, so the clip gets added to the end of the project on the primary storyline.

3. Let's add a third shot, *ls woman getting sample.* Mark a selection from the beginning of the clip to about 9:25, after she gestures to the woman beside her, by pressing the **O** key at the end. The clip is selected from the first frame to the marked Out point.

4. To edit the clip into the Timeline click the Append button, the third in the group of four in the Toolbar (see Figure 4.3).

5. Let's Undo that with **Command-Z**, and we'll do the edit a little differently.

6. We'll mark up a second piece in the same shot. Play forward to about 14:00, after the camera comes around to be beside her, and use **Shift-Command-I** to make the start of the selection. As in the Import window this marks a second selection without losing the first.

7. Play forward to about 24:07, shortly before the end of the shot, and mark the end of the selection with **Shift-Command-O**.

8. Press the **E** key, just like iMovie, to do an Append edit and drop both selections into the Timeline after the others.

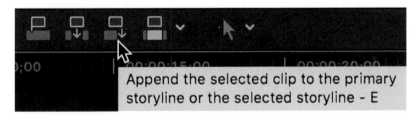

Append the selected clip to the primary storyline or the selected storyline - E

Figure 4.3 Append Button

TIP

Marking Favorites: A trick that many editors have adopted is to mark a selection with the **F** key, marking it a Favorite, before you make other selections using the standard **I** and **O** keys. This makes it easy to come back to a selection in a clip, or activate multiple selections, before editing into the Timeline.

> **NOTE**
>
> **The Magic Frame:** When the playhead moves to the end of the last clip in a project, the Viewer displays the last frame of the clip with a torn page overlay on the right side. This is the Magic Frame, because the playhead is actually sitting on the next frame of video—the blank, empty frame—but the display shows the previous frame.

Insert

While the Append function is fairly common at the start of the editing process, very often you don't want to put the clip at the end of the project but somewhere in the middle of it. To do this you do an **Insert** edit. Let's add a few clips at the beginning of the Timeline. Look at the lengthy shot called *cutting meat*. We're going to use a few pieces of this. We'll begin with the wide shot.

1. Because the shot is so long a shot selection would be very difficult to grab in the preview in List view, so let's switch to Filmstrip with the button at the top or the shortcut **Option-Command-2.**

2. Depending on the size of your monitor adjust the thumbnail slider to either five or 10 seconds per thumbnail. As in iMovie **Command-plus** will zoom into the filmstrip, **Command-minus** will zoom out, and **Shift-Z** will give one icon for each clip.

3. In *cutting meat* go down to 31:09 and mark an In point and mark the Out point at 34:15.

4. Grab the selection directly from the Browser, and drag it to the Timeline right at the beginning so it pushes everything out of the way.

5. Let's add another piece of the same shot to the Timeline, but first let's position the playhead to where we want to go. Either drag the playhead to the edit point between the first and second shots, or move the skimmer to that point and click to bring the playhead there.

As you move the playhead or skimmer onto the edit point, it should snap strongly to the join as it does in iMovie. This doesn't allow you to skim a project smoothly as the skimmer sticks to the edit points. To skim smoothly switch off **Snapping** by pressing the **N** key or click the Snapping button in the right end of the Toolbar (see Figure 4.4). Remember blue means it's on and gray means it's off.

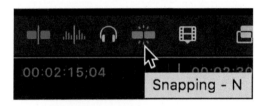

Figure 4.4 Snapping Button

When the playhead is between the two clips notice the slightly translucent L in the lower right corner of the Viewer (see Figure 4.5). This overlay indicates that you're on the very first frame of that clip in the Timeline. If you step back one frame with the left arrow key, you'll see a reverse L in the lower right corner of the Viewer, indicating you're on the last frame of that clip in the Timeline (see Figure 4.6). Make sure the playhead is back at the edit point so you see the first frame indicator in the Viewer.

Figure 4.5 First Frame Overlay

Figure 4.6 Last Frame Overlay

Let's insert a shot between edit points:

1. With the playhead positioned where you want to insert the next shot, between the first and second shots in the project, let's make another selection from the *cutting meat* clip, a close-up section where the meat is being cut, marking a three-second selection beginning around 26:06.

2. You could do the edit by using the menus, selecting **Edit>Insert**, but instead just click the Insert button in the Toolbar (see Figure 4.7), the second of the four edit buttons.

3. Close-ups are often excellent cutaways, so make a selection of the close-up of the butcher, starting at 20:06 and ending at 22:10.

4. To edit this into the Timeline after the other *cutting meat* clips use the keyboard shortcut **W** to insert the shot. The shortcuts are the best ways to do these types of edits in my view.

Figure 4.7 Insert Button

> **TIP**
>
> **Moving Between Edit Points:** The simplest way to move between edit points is to use the **Up** and **Down** arrow keys. The **Up** arrow takes you back one edit event. It moves the playhead back from where you are to the edit before. The **Down** arrow key moves the playhead to the next edit event, whether an audio or video edit point, whichever comes next in the Timeline. You can also use the **semi-colon** key to move backwards through the edits, and the **apostrophe** key to move farther down the Timeline. The **Home** button (**fn-left arrow** on a laptop) takes you to the beginning of the Timeline, and **End** (**fn-right arrow** on a laptop) takes you to end of the Timeline.

> **TIP**
>
> **Going to a Place in the Video:** To go to a specific frame of video either click the timecode display in the Dashboard or press **Control-P** for playhead (see Figure 4.8) and type in the number you want, such as *2606* and press **Enter**. You don't need to type in the colon or semi-colon.

Figure 4.8 Moving the Playhead in the Dashboard

Connect

A **Connect** edit works just like it does in iMovie. The only difference is that, while in iMovie you can only have a single connected video clip, in FCP you can connect as many video clips as you want, stacked vertically in layers just as you can audio clips. Let's connect a couple of clips starting with a cutaway in the middle of the *man handed bag* shot.

1. Move the Timeline playhead to around 19:00, a beat after the camera pulls back and the image brightens. This is where we'll connect the first clip.

2. Select the *prosciutto samples* clip and mark an Out point at about 3:00.

3. We want to edit only the video into the Timeline. To do this use the little triangle menu next to the edit buttons in the Toolbar. Select **Video Only** or use the keyboard shortcut **Shift-2**. In Figure 4.9 you'll see the way the buttons change indicating Video Only edits.

4. You could use the **Edit>Connect to Storyline** function, but instead use the Connect button in the Toolbar, the first of the four edit buttons.

Figure 4.9 Video Only Edits

We did a Video Only edit, but you can also do an Audio Only edit, also selected from the edit button popup menu or with the shortcut **Shift-3**. The keyboard shortcut **Shift-1** will return to doing All, both video and audio together.

Let's add part of the *dried tomatoes* clip right after the first connected clip, but let's use a slightly different technique, defining the duration of the clip in the Timeline.

1. With the playhead at the end of the first Connected Clip mark the beginning of a selection with the **I** key. This marks the clip on the primary storyline from that point to the end of the clip.

2. Play forward till the woman in the foreground clears the frame, about 24:16 and mark the end of the selection with the **O** key. Notice that the duration of the selection is displayed in the Toolbar.

3. Click on the *dried tomatoes* clip in the Browser to select it. The whole clip, that's 17 seconds long, is selected.

4. Press the **Q** key to execute the Connect edit. The clip takes its duration from the selection in the Timeline.

This technique allows you to edit with great precision, but let me show you another very useful trick.

1. Undo the last edit with **Command-Z**, so that the Connected Clip disappears from the Timeline, but the Timeline selection remains.

2. Play the *dried tomatoes* clip until almost the end after the woman arranging the olive oil leaves the frame around 15:29 and mark an Out point. The selection is from the beginning of the clip to the Out point and is 16 seconds long.

3. Instead of simply connecting the clip we're going to backtime the connection. Press **Shift-Q**.

The shot is connected to the Timeline for the same duration, using the marked Out points as the reference, the Out point in the Browser matched to the Out point in the storyline, the duration backtimed from that point. Other edit functions such as Insert and Overwrite can use this technique as well.

Overwrite

The Overwrite edit function, while common to most editing applications, is not now probably used that much in FCP. An Overwrite edit is one in which the video will punch into the storyline overwriting what's already there, cutting it out for the duration of the new shot. Unlike the other edit functions you cannot Overwrite by dragging into the Timeline with the Select tool. To do an Overwrite you can use the fourth of the edit buttons in Toolbar or the menus or a keyboard shortcut.

1. As a moment ago, we'll start by marking a selection in the Timeline. Mark an In point with the **I** key at the beginning of *ls woman getting sample* and mark an Out point three seconds nine frames later.

2. Press **Shift-1** to reset the edit functions to All so that we can edit both video and audio into the Timeline.

3. Select the *dried tomatoes* clip again, and this time we'll use the beginning of the shot. With the clip selected use the Overwrite edit button, the last of the four, or **Edit>Overwrite**, or the keyboard shortcut **D**.

The clip punches into the storyline, cutting out what's there, replacing it with the shot from the Browser, taking its duration from the selection in the storyline.

Another useful Overwrite function is the ability to collapse Connected Clips in the primary storyline.

1. Select the two Connected Clips in your sequence.

2. You can then either use **Edit>Overwrite to Primary Storyline** or the keyboard shortcut **Option-Command-Down** arrow to put the two clips into the primary storyline. Your Timeline will then look like Figure 4.10.

Notice the audio for the adjacent clips expands out to make room for the audio from the new clips and is not wiped out when Connected Clips use the Overwrite to Primary Storyline function. We'll look at expanding clips in Lesson 6 on audio.

Figure 4.10 Connected Clips Overwritten into Primary Storyline

You can also lift clips out of the primary storyline and make them Connected Clips.

1. Select the two clips you just collapsed and use either **Edit>Lift from Storyline** or press the keyboard shortcut **Option-Command-Up** arrow. The two clips lift from the storyline and appear as clips connected to the Gap Clip on the primary storyline (see Figure 4.11). Notice that the Connected Clips are now bridged with a dark bar called the *shelf*. This connects the clips into a secondary storyline.

2. Select the *man handed bag* clip and you can either use **Clip>Collapse Audio/Video** or you can use the shortcut **Control-S** or simply double-click the audio to collapse it back into the video.

The principal editing shortcuts used in FCP are listed in Table 4.1.

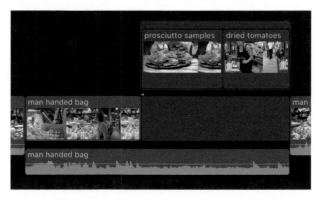

Figure 4.11 Primary Storyline Clips Converted to Connected Clips

TIP

Used Media Ranges: One thing iMovie users are accustomed to seeing is the orange bar in the Browser under sections of clips that have been used in the project. This is also available in FCP, though it's not switched on by default. To see the orange bars use **View>Browser>Used Media Ranges**. The orange bar shows only for segments used in the project open in the Timeline. When you go to another project, the bars will change.

Table 4.1 Principal FCP Edit Shortcuts

Edits	Shortcuts
Connect	Q
Insert	W
Append	E
Overwrite	D
All (Video and Audio Edit)	Shift-1
Video Only Edit	Shift-2
Audio Only Edit	Shift-3

Replace

The **Replace** edit function is similar to the Replace edit in iMovie with a few extra options. It will replace a clip in the Timeline with another clip from the Browser. It replaces it in a number of different ways: a full Replace ignoring duration; Replace from Start; timed forward from start of the clip; Replace from End; backtimed from the end of the clip, as in iMovie. The Replace Insert function that's in iMovie is not available in FCP, as you can Insert edit into the middle of any shot. Replace in FCP has a few other functions. Let's do a Replace edit:

1. Start with the first shot in the Timeline, the long shot portion of *cutting meat*, which is 3:07 in length. In the Browser find *ls cleaning fish*, which is eight and a half seconds.

2. Drag *ls cleaning fish* onto the first *cutting meat* shot, hold till the Timeline clip turns white, then release the clip to bring up the shortcut menu as in Figure 4.12. Notice the additional Replace functions.

3. Select **Replace from Start**, and the clip drops into the Timeline taking its duration from the clip that's already there. You can also select the clip in the Browser and use **Option-R** to Replace from Start.

4. Select the second *cutting meat* shot in the Timeline, and in the Browser find the *cleaning fish* clip.

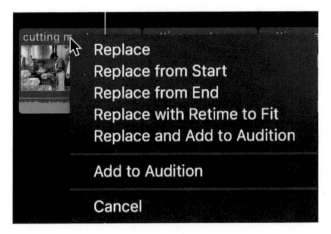

Figure 4.12 Dragging to Replace

5. Play the clip till the camera settles on the medium long or three-quarter shot around 22:27 and mark an In Point.

6. With the second *cutting meat* clip selected in the Timeline press **Shift-R**. This will do the full replace edit, replacing the duration of the Timeline clip with the duration of the clip in the Browser.

7. Undo that with **Command-Z**.

8. Instead of the full replace, press **Option-R** for the **Replace from Start** edit function.

This is a really handy and efficient way to change shots and try different material, but there is an even more powerful tool in the shortcut menu, which we'll see next.

> **TIP**
>
> **Multiple Clips:** You aren't limited to dragging a single clip to the Replace function. You can if you wish make two or more clip selections and drag them into the Timeline to replace a single clip.

Audition

Audition is a unique Replace function. It lets you create a container of clips that you can easily switch between to replace a clip in the Timeline to try multiple different options as we saw in Auditions in

the previous lesson. To see what it does and how it works we need to do a Replace edit.

1. From the *cleaning fish from behind* clip select a short portion of about three seconds in the close-up of cutting the fish. Mark an In point at 4:00.

2. To make the selection three seconds you can either double-click the timecode in the Dashboard or press **Control-D** for duration.

3. Type in *3.* (that's three and period) or *300* as in Figure 4.13 and press **Enter**. The clip's duration will be set to three seconds.

4. We're going to replace the last *cutting meat* shot, so drag the selection from the Browser to the Timeline onto the remaining *cutting meat* clip, hold for it to turn white, then select **Replace and add to Audition**.

Figure 4.13 Setting the Duration in the Dashboard

If you zoom into the Timeline you'll see that the clip has a badge in the upper left corner that looks like a spotlight. Click on it to open the Audition HUD (see Figure 4.14) or select the clip and press **Y**. In the HUD you see both clips—the current clip in the Timeline plus the clip it replaced. To select the other clip simply click on it to change the clip in the Timeline. You can also use **Left** or **Right** arrow to switch between the two.

An interesting feature is the behavior of the spacebar play function while the HUD is open. If you press the spacebar, the playhead will start playing the Timeline before the clip, play through the clip, and past the clip. It will automatically be in looped playback mode, so it just keeps playing over and over while you try different possible selections. You can add as many clips to the Audition container as you want and keep switching between them.

Figure 4.14 Audition HUD

Notice the HUD also has the option to duplicate a clip. This allows you to have multiple copies of the same clip with different effects applied to them, perhaps with different color looks. We'll see this in the lesson on effects and on color correction. The Replace with Retime to Fit we'll look at in the section on speed changes in Lesson 9.

Though you can simply leave the Audition container in the Timeline throughout your project, if you do finally decide on a specific shot, you can select **Finalize Audition** from the **Clip>Audition** submenu or use **Shift-Option-Y** to close the container and leave the final shot in the Timeline.

> **TIP**
>
> **Audition HUD:** Another really useful shortcut is **Control-Command-Y**, which not only opens the Audition HUD, but also sets off playback, putting the playhead in looped playback mode.

ADDING TRANSITIONS

Transitions can be helpful to smooth out difficult edits. Traditionally transitions were used to denote changes in time or location: dissolves indicated small changes while a fade to black marked a longer passage of time. There are a great many transitions in FCP, 110 at the moment, and of course many, many more available through third party developers. Just because there are many of them doesn't mean you have to use them. Most film and television programs use only cuts and the occasional dissolve or fade.

Transitions are accessed from the Transition Browser at the far right end of the Toolbar (see Figure 4.15). Click the button to open the Browser. Here you can see the available transitions, which can be skimmed or played while a preview appears in the Viewer.

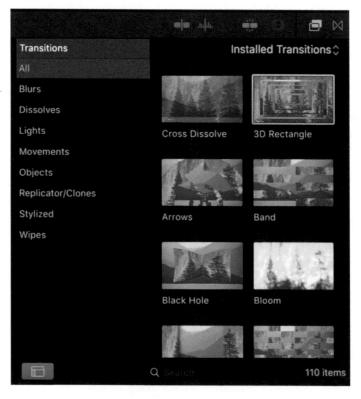

Figure 4.15 Transition Browser

The transitions are divided into categories that appear in the sidebar. There is a search box at the bottom of the pane and the button in the lower left will close and open the sidebar. The Stylized category holds a collection of themed transitions that have corresponding titles in most of the title categories and corresponding themes in the Generators Backgrounds category.

The default transition in FCP is the Cross Dissolve, which is why it appears first in the list. You can make any transition the default transition, by right-clicking on your preference and selecting **Make Default**. The default transition preference is one second, which can be set in Editing preferences. Like most transitions, Cross Dissolve has controls in the Transition inspector. This is no simple Cross Dissolve; it has 11 different types of cross dissolves built into it. Every transition has controls in the Transition inspector where you can adjust its parameters. Some transitions such as Page Curl also have on screen controls that are very handy (see Figure 4.16).

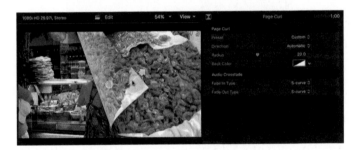

Figure 4.16 Page Curl Controls

You can apply a transition in Final Cut Pro in several different ways:

- Drag the transition you want from the Transition pane, and drop it on an edit point
- Move the playhead to the edit point and select it with [or] or \, or click on it. Then double-click the transition you want in the Transitions Browser
- Select the edit point, and apply the default transition with the keyboard shortcut **Command-T**

If you want to replace a transition in the Timeline with another one from the Transitions Browser, select the one that's in the Timeline and double-click the transition you want to replace it with. Any duration change you made to the transition will be maintained.

> **NOTE**
>
> **Embedded Motion Projects**: Notice the popup in the upper right of the Transitions Browser (see Figure 4.17) that allows you to view transition or effects content specifically for the library you're using that has been consolidated into the library. This is a great feature that facilitates collaborating between editors.

> **NOTE**
>
> **Transitions on Both Ends**: If you select a clip rather than an edit point the transition gets applied to both ends.

Figure 4.17 Selecting Custom Motion Transitions

Available Media

Let's insert clips into our *Edit* project to see how transitions work.

1. Select a section of about three seconds from the *cheese* shot and use **W** to insert it after the *dried tomatoes* shot.

2. Select the *fresh tomatoes* shot in the Browser and click on the preview if you're in List view.

3. Use **Control-D** and type in *300* to make the duration three seconds.

4. Insert the shot after the *cheese* shot.

5. Select the edit point between *cheese* and *fresh tomatoes* and press **Command-T** to apply the default transition.

Figure 4.18 Insufficient Media Warning Dialog

Figure 4.19 Selected Edit

A warning dialog appears (see Figure 4.18) that says there isn't available media and if you apply the transition the project will be shortened. Click **Cancel** so the transition isn't applied. Why is this happening?

1. Click on right side of the edit point at the start of *fresh tomatoes*. Notice the selection is red instead of the usual yellow, indicating you're on the limit of the available media. If you use the \ key to select both sides of the edit point you'll see a yellow selection on one side and red on the other (see Figure 4.19).

2. If you double-click the edit point to open the Precision Editor you'll see that the outgoing side has a media handle that extends past the edit to create the overlap needed for the transition while the incoming side does not (see Figure 4.20). We'll look at the Precision Editor in the next lesson.

Figure 4.20 Precision Editor Showing Lack of Handles

Figure 4.21 Dragging a Transition Length

When you apply the transition to these clips you can either accept the dialog and shorten the project or you can use the Slip function to create more available media for the transition overlap. You'll look at the trimming tools in the next lesson.

To change the duration of an applied transition, to make it longer or shorter than the default, you can:

- Drag one edge of the transition, pulling it in or out as in Figure 4.21 if media handles are available

- Select the transition and press **Control-D** for the duration control in the Dashboard and type in a new value

> **NOTE**
>
> **Transition from Black**: To fade up from black at the beginning of a project, or to fade to black at the end of a project, the simplest way is usually just to add a Cross Dissolve.

Transitions and Connected Clips

Transitions that are applied to Connected Clips behave a little differently. Applying a transition to Connected Clips will automatically create a secondary storyline to link the clips together or just to link the clip to the transition.

1. Select a couple of adjacent clips in the project and drag them out of the primary storyline so that they're on a layer above. (Do not use the keyboard shortcut for lift from primary storyline.)

2. Select the edit point between the shots and press **Command-T**.

The edit will have the Cross Dissolve applied, and two shots will be converted to a storyline with the Shelf bridging them (see Figure 4.22).

Figure 4.22 Additional Storyline with Transition

The storyline is treated as a single unit, pinned on the first frame, and can be moved as a unit. It can also be broken apart at any time. If you do break apart the secondary storyline the transitions will be lost, but not until after you get the warning.

> **NOTE**
>
> **Transition from Transparency:** I noted earlier that the fade out and fade in at the beginning and end of the primary storyline defaults to fading from black; in the case of additional storylines the fades at the beginning and end default to fade from transparency, not from black, which is probably what you want.

Copying Transitions

Sometimes you've applied a customized transition and you want to apply it again. There are basically two ways to do this.

1. Select the transition in the Timeline and copy it.

2. Move to another edit point and use the **bracket** key to select it, or click on it to select it.

3. Use **Command-V** to paste the transition onto the edit point. You'll have to select and repeat this for multiple edit points.

4. You can also hold the **Option** key, then grab the transition and drag it to another edit point. I think this is the simplest method if you want to apply the transition to multiple edit points.

SUMMARY

In this lesson you've learned how to use the editing tools that move clips into the Timeline: the Append edit, to add the end of the Timeline; the Insert edit, to push a clip into the storyline to make room for itself; the Connect edit, to attach a clip to the primary storyline; the Overwrite edit, to punch into the storyline; and the Replace edit to change a shot in the Timeline. We used drag and drop, the buttons, and the keyboard shortcuts. We saw how to edit video and audio independently, and how to use Audition as a replace function to try out different clips. Finally, we looked at working with transitions in FCP. Now that we've looked at how to edit your shots into the Timeline, we'll next see how to adjust, trim, and reposition clips in the project.

Advanced Editing
Trimming

Now that you've cut up your material in Final Cut Pro and learned the editing functions, it's time to fine tune your project. There is no right or wrong way to edit a scene or a sequence or even a whole film or video; there are only bad ways, good ways, and better ways. Trimming in FCP is done in the Timeline, using selections and special tools.

LOADING THE LESSON

For this lesson we'll use the *FCPX4* library. If you haven't downloaded the material or the library has become messed up, download it from the www.routledge.com/products/9781138209978 web page by going to the eResources tab.

1. Once the *FCPX4.zip* file is downloaded, double-click the ZIP file to unpack it.
2. Drag the *FCPX4* library to your media drive and double-click it to launch the application.

The library has two projects that you can see in the Library Projects Smart Collection, one called *Trim 1* and the other called *Trim 2*. Inside the event, you'll see the media we're going to work with. Before we begin I'd suggest duplicating the *Trim 1* project.

1. Select the *Trim 1* project listed and use **Command-D** to duplicate it.

2. The duplicate will be named *Trim 3*, but you can name it anything you want, like *Trim 1 Work*.

3. Open the duplicate project.

> **NOTE**
>
> **Duplicate as Snapshot:** In addition to the Duplicate function you can also use **Edit>Duplicate as Snapshot (Shift-Cmd-D)**. This duplicates the project with a date/time stamp. This is useful as an interim backup. It's a full project and can be edited like any other project, but it's intended just as a snapshot to preserve an interim state of the project. Also snapshots are not recursive so changes made to items like compound clips and multicam clips are not reflected in snapshots, which are completely independent projects.

> **TIP**
>
> **Closing the Libraries Sidebar:** Because you're not working with events or collections in events, the Libraries Sidebar is unnecessary. Select the library itself so the Browser shows all the content and use **Command-`** to close the sidebar, giving you more space for the other panes.

TRIMMING SHOTS

FCP has several tools for refining your edit, fine-tuning, and rearranging the sequence. Let's look at some of those, working with the shots that we have edited together into the Timeline.

Moving Shots

Very often you'll want to rearrange shots, changing their order in the sequence. As in iMovie, because of the magnetic timeline, this is very quick and easy to do. We're going to move everything from after *man standing at counter* until the end of the project, to the beginning of the sequence.

1. You can either drag select the clips, or select *man standing at counter* and then hold the **Shift** key select the last clip *ls woman getting sample*. You do not have to select the Connected Clips. They will move with the clips they're attached to.

2. Drag the clips to the very front of the Timeline until everything else pushes out of the way and drop the clips.

Changing Attachment

Sometimes you want to move Connected Clips, and when you do the attachment points, which are at the head of the clip, move as well, perhaps to another clip that you don't want them attached to. You can change the attachment point fairly easily. Let's start by moving the two Connected Clips a little earlier in the Timeline. We'll ignore how they look as edits.

1. Grab the two Connected Clips, *prosciutto samples* and *dried tomatoes*, and drag them to the left so they bridge the first edit as in Figure 5.1. The first Connected Clip will be connected to the first clip and the second Connected Clip to the second in the primary storyline. We want the first Connected clip attached to the second as well.

Figure 5.1 Moving Connected Clips

2. Holding the **Option** and **Command** keys together, click on the *prosciutto samples* clip above the second clip on the primary storyline, *man handed bag*, as in Figure 5.2. The attachment point will jump to your click point.

3. Use **Command-Z** to undo the move of the two Connected Clips so both shots are back over *man handed bag*.

Figure 5.2 Reattaching Clip

Blade Edits and Gap Clips

Let's look at some simple ways to cut clips that are in the Timeline. To see this, let's append a shot into the Timeline.

1. Select the *cleaning fish from behind* clip and press **E** to Append the whole clip into the end of the project.

2. Play the *cleaning fish from behind* clip in the Timeline until the camera pushes in and settles at 54:24 in the Timeline.

3. Make sure Snapping is turned on, and from the Tools popup select the Blade tool (see Figure 5.3) or press **B** to activate it.

4. Drag the pointer across the clip in the Timeline till it snaps to the playhead. Notice that when the Blade tool is over a clip the Dashboard no longer shows the Timeline time, but the clip timecode underneath the Blade tool.

5. Click with the Blade tool at the playhead to cut the clip.

6. Undo that edit to see a variation of using the Blade tool that can be very helpful.

7. Press the **A** key (A for arrow) to return to the normal Select tool.

8. Move the pointer so it snaps to the playhead then hold down the **B** key before clicking the clip. When you release the **B** key the pointer reverts to the Select tool. Most of the tools have this very useful capability.

9. Select the cut portion at the head of the clip and press the **Delete** key. On most keyboards this is the large **Delete** key next to the = key.

10. If you want to do a Lift edit, which removes the clip from the Timeline but leaves the gap, press **Shift-Delete** or the **Forward Delete** key on an extended keyboard. This will leave a **Gap Clip** in the Timeline in place of the deleted clip.

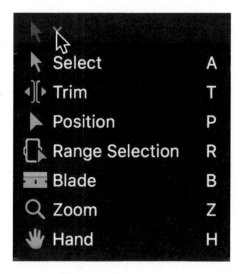

Figure 5.3 Tools Menu

Gap Clips are objects in the Timeline. The Gap Clip can be cut, edited, trimmed, and perhaps most importantly have Connected Clips attached to it.

Let's look at another way to do this.

1. First undo the edits you did until you're back to the complete *cleaning fish from behind*. Use **Command-Z**. If you step back too far, use **Shift-Command-Z** to redo.

2. Put the Timeline playhead at the same position as before, 54:24.

3. Rather than selecting the Blade tool, simply press **Command-B** to make an edit at the playhead, cutting the clip in the Timeline. Be careful the skimmer isn't in the Timeline or the blade cut will be at the skimmer, which takes precedence over the playhead.

4. Select the cut beginning of the clip and press **Delete** to remove that section.

If you want to blade a connected clip, you can either do this by using the Blade tool and clicking on the clip, or by selecting the clip first and then using the shortcut **Command-B** to cut at the skimmer or playhead.

TIP

Moving the Playhead: Remember the **Left** or **Right** arrows move the playhead in one frame increments and **Shift-Left** or **Right**-arrow will move the playhead forward or backward in 10 frame increments.

TIP

Multiple Layers: Using **Command-B** is an excellent way in FCP to cut through a clip. If you need to cut through multiple layers of video and audio that are stacked, move the playhead or skimmer to where you want to cut and press **Shift-Command-B** to cut all the layers.

Marking a Selection

Instead of using the Blade tool or **Command-B**, you can remove sections by marking an In and Out point in the Timeline. One of the important features of marking a selection or using the Range Selection tool is that it can bridge across an edit or multiple edit points.

1. Go back in the Timeline to the two shots called *ls woman getting sample.*

2. Play in the Timeline until about 35:11, just before the camera starts to move forward.

3. Press **I** to mark an In point in the Timeline, which is marked on the primary storyline clip, from that point until the end of the clip.

4. Play forward until 41:27, across the edit point, into the second *ls woman getting sample,* until just before the woman starts to take off her glasses.

5. Press **O** to mark the end of the selection. You can then use the **Delete** key to remove that section.

6. If you deleted the selection Undo that so I can show you a couple of more methods.

Range Selection

As in iMovie where you have to hold **R** for range to drag in a clip to mark a selection, in FCP you can activate a specific Range Selection tool. You can call up Range Selection from the Tools menu in the Toolbar or with the **R** key as in iMovie. Like the Blade it can also be called up temporarily by holding down the **R** key. Let's make the selection using the tool.

1. Put the playhead at 41:27 in the Timeline.

2. Move the skimmer to 35:11, then hold down the **R** key, and drag across the clips till the Range Selection tool snaps to the playhead.

3. Then release the mouse and release the **R** key. The selection has been made on the clips, across the edit point.

4. Press the **Delete** key to remove the section.

Trim Shortcuts

The **Trim Shortcuts** in FCP are similar to the Trim to Playhead function in iMovie but allow for more control.

Let's begin by trimming some more from the start of the *ls woman getting sample* clip, using the edit function called **Trim Start.**

1. Play the start of the clip in the Timeline until you're at about 38:09, shortly after she takes off her glasses.

2. Select **Trim Start** from the **Edit** menu or even easier press **Option**-[(that's the left bracket key). That removes everything from the start of the clip up to that point, up to where the playhead is.

3. Let's take some off the end of the shot around 11:00, *man standing at counter.* Play the Timeline from the start for about three and a half seconds, and use **Trim End** from the **Edit** menu or press **Option**-] (that's the right bracket) to trim from the playhead to the end of the clip.

Let's do a **Trim to Selection** edit, which allows you to keep a section in the middle of the clip, and will "top and tail the shot" as it's called. For this we'll use the *cleaning fish from behind* shot at the end of the sequence. You can mark the selection of the area you want to keep either with the Range Selection tool or by marking In and Out points for greater precision.

1. Play the clip until about 48:00, until just after the camera pulls back and stops.

2. Press **I** to mark the beginning of the selection.

3. Play forward until just before the camera starts to push in, around 53:00, and mark the end of the selection with the **O** key.

4. With the selection made use **Edit>Trim to Selection** or the keyboard short **Option**-\ (backslash key) to trim the top and tail of the clip, leaving only the center selected section in the Timeline.

> **TIP**
>
> **Topping and Tailing on the Fly:** If you're feeling very confident or if you just need to roughly trim shots while playing back, you can simply press the shortcuts **Option-[** or **]** on the fly as the project plays. No clips have to be selected. If the only clips are on the primary storyline, the trim functions will trim those clips. If there are connected clips above, the trim function will top or tail the shots on top, not the shots on the primary storyline. However, if the clips on the primary storyline are selected, then the trim start and trim end functions will cut the primary storyline clips, not the connected clips above them.

TRIM TOOLS

As in iMovie, whenever you shorten or lengthen a clip in FCP to fine tune your edit, what's called a ripple edit, the application will always change the length of the sequence, making it shorter or longer as needed. While there is no Clip Trimmer in FCP that's identical to iMovie, in FCP you have Trim tool to do this directly in the Timeline with a two-up display in the Viewer.

There are basically four types of trim edits: **Ripple** and **Roll**, and **Slip** and **Slide**. Each of the trim edits work differently: the Ripple and Roll edits change the duration of clips, while the Slip and Slide edits leave the clip duration intact.

A *Ripple* edit moves a start or end of a clip up and down the project by pushing or pulling all of the material on the storyline, shortening or lengthening the whole sequence. This works exactly like iMovie when you're shortening or lengthening a clip in the project.

A *Roll* edit moves an edit point up and down the project between two adjacent shots. Only those two shots have their durations changed. One gets longer, and the adjacent shot gets shorter to accommodate it. The overall length of the project remains unchanged.

A *Slip* edit changes the In and Out points of a single clip and works like iMovie's Clip Trimmer.

A *Slide* edit moves a clip forward or backward along the project. The clip itself, its duration, and its content remain unchanged. Only its position on the project, earlier or later, shortens and lengthens the adjacent shots as it slides up and down the track. The shot you're sliding doesn't change, only the two adjacent shots change.

You can trim an edit by:

- Dragging
- Nudging
- Numerically
- Extending

The Ripple Edit

Let's begin by duplicating the project in the *FCPX4* library called *Trim 2*. This will give you a clean project to work on and keep the original to go back to if you need to. Duplicate the project with the shortcut **Command-D**, just as in the Finder, and name the duplicate *Trim 2 Work*. Double-click the duplicate to open it into the Timeline.

To trim an edit you have to select an edit. You can do this by clicking on an edit point, or by using a keyboard shortcut.

1. Move the pointer to the left side of the edit point, the A or outgoing side, between the first and second shots, *fresh tomatoes* and *cheese*. The pointer will change to the Ripple tool as in Figure 5.4.

2. If you move to the right side of the edit point, the B or incoming side, the pointer will change to ripple the other side of the edit as in Figure 5.5.

3. Click and drag on the left side of the edit. A time value will display above the edit as you drag. Pulling to the left will make *fresh tomatoes* shorter, and pushing to the right will make *fresh tomatoes* longer.

Figure 5.4 Ripple Tool in the Timeline

Figure 5.5 Ripple Tool on the B Side

If you have **Show Detailed Trimming Feedback** switched on in the FCP Editing preferences, which you should always do, you'll see the edit point displayed in the Viewer (see Figure 5.6) The image on the left will show the outgoing shot, which will change as you drag the outgoing side, and the image on the right will show the first frame of the incoming shot, which will remain unchanged as you drag the left side.

Notice that when you select the edit point it turns yellow, indicating it's selected and ready to be trimmed. Click on the right side of the edit point at the start of *prosciutto*. Notice that it's red rather than

Figure 5.6 Two-Up Viewer Display

yellow. This indicates there is no more available media to lengthen the shot. All of the shot is in the Timeline. I can't make the shot longer, but I can of course make it shorter.

You can select an edit point to trim it either by clicking on it as we just did, or by moving the playhead to the edit point and pressing either of the **bracket** keys, **left bracket** ([) to select the outgoing side, and **right bracket** (]) to select the incoming side.

With the edit selected in trim mode, you can nudge the clip earlier or later in time using the **comma** (earlier) or **period** (later) to nudge the edit one frame at a time. **Shift-comma or period** will move the edit in 10 frame increments.

To trim the clips numerically you simply have to type + or - and then a time value to move the edit later or earlier in the Timeline. Let's trim the *prosciutto* clip.

1. To select the right side of the edit at the start of the clip, move the playhead to the edit point and press the **right bracket** key. The selection will be red.

2. To move the edit later in time (you can't move it earlier because there isn't any more media) type **+1.** (plus one and period) for one second. The Dashboard will display the value as in Figure 5.7.

3. Press **Enter** to execute the edit.

Figure 5.7 Numerical Ripple

Another way to trim a shot is to use the Extend edit function. You select the edit point and then move the playhead to where you want the edit to move to.

1. Click on the outgoing edge (the left side) at the end of the first shot so the left side of the edit point is marked in yellow.

2. Move the playhead or the skimmer to the left to 3:15 in the Timeline.

3. Use **Edit>Extend Edit** or the keyboard shortcut **Shift-X** to ripple the edit to that point.

These functions that are used to adjust edits using the Ripple tool apply to all the other edit tools as we shall see. The only difference is the way in which the edit or clip is selected. This uniformity of behavior is one of the best features of trimming in FCP.

The Roll Edit

Unlike the Ripple edits, which are automatically accessed when the Select tool moves to the edit point, the Roll edit needs to use a special Trim tool if you want to drag the edit. The tool can be accessed from the Tools menu in the Toolbar or by pressing the **T** key.

The Roll edit does not affect the overall length of the sequence, only the two adjacent shots, making one longer and the other shorter. Let's roll the edit between *ms ham* and *cu ham*.

1. Turn on the Trim tool with the **T** key.
2. Click the edit point to select it. Both sides of the edit are selected.
3. Drag the edit point to left to shorten the outgoing A side and lengthen the incoming B side as in Figure 5.8.

Figure 5.8 Rolling an Edit in the Timeline

If you drag it 27 frames as I did you'll see that the selection indicator on the right side turns red, showing that you are at the end of the available media for that shot. Also notice the filmstrip overlay on the left edge of the incoming shot in the two-up display in the Viewer that indicates you're at the limit media (see Figure 5.9).

Figure 5.9 Media Limit Indicator in the Viewer

You can also do this edit numerically and by nudging. To do it numerically or to nudge it you do not have to have the Trim tool selected, you simply have to select the edit in Roll mode, which you can do with the \ (backslash) key.

You can nudge the edit in the same way, select it, and use the **comma** or **period** keys, or **Shift-comma** or **Shift-period**. You can also do an Extend edit by moving the playhead to the point you want the edit to go to and pressing **Shift-X**.

The Slip Edit

Slip edits move the content of the shot without changing the clip's duration or its place in the Timeline. This is one of the most useful trim tools for making small adjustments to clips in the project. In iMovie you use the Clip Trimmer; in FCP you use the Trim tool.

Let's look at the second shot in the project *cheese*. If you play the shot you'll see it pans from right to left across a cheese display. Rather than the pan, perhaps I'd like to use the static portion at the beginning of the shot or maybe the portion near the end of the shot. To do this we do a Slip edit.

1. Select the Trim tool from the menu or press **T** for trim.

2. Click on the *cheese* shot to select it. The icon will change to the Slip tool and the two ends of the clip are selected, bracketed inwards (see Figure 5.10).

3. Drag the clip as far to the right as you can. As you do you'll see the contents slip in the Timeline filmstrip and also in the two-up display in the Viewer.

Figure 5.10 Clip Selected for Slip Edit

By moving to the right you are selecting a piece of the clip that's earlier in the shot. Now the pan has been eliminated, and the shot is mostly static. If you want to nudge the shot, select it in Slip mode and use the **comma** or **period** keys as we've done before. To slip it numerically, select the clip in Slip mode and type in a - or + time value and the clip will slip that amount, or as far as it can assuming available media.

The Slide Edit

Let's look at the last trimming function, the Slide edit, which is not available in iMovie. This edit leaves the clip you're sliding untouched, simply moving it earlier or later in the project, making the adjacent clips longer and shorter as needed. Though this can be a useful tool in some situations, I find in practice that I don't use it very often.

1. Make the Trim tool active by pressing the **T** key.

2. Inside of simply clicking the clip, which will select it in Slip mode, hold the **Option** key and click on the clip to select it. You'll see the clip is selected differently from Slip mode—it's bracketed to the outside rather than the inside (see Figure 5.11).

3. Once you're holding the clip in Slide mode, you can release the **Option** key and drag to the left to move the clip earlier in the Timeline.

Figure 5.11 Sliding a Clip in the Timeline

When you drag to the left the clip in front of the clip being slid, *fresh tomatoes*, gets shorter and the clip after it, *prosciutto*, gets longer.

When you slide to the right, the clip before gets longer and the clip after gets shorter. It's a bit like doing two roll edits at the same time. A two-up display in the Viewer shows the adjacent shots rather than the shot you're actually dragging (see Figure 5.12).

Figure 5.12 Sliding Two-Up Display

Just as in the other trim functions, you can use the nudge keys, **comma** or **period**, to nudge the clip up or down the Timeline.

Trimming With Transitions

To edit the shots underlying a transition you have to use specific control points.

1. To start select a clip and press **Command-T** to add the default transition on both ends.

2. Zoom into the transition if necessary so it's easier to control.

There are three grab points on the bar at the top of the transition (see Figure 5.13). The ones on either end allow you to ripple the underlying shots. The one on the right grabs the end of the outgoing shot, the A side, and lets you shorten and lengthen it as you like. The one on the left selects the beginning of the incoming shot, the B side, and lets you ripple that shot. The grab point in the middle of the transition with the two triangles lets you roll the edit up and down the Timeline. There is no need to select the Trim tool to roll the edit point here. Notice the time display for the duration of the shot that's being rippled as well as the amount of change.

Figure 5.13 Rippling the Underlying Shot

You can also trim the edits under the transitions numerically and by nudging them. If you use the up and down arrow keys to move between the edits, you'll notice that, on most of them, the playhead makes three stops at each transition. It will stop at the beginning of the transition, at the middle of the transition, and at the end of the transition. You can select the beginning or the end of the transition with the corresponding left or right bracket key, which allows you to ripple the underlying shots numerically or with the nudge keys, **comma**, and **period**. You have to click the middle of the transition to be able to move the edit point in a Roll edit.

The Position Tool

One of the primary features of iMovie and FCP is the Magnetic Timeline. Sometimes you just want to shorten a shot or move it, but not move anything else that's in the Timeline downstream from it. To do this you can use the Position tool. Let's shorten the *ms ham* shot.

1. To activate the Position tool, select it from the **Tools** menu in the Toolbar or press the **P** key.

2. Go to the end of the clip and you'll see a slightly different cursor, one which can only affect one side of the edit but will not ripple the sequence.

3. When you pull the end of the *ms ham* shot to the left a hole will be created in the Timeline, which is filled with a Gap Clip (see Figure 5.14).

4. Click on the Gap Clip to select it and press the **Delete key**. The clip will be removed, and the Magnetic Timeline will close up the project.

5. Moving an edit to shorten a clip to create a gap is pretty benign, but the Position tool has the potential to be very destructive as well.

6. Take the last clip, the *prosciutto samples* clip, and drag it to the left, right on top of the previous clip. This is doing an Overwrite edit, wiping out part of the clip in the Timeline.

7. Undo that edit with **Command-Z**.

Figure 5.14 Creating a Gap Clip in the Timeline

Trimming Connected Clips

Most of your preliminary editing is done to the primary storyline, what's usually called the A-roll for historic reasons. The shots that illustrate the A-roll are then added as Connected Clips, which are often called the B-roll. Trimming these Connected Clips is different from clips in the storyline simply because they're not in a storyline and are not connected to each other. You cannot Ripple, Roll, or Slide Connected Clips because they're not attached to the adjacent

clips, though you are able to do Slip edits. Let's look at how to handle Connected Clips, but first we need to create some in our Timeline. As we've seen, a useful feature in some instances is the application's ability to lift clips from the primary storyline and make them Connected Clips.

1. Select the last three clips in the project and drag them up and to the left so they are connected on top of the other clips, something like Figure 5.15.

Figure 5.15 Clips Lifted from the Primary Storyline

The clips will move up and attach to other clips below them. They may all be attached to different clips or to a Gap Clip. If you drag a clip to shorten it, you will simply create a gap between two adjacent clips, revealing the primary storyline below it. If you try to push a clip to lengthen it, the adjacent clip will simply move out of the way onto a higher layer as in Figure 5.16. It's fine to work like this.

Figure 5.16 Connected Clip Pushed to Higher Level

You can simply drag clips to lengthen and shorten them and push them around as you like. Another, better way in my view, is to create a secondary storyline.

2. Select all three Connected Clips and use **Clip>Create Storyline** or the useful shortcut **Command-G** (see Figure 5.17).

3. Use Undo (**Command-Z**) until the three clips you connected into the secondary storyline are back where they were at the end of the primary storyline.

We saw how you can lift a clip from the primary storyline with **Option-Command-Up arrow**, but if you lift multiple selected clips from the primary something different happens.

4. Select the three clips at the end of the primary, and use **Option-Command-Up arrow**.

Figure 5.17 Additional Storyline

The clips are lifted from the storyline and all joined together into a secondary storyline connected by the Shelf, the dark bar above the clips. The storyline itself is connected to a Gap Clip that replaces the lifted shots.

A secondary storyline can be picked up by the Shelf and dragged as a single group. Now any of the clips in the additional storyline can be trimmed and adjusted using any of the trim tools just as in the primary storyline.

Another technique that's very useful, especially when working with material like interviews or narration that's covered with the B-roll, is to create an additional storyline immediately after the

first Connected Clip is created. After the first Connected Clip is added and converted into a storyline, additional clips can be inserted, appended, or overwritten directly to that storyline simply by selecting the Shelf. So for instance in Figure 5.18, I have two storylines. If the primary storyline is my A-roll, I have an additional storyline that I have connected with a single point at the head of the Timeline.

Figure 5.18 B-roll in Secondary Storyline

If I select the secondary storyline I can edit directly into it, keeping it a continuous additional storyline. If at any point I need to see the contents of the A-roll on the primary storyline I can simply add a transparent Gap Clip into the additional storyline, making it however long I want. Any of the edits can be rippled and rolled, slipped and slid, on the additional storyline in relation to each other and to what's on the primary storyline. This is a great technique for documentary, reality, and news programming, and can be used well for most productions that require a B-roll to illustrate the story.

After you've adjusted your B-roll clips in the additional storyline you can if you wish break apart the secondary storyline at any time with **Clip>Break Apart Clip Items** or **Shift-Command-G**. The clips will then appear as Connected Clips and any Gap Clips will just disappear.

Additional storylines are a really useful and powerful feature in FCP.

THE PRECISION EDITOR

The Precision Editor was at one time in iMovie but has disappeared in recent versions. It's a tool that is perhaps underutilized, which may be because for many users it seems to be incomplete.

You can activate the Precision Editor in one of three ways:

- Select the edit and use **Clip>Show Precision Editor**
- Select the edit and press **Control-E**
- Or, simply double-click on an edit point

If you have the Secondary Storyline in place in *Trim 2 Work* use the Shelf to drag it to the right out of the way. Let's double-click on the edit point between the second and third shots, between *cheese* and *prosciutto*. The Timeline splits apart and the clips appear on separate layers, the outgoing shot, called the A side, on the layer above, and the incoming shot, the B side, on the layer below with a dark separator bar between them (see Figure 5.19). The beauty of the Precision Editor is that you can see not only what's in the Timeline but all the content of the clip beyond the edit point, what's commonly called the *handles*, the additional available media for each shot that's not used in the project.

Figure 5.19 Precision Editor

You will also see buttons along the separator bar. You can click on any of them to move to another edit point in the Precision Editor, or you can use the Up or Down arrow keys to move between edit points while keeping the Precision Editor open. The Precision Editor is only available for clips on the primary storyline; you cannot use it for clips on a secondary storyline.

The pointer will change into different tools as you move around the Precision Editor, and different clips will play depending on where the pointer is.

Let's do some editing in the Precision Editor:

1. Move the pointer in front of the edit point on the clip on the upper layer. Notice that it changes to a Hand tool and the skimmer does not extend vertically. This is called the Clip Skimmer (see Figure 5.20).

2. Press the **spacebar** to play. The outgoing clip, *cheese*, will play through the material in the project and the available handle.

3. Move the pointer onto the beginning of the clip on the lower layer and play that clip using the **JKL** keys to shuttle back and forth through the incoming clip.

4. To play through the edit itself, move the pointer anywhere off the clips so the Clip Skimmer is no longer active.

5. To roll the edit point, grab the button between the two clips on the separator bar and track it left or right.

6. To Ripple either shot you can drag the edge of the edit as you would in the Timeline, or you can simply grab the clip and push or pull it in the editor.

7. You can also use the Extend edit feature in the Precision Editor. This allows you to precisely position the skimmer using the play and arrow keys and then using **Shift-X** to execute the Extend edit. If a clip is selected on one side, a Ripple edit will be done. If both clips are selected in Roll mode, by selecting the button between the two tracks, a Roll edit will be performed.

8. To close the Precision Editor you can double-click on the separator button, press **Control-E**, use **Clip>Hide Precision Editor**, or perhaps simplest of all just press the **Escape** key.

There is no dynamic trimming in the Precision Editor unfortunately. You cannot play an edit with **JKL** and simply execute it by stopping playback.

Figure 5.20 Clip Skimmer

TIP

Transitions: Transitions can be edited in the Precision Editor. The shots can be rippled; the edit point can be rolled; the transition can be made longer and shorter by dragging the handles. You cannot, however, open a transition edit point into the Precision Editor by double-clicking on it. You need to select it and use the keyboard shortcut **Control-E**.

SUMMARY

In this lesson we've learned how to rearrange our shots using moving shots, changing attachment points, blading clips and using Gap Clips. We also saw how to trim our clips, marking clips to make selections, using the Range Selection tools, and using Trim

Shortcuts. We worked with the Trim tools to do Ripple, Roll, Slip, and Slide edits. We also used the Position tool and edited Connected Clips, creating secondary storylines, and used the Precision Editor.

Now you know the basic tools of editing with Final Cut Pro, cutting your clips, getting them into the Timeline, and trimming them. In the next lesson we look at working with audio.

LESSON 6

Working with Audio

Video is primarily a visual medium, but often the moment an edit occurs is driven more by the sound than by the picture. Truthfully at least 50% of a video is the audio. So let's look at working with sound in Final Cut Pro. With few exceptions, sound almost never cuts with the picture. Generally the sound comes first and then the picture, but sometimes the picture leads the sound; rarely do they cut together. The principal reason video and audio are so often cut separately is that we see and hear quite differently. We see in cuts—for example, we look from one person to another, from one object to another, from the keyboard to the monitor. Though my head turns or my eyes travel across the room, I really only see the objects I'm interested in looking at. We hear, on the other hand, in fades. I walk into a room, the door closes behind me, and the sound of the other room fades away. As a car approaches, the sound gets louder. Screams, gunshots, and doors slamming and other staccato, "spot" effects being exceptions, our aural perception is based on smooth transitions from one sound to another. Sounds, especially background sounds such as the ambient noise in a room, generally need to overlap to smooth out abrupt changes.

Creating overlapping sound and picture with precision is one of the primary features that raises FCP to a much higher production level than iMovie.

To overlap and layer sound we'll use split edits, which are incredibly easy to create in FCP, as the application flows the content around each other. Nothing bumps against anything else;

it simply moves out of the way allowing you to easily cut video and audio separately from each other.

LOADING THE LESSON

This is going to sound familiar, but it's worth repeating. Begin by loading the material you need on the media hard drive of your computer. For this lesson download the *FCPX5.zip* file www.routledge.com/products/9781138209978 web page by going to the eResources tab.

1. Once the downloaded ZIP is opened, copy or move the *FCPX5* library it contains to the top level of your dedicated media drive.
2. Double-click the *FCPX5* library to launch the application.

As in earlier lessons, if you need to work with proxy media transcode the files and switch to proxy playback.

The library contains an event called *Audio*, together with three projects.

Before we begin I'd suggest duplicating the *Audio 1* project.

1. Select the project on the *Audio 1* project and use **Command-D** to duplicate it. The duplicate will automatically be named *Audio 4*.
2. Rename the project something like *Audio 1 Work*.
3. Open the duplicate project.

> **TIP**
>
> **Opening a Project:** A quick, simple way to open a project that's selected in the Browser is simply to press the **spacebar**. The project will open and immediately start playing from the head.

THE SPLIT EDIT

A common method of editing is to first lay down the shots in scene order entirely as straight cuts, image and audio as in the *Audio 1 Work* project. What's striking as you play through the project is how

abruptly the audio changes at each shot. To smooth this you have to overlap the audio edit points.

When audio and video have separate In and Out points that aren't at the same time, the edit is called a split edit (see Figure 6.1). Split edits are sometimes called J-cuts or L-cuts if the split is only at the beginning or at the end.

Figure 6.1 Split Edit

In this type of project you can smooth out the sound cuts by overlapping the clips and cross fading them. Another common way to smooth out the sound is to use a wild track, sound shot on location that can be used as a bed for the picture. This is sometimes called *room tone* when it's the ambient sound indoors or *atmos* when it's outdoors. Atmos is a long section, 30 seconds or a minute, of continuous sound from the scene. Here there is no specially recorded atmos track, though some of the shots are nearly long enough to be used in this way.

Making Split Edits

1. First it's a good idea to change the Clip Appearance menu at the right end of the Toolbar and select the second option (see Figure 6.2). Only options 1 through 4 allow audio expansion and show waveforms.

2. Double-click the audio portion of the first clip *ls valley* to expand it. You can also select the clip and use the keyboard shortcut **Control-S**, which will also collapse the audio.

Figure 6.2 Timeline Clip Appearances

3. To overlap the audio, drag the tail of the audio edit point as far as it will go underneath the audio of the second clip (see Figure 6.3). While you drag it, a box appears that shows the duration change for the edit you are making. Notice the display shows 100ths of a frame as you can edit audio at a subframe level.

Figure 6.3 Creating Split Edit

4. There is a sharp spike of wind noise at the end of the clip, so drag the audio back a little to the left to clip that off.

5. At the right end of the audio track, just below the area with the clip name, is a small fade button. When the pointer is over the button,

it will change to a drag tool. Drag it to the left to create a slow fade out as in Figure 6.4.

Figure 6.4 Audio Fade Out

6. Double-click the audio portion of the second clip, *flowering tree*, which will expand it below the first clip.

7. Drag the head of the audio to the left to stretch it out underneath *ls valley* and the tail to the right as far as it will go.

8. Drag the fade button at the head of the *flowering tree* audio to the right to fade it in and use the fade button to create a fade out underneath *cs coffee flowers*.

9. The *drying beds* clip has poor audio with wind noise so we shouldn't use it at all. Grab the bright level line that runs horizontally through the clip and drag it all the way down to the bottom as in Figure 6.5.

Figure 6.5 Reducing the Level

10. One last step to clean up the project is to select the first two clips and press **Control-S** to collapse them. Though the fades are visible in the Timeline and appear to have shifted, the sound transitions smoothly underneath the clips.

You have now created split edits in the Timeline, overlapped the audio and cross faded it. That's basically the process. Because the audio tracks always move out of the way for each other it's really simple to overlap them and smooth out the audio transitions.

Trimming Expanded Clips

When clips are expanded the video and audio can be trimmed independently. To select the audio edit or the video edit, you can simply click on the expanded audio edit or in the video edit. Before expanding the audio you can also move the playhead to the edit point and press **Shift-[**, or **Shift-]**, or **Shift-** to expand the audio and select the Ripple A side, the Ripple B side, or Roll edit functions. Once the audio is expanded you can select to do a Ripple edit by clicking on the edit point and dragging, or to do a Roll edit by clicking on the edit point with the Trim tool and dragging. You can then ripple or roll the edit as desired by nudging the edit with **comma**, **period**, or **Shift-comma** and **Shift-period**. You can also move the edit points numerically by typing a value, plus or minus, which will appear in the Dashboard.

Transitions and Audio

Whenever you have video and audio together, as we do here in the Timeline, and you apply a transition, FCP will always apply an audio cross fade as well. For a great deal of material this is fine and works well. Unfortunately when audio and video are concerned you seldom cut them together so you often have different priorities for where cross fades are placed.

If you want to apply a video transition and not an audio cross fade, you have to expand the audio from the video. Let's start by looking at the transitions they way they are at the moment.

1. Select the edit point between *drying beds* and *cs coffee flowers* and press **Command-T** to apply the default transition.

2. Select the two adjacent clips around the transition and press **Control-S** to expand them. What you'll see is the two tracks of audio overlapping, each with a fade applied as in Figure 6.6.

3. If you don't want the audio cross fade, select the transition and delete it or use Undo.

4. Click on the video edit to select it or press a **bracket** key and then apply the transition with the keyboard shortcut. Now only a video transition is applied with no audio cross fade as in Figure 6.7.

Figure 6.6 Video and Audio Transition

Figure 6.7 Video Transition Without Audio Cross Fade

If you want to apply an audio cross fade only, there is unfortunately no transition in FCP for this. You can of course manually create an overlap with added cross fades as we did above. There is however a free third party alternative. Alex Gollner has created many useful tools for FCP users, one of which is an audio cross fade transition that can be found at http://alex4d.wordpress.com/2011/07/11/fcpx-transition-sound-only/.

CONTROLLING LEVELS

To control audio levels properly you need two things. First, you need good speakers that you set to a comfortable level for listening, which you do not touch and leave at the set level. The second thing is audio meters to display the peak levels of your audio.

Audio Meters

In FCP there are miniature audio meters in the Dashboard, which really aren't of much practical value. To see the real meters, either click on the tiny audio meters in the Dashboard or press **Shift-Command-8**. The meters will display levels for whatever clip is being played back, either in the Browser, the Timeline, or the Sound Browser. The meters will display either stereo or 5.1 surround, where the meters will display six tracks (see Figure 6.8).

There are a number of standards for audio levels, but the most widely used for digital audio is, I think, –12dB. Unlike analog audio, which has quite a bit of headroom that allows you to record sound above 0dB, in digital recording 0dB is an absolute. Audio cannot be recorded at a higher level because it gets clipped off and turns into distortion. The standard reference level of –12dB is the level for normal speech, lower for soft or whispered sound, and higher for shouting. Normally only very loud transients like gun shots will peak close to zero around –2 or even –1dB. Make sure your audio does not bang up to the top of the meters or exceed 0dB so that the LEDs at the top of the meters turn red as in Figure 6.9. Notice that if the meters are made wide enough a numeric display appears at the top as a guide to how far over 0dB the audio is going.

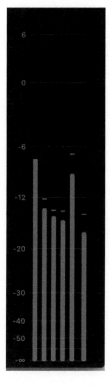
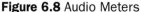

Figure 6.8 Audio Meters

Figure 6.9 Overmodulated Audio Meters

You can adjust audio in either the Browser or in the Timeline. For long interviews, it's often easier to make an initial overall adjustment of the level before editing into the project.

1. In the *Audio* event select the clip called *rich* and play it back. For most of the clip the meters barely reach –20dB.

2. Open the Inspector by clicking the button on the right side of the top bar or by pressing the shortcut **Command-4**.

3. Switch to the Audio inspector (see Figure 6.10). Here you have controls for Volume and Pan, Audio Enhancements, and Audio Configuration.

4. While playing back the clip in the Browser push the Volume slider up to about 9.

Figure 6.10 Audio Inspector

Audio Enhancements

Sometimes audio files have problems such as background noise, or hum, or low levels. These can be fixed to some degree with Audio Enhancements.

1. Select the *rich* clip and click the hooked arrow opposite Volume in the Audio inspector to reset the levels to their original values.

2. If Audio Enhancements is hidden, double-click on it or click once on the **Show** button that will appear next to the hooked reset arrow if you move the pointer over it. Here you have access to Equalization and Audio Analysis.

3. Click the **Show** button at the end of the Audio Analysis bar to open the Audio Analysis section.

4. Click the magic wand button next to **Show** to run the analysis.

5. If you've run the analysis the blue checkmark for **Loudness** is active, and you'll see that the audio is automatically increased (see Figure 6.11).

6. Under Audio Enhancement there is a line for Equalization that has a popup where you can select some standard equalizations, such Voice Enhance, Music Enhance, Bass Reduce and others.

7. Farther to the right, on the edge of the panel, is a small button icon with sliders. Click it to open the Equalization HUD.

8. You can change the number of sliders with a button at the bottom from 10-band EQ to 31-band EQ (see Figure 6.12). Adjust the mids to help enhance the voice.

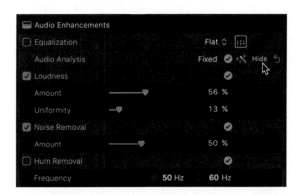

Figure 6.11 Audio Enhancements

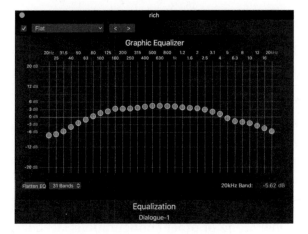

Figure 6.12 31-band EQ HUD

A useful tool in Audio Enhancements is the Hum Remover, which works well for electrical interference in either 50 or 60 Hz.

1. In the browser select the audio file *LatinWithHum* and if it's not open go to the Audio Enhancements section of the Inspector.

2. Click the magic wand analysis button and Hum Removal will be switched on. This would happen automatically on import when analysis is switched on and AC hum is detected. Try switching off the Hum Removal, and you'll hear the low frequency 60-cycle hum that can easily be picked up from improperly grounded cabling.

3. Switch Hum Removal back on when you're done.

In addition to activating Audio Analysis in the Inspector you can also do this with the Magic Wand menu under the Viewer and selecting **Auto Enhance Audio** or using the keyboard shortcut **Option-Command-A**.

> **TIP**
>
> **Drawing an EQ Curve:** If you hold the **Control** key in the EQ you can actually draw an EQ curve rather than having to adjust individual frequency sliders.

Audio Configuration

FCP Audio Configuration allows you change how channels in clips are handled. This can be set to clips either in the Browser or in the Timeline.

1. Select the *measuring moisture* clip in the Browser.

2. Go to the Audio panel of the Inspector to the last item, which is Audio Configuration. There's actually a drag bar at the top of the section that lets you pull the pane up to the Volume slider on top of Enhancements.

3. There is a popup that lets you set the audio configurations either Stereo or Dual Mono or other configurations (see Figure 6.13).

4. Notice the checkboxes that allow you to selectively switch off channels as needed. In this case one of the stereo pairs is empty and can be disabled.

Audio Configuration can be changed not only for single clips, but for multiple selected clips in the Browser or in the Timeline.

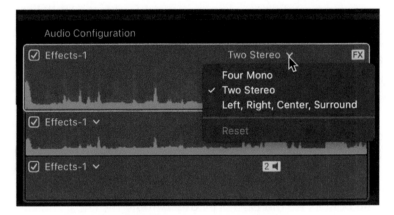

Figure 6.13 Audio Configuration

TIP

Single-Track Audio: Cameras such as DSLRs with external mics often record only a single channel, only using one channel of a stereo pair. If this is the case it's worth deleting the empty track. Sometimes the second track isn't actually empty, just poor quality from the camera mic. If the audio is a stereo pair, first change it to dual mono and then switch off the unwanted channel. You will still get stereo output in a stereo project.

Mixing Levels in the Timeline

Let's look at adjusting levels and mixing audio in the FCP Timeline. There is no separate audio mixer as such, but you do have direct control of the audio levels of your media in the project. We'll work in the *Audio 2* project and start by duplicating it.

1. Select the project in the library's Projects Smart Collection and use **Command-D** to duplicate it.

2. If you wish rename it something like *Audio 2 Work*.

3. Double-click the duplicate project to open it.

The first thing you might notice in this project is that the clips have different colors. These are defined by their audio Roles, dark blue for Dialogue, teal for Effects, and green is used for Music. We'll look at working with Roles, assigning them, and creating SubRoles later.

You can adjust clip audio levels either in the Timeline, or in the Audio inspector, which has the slider Volume control as in iMovie adjustments.

Play through the last few clips in the project to hear some of the problems. We already know that Rich's audio is too low; we've already fixed that in the Browser. We'll look at how to apply those to the Timeline clip. The connected B-roll audio all needs to be smoothed out as we did earlier by overlapping the clips, and the last couple of shots are too loud. We also want to add some music at the beginning and a couple of more shots to open it up a bit. Let's fix Rich's audio first and then add the music to the beginning. I like to have everything in the Timeline if I can before I start mixing the sound.

FCP has a great feature called Paste Attributes. Unfortunately, you can't Paste Attributes from the Browser to a Timeline clip. Do this:

1. Select the *rich* clip in the Browser and press **E** to append it to the *Audio2 Work* project.

2. Select the *rich* clip that you've added to end the Timeline and copy it.

3. Select the original *rich* clip that was in the Timeline and use **Edit>Paste Attributes** or **Shift-Command-V**.

4. In the dialog that appears check on Volume, Loudness, Background Removal or whatever adjustments you used to bring up the level and click **Paste** to apply them (see Figure 6.14).

5. Delete the extra appended *rich* clip from the project.

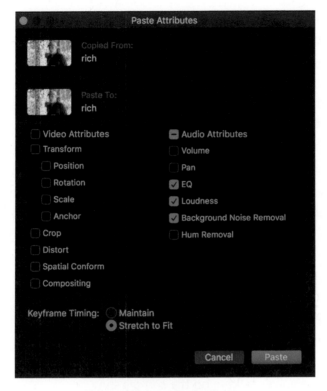

Figure 6.14 Paste Attributes

Let's add the music. You could attach it to the first clip, but we want to add more shots, plus I think it's usually a good idea to begin the music over black and attach the music to that. You should be aware that FCP has no separate independent audio track like iMovie that will let the sound expand as more clips are added to the project.

1. Put the playhead at the beginning of the Timeline and use **Edit>Insert Gap** or the handy shortcut **Option-W**. The inserted gap is three seconds, but you can make it any length you want. You could make it a single frame if you really needed to, just so the sound is completely independent from and not attached to any picture.

2. Notice the playhead doesn't move when you insert a Gap Clip, which is a neat little feature I think. So with the playhead still at the beginning of the Timeline, find the *LatinWithHum* clip in the

Audio event and press the **Q** key to attach it to the Gap Clip at the beginning of the project.

3. Unlike iMovie that will end the music at the end of the project, the playhead in FCP may zoom to the end of the project and all the pictures in the Timeline may disappear because the music is much longer than the picture.

4. Press the **Home** key (or **fn-Left** arrow on a laptop) to go back to the beginning of the project.

5. Move the pointer to the end of the Gap Clip so it changes it to the Ripple function and push the gap so it's about 15 frames longer.

6. Play the Timeline for the first few beats to the beat at 1:06 and press **I** to mark an In point in the Gap Clip. This marks an In from that point to the end of the Gap Clip. We're going to leave the first bit in black so the music starts before the picture.

7. In the Browser find the *cottage* shot and mark an In point beginning about a second after the start of the clip.

8. Press **Shift-2** so that you do a video only edit. We don't want to hear the voices talking on the *cottage* shot.

9. Press the **D** key or click the Overwrite button to add the shot into the primary storyline.

10. With the video only edit still on, Insert a couple of seconds of the *dalmatian* shot after the *cottage* with the **W** key.

Fading Levels in the Timeline

Often the easiest way to create split edits and the overlaps you want is just to expand everything in the Timeline, but before we do that we'll add in one more piece of sound.

1. In the Timeline move the playhead so you're at the start of the first shot, the *cottage* clip and press **I** to mark the beginning of a selection.

2. Play forward till you're a second or two past the beginning of the *ls valley* shot, about 7:15, and press **O** to mark the end of the selection.

3. Press **Shift-3** to prepare to make an audio only edit.

4. Find the *ls valley* shot in the browser, select it, and press **Q** to connect the audio to Gap Clip underneath the music.

5. To expand all the clips we'll use the Timeline Index. Click the **Index** button at the left end of the Toolbar. Then click on the **Roles** button. We'll look at working with Roles in more detail later in the lesson.

6. Click the first of the three buttons to expand the lanes for Dialogue and Effects (see Figure 6.15).

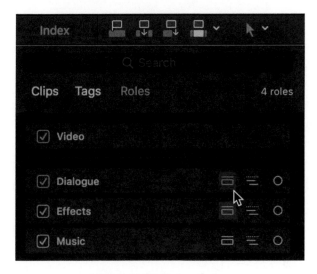

Figure 6.15 Roles Index

7. Grab the fade button at the beginning of the single *ls valley* audio clip and drag it to the right to get a nice fade up of the birds singing. The farther you drag the fade the slower it will be.

8. Right-click on the fade button and a HUD will appear to allow you to select the type of fade you want to use. Select the Linear fade (see Figure 6.16).

The default curved or logarithmic ramp is the +3dB fade, which is perfect if you are cross fading between overlapping sounds as we did in the first project. This gives what's called an equal power fade

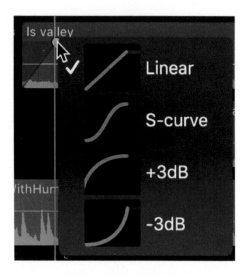

Figure 6.16 Fade HUD

where there is no apparent dip in the audio level in the middle of the crossing fades. Generally you use a Linear 0dB fade when you are fading up or fading down to silence as we are here. There are four fade types to choose, and you can use whatever's right for the sound you're working with. Sometimes fading in or out of speech with an S fade or a –3dB fade might work better.

Before you get to mixing the body of the project you should set the level for the primary audio, which in this case is on the primary storyline.

1. To make it easier to hear the clip, select *rich* in the Timeline and either click the Solo button in the upper right of the Timeline so it becomes blue, or press **Option-S**, or use **Clip>Solo** (see Figure 6.17).

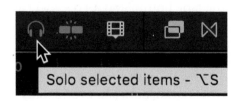

Figure 6.17 Solo Button

2. Play the clip and check the audio, making any overall level adjustment using the level line on the audio portion of the clip.

3. When you're done unsolo the clip with **Option-S**.

TIP

Timeline Waveform Color: The waveforms in FCP give use indication of levels as they change from green to yellow and then to red. These are rough guides only and should not be used for level adjustment. Use the audio meters as your level reference.

Changing Levels on Part of a Clip

Rather than changing the overall level of a clip, you will often want to change the audio level of a section of a piece of audio, reduce a section of music while someone is speaking, raise a section where the level is too low. We want to reduce or "duck" the level of the music as Rich starts to speak, and then after a while fade it out completely. To select the area to reduce we're going to use the Range Selection tool. By the way, there is no automatic ducking in FCP as there is in iMovie, but with the Range Selection tool you can duck audio quickly and efficiently.

1. Activate the Range Selection from the Tools menu or by pressing the **R** key. This is similar to the Range tool that appears in iMovie.

2. Drag an area on the *LatinWithHum* clip in the Timeline beginning shortly before the voice begins until about 11 seconds into the project. This might be easier to do without snapping (**N**).

3. With that area selected pull down the level line so the audio is reduced about –15dB (see Figure 6.18). Keyframes will automatically be added ramping the sound down and back up at the end of range selection.

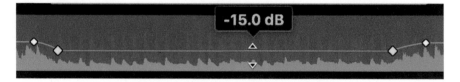

Figure 6.18 Audio with Keyframes

4. Return to the Select tool by pressing the **A** key and either click off the clip to drop the selection or use **Shift-Command-A**.

5. To make the fade at the start slower pull the outside keyframe a bit to the left so the ramp isn't so abrupt.

6. At the end of the reduced audio section drag the final keyframe farther along the Timeline and then drag it down to 0dB so the audio fades out slowly.

If you need to add additional keyframes to raise or lower the audio levels, simply move the pointer to the level line, hold the **Option** key and click on the level line. A new keyframe will be added. You can add as many as you need, raising and lowering the audio as required. If you want to delete a keyframe, or a group of keyframes, drag with the Range Selection tool to select them, right-click on one and use **Delete Keyframes**. You can also use the shortcut **Shift-Option-Delete**, which will remove any selected keyframes.

TIP

Moving Keyframes: If you want to move keyframes, you can select them and drag one to move them all. You can also cut them using **Edit>Keyframes>Cut** or the shortcut **Shift-Option-X**. To paste them move the skimmer to where you want them and use the shortcut **Shift-Option-V** or the **Edit>Keyframe** menu. You can also drag multiple selected keyframes horizontally in the Timeline to shift their position.

> **TIP**
>
> **Nudging Keyframes:** While there are no shortcuts to nudge audio keyframes horizontally, selected keyframes can be nudged up and down, increasing or decreasing the level by 1dB, by using **Option-up** or **down** arrows. Repeatedly tapping the shortcut will move the keyframe up and down in the Timeline. If you have the level bar between two audio keyframes selected, which you can do simply by clicking on it, you can raise or lower the bar with the keyboard using **Option** and **Up** or **Down** arrow.

Setting Clip Levels

Let's move on to setting the levels for the Connected Clips.

1. Zoom out so you can see all the Connected Clips easily and drag select to select them.

2. From the Enhancements popup in the Toolbar select **Auto Enhance Audio** or **Option-Command-A**. Done. Noise reduction or other enhancements are applied to all the clips that need it.

3. With all the clips still selected, in the Audio inspector drag the Volume slider to the left to about –17dB to reduce the overall level of all the clips, setting the ratio of voice to atmosphere for the beginning clips.

4. Adjust the levels on individuals clips if you need to.

A great way to adjust the levels of a clip is to do it dynamically while it's playing back. If you select a clip in the Timeline (use the **C** key to select each clip as the pointer passes over), you can raise and lower the audio levels with the keyboard shortcuts **Control- –**(minus) and **Control- =** (think of it as plus). The first will lower the level by 1dB, and the second will raise it 1dB. The great thing about these shortcuts is the audio can be adjusted during playback. This is especially useful for setting the level for music or an interview.

Another useful function is the ability to mute a clip or a section of selected audio. Select the clip or with the Range Selection

tool make a selection in an audio track and use **Modify>Adjust Volume>Silence** to set the level to zero. There is no default keyboard shortcut for this, but you can of course create your own in Command Editor. How about **Control-Delete?** This function is the equivalent of the Mute button in iMovie's Volume controls.

> **TIP**
>
> **Levels Shortcuts:** In addition to raising and lowering 1dB with the keyboard shortcuts, there are also shortcuts allowing you to enter specific level values. To change clips relative to the current settings, use **Control-L** and type into the Dashboard a plus or minus value, such as −6dB. To change the levels to an absolute amount, removing any keyframes, use **Control-Option-L** followed by the value you want the level to be.

> **TIP**
>
> **Reference Waveform:** When you're reducing the audio levels of clips in the Timeline, especially to low levels, it's handy to still see what the waveform looks like even when the audio is very low. You can do this by checking on **Show reference waveforms** next to Audio in the Editing tab of FCP Preferences. With reference waveforms switched on you see a ghost of the waveform in the Timeline.

Match Audio

A handy feature of FCP is the Match Audio function. What this does is compare the audio equalization of one clip and balances it to another by applying EQ settings.

1. In the Timeline select the *luna sign* shot, the third from the last Connected Clip.

2. From the Enhancement popup in the Toolbar select **Match Audio** or use **Shift-Command-M**. A two-up display appears in the Viewer (see Figure 6.19).

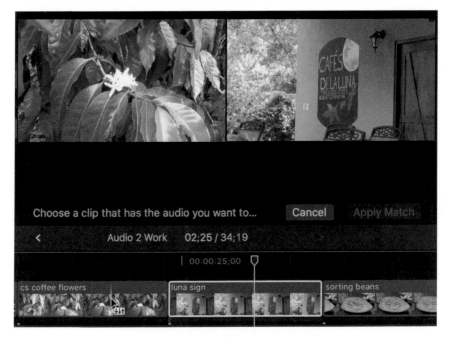

Figure 6.19 Match Audio Display

3. Move the skimmer over the shot before *luna sign,* the *cs coffee flowers* shot. The pointer will change to an EQ icon. Click on the *cs coffee flowers* shot.
4. In the Viewer click the **Apply Match** button.

If you want to change it, you can click the little microphone button that will appear opposite Equalization in the Audio inspector. If you want to see what equalization has been applied to the clip, click the EQ icon next to it to bring up the HUD that controls the effects (see Figure 6.20). You can make any adjustments you want in the HUD to fine-tune the audio.

Subframe Precision

One of the features of editing sound in FCP is that you can do it with great precision, down to subframe accurate detail. To help you

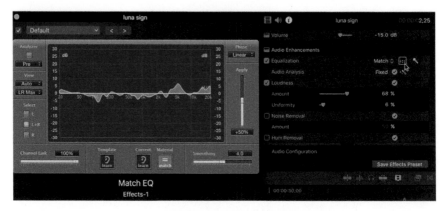

Figure 6.20 EQ HUD

do this you can switch the Dashboard display to show subframe amounts. In the FCP General Preferences from the Time Display popup select HH:MM:SS:FF+Subframes.

With subframes displayed in the Dashboard, you can use the **Command** key and the **left** or **right** arrows to move the playhead in increments of 1/80th of a frame. You can only edit audio in subframe amounts. Video has to be cut on whole frames.

If you zoom into the waveform in the Timeline, you can set keyframes within a single frame of audio. This is really useful if there are spikes in the audio you need to reduce or cut out. In Figure 6.21 the paler area across the image represents a single frame of video. As you can see I could cut down a very small section of that 1/30th of a second to reduce the level. Also notice the Dashboard is displaying values in hundredths of a frame.

> **TIP**
>
> **Zoom a Selection:** You can use the Zoom tool (**Z**) to drag a selection around a section of the waveform to zoom into just that portion of the display.

Figure 6.21 Subframe Audio Edit

PAN LEVELS

In addition to controlling the volume of a clip in the Inspector you can also control Pan. To access Pan, which is below Audio Enhancements, click the **Show** button at the end of the Pan bar. Here you can set the Pan Mode, which defaults to None. With the popup you can change it to Stereo Left/Right or different surround presets (see Figure 6.22). In Stereo the Pan Amount slider allows you to move the audio from left to right as you like and to animate it to move from the left or right speaker across the screen. Let's for fun do this to the music in the Timeline. You can do this entirely in the Audio inspector, and you can do this also in the Timeline. We'll start in the Inspector.

Figure 6.22 Pan Mode Popup

1. Select *LatinWithHum* in the Timeline and move the playhead right to the beginning of the project with the **Home** key.

2. In the Audio inspector with Stereo Left/Right selected for the Pan Mode move the Pan Amount slider all the way to the left to –100 and click the **Add Keyframe** button on the right end to the slider (see Figure 6.23).

Figure 6.23 Pan Keyframe Button

3. Move the Timeline playhead to 2:15 and move the Pan Amount slider all the way to the right to 100, and listen to the music. You'll hear it move from the left speaker to the right speaker.

4. To do the Pan animation in the Timeline select the clip and press **Control-A** for Audio Animations.

5. Double-click Pan Amount in the Timeline to open the keyframe graph for that parameter (see Figure 6.24).

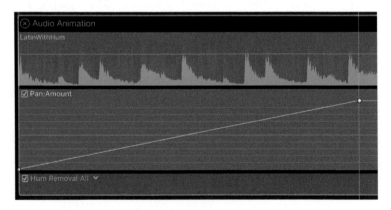

Figure 6.24 Pan Keyframe Graph in the Timeline

6. Move the playhead forward to about 5:00 and holding the **Option** key click on the Pan Amount level line to add another keyframe.

7. Drag the third keyframe back down to zero (not all the way down to –100). The music will move from left to right and then come back to be center panned.

Here the effect is pretty silly, but it's often useful to move sound from one side to the other, for instance for a car that drives across the screen. Setting the pan position is also important when you want to convey something is happening on one side of the screen or from somewhere off screen to left or right before someone appears in the scene.

The Pan Mode popup also has presets for 5.1 Surround panning, such as Dialogue and Music and Ambience, which spreads the sound to the periphery and leaves the center open for voice as in Figure 6.25. The Surround Panner is revealed with the **Show/Hide** button. Dragging the puck around lets you control the position of the audio in the surround space. Not only is the position of the puck keyframeable, but so are all the advanced properties such as

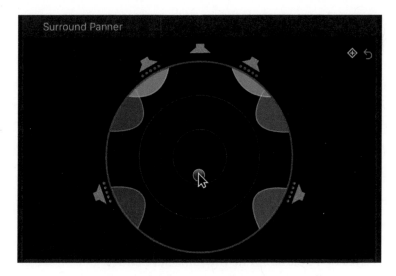

Figure 6.25 5.1 Surround Panner

Surround Width, LFE Balance, and Rotation. You need a proper surround monitoring system of course to appreciate the effect.

EDITING MUSIC

As I mentioned before, FCP has no separate detached music track like iMovie, but that of course doesn't prevent you from adding as much music as you wish.

Adding Markers

One of the best ways to edit music is to use markers. You can add markers to a clip either when it's in the Browser before you put it in the Timeline or to a clip after you've put it into the Timeline. Just as in iMovie, you can add markers to the beat by tapping the **M** key. You should be aware that because audio only files like *LatinWithHum* have no real timebase in the browser they are treated as 59.94 frames per second material (60fps). In the Timeline however they use the timebase of the project they're in. So let's make a new project and edit some music.

1. Press **Command-N** to make a new project and name it *Music*.
2. Select *LatinWithHum* in the *Audio* event and press **E** to append it into the Timeline.
3. Because this is an audio only clip a dialog appears asking you to set the project properties. Make the Video **1080i HD**, the Resolution **1920 × 1080**, and set the Rate to **29.97i**. You use these settings because they match the video we're working with.
4. Set Clip Appearances in the right end of the Toolbar to the first option for waveforms only (**Control-Option-1**).

The music will appear in the primary storyline ready to have clips connected to it. This is a very common way of working in music video; with the music on the primary storyline it's locked in place and all the clips that illustrate the music are added as Connected Clips or into secondary storylines.

Though we don't have enough video for all the music, we'll put a few shots into the project, but first let's add the markers.

1. Move the playhead back to the beginning of the sequence with the **Home** key and zoom in with **Command-plus** so it's easier to see the waveform.

2. You can either play the project and tap the **M** key as you play or you can add the markers at specific frames. Put the first marker at the beat at 1:07 in the Timeline.

3. Add the next marker at the beat at 2:14.

4. If the marker is in the wrong place you can delete it by going to the marker and pressing **Control-M**. You can delete all the markers on a selected clip or a selected range of a clip with **Control-Shift-M**.

5. You can name markers in the marker HUD by either pressing the **M** key when you're on a marker or simply double-clicking it (see Figure 6.26). Notice there are three different types of markers: Standard markers, which are blue, To Do markers, which are green, but can be converted to Completed markers, which are red, and finally orange Chapter markers.

6. Go down the Timeline to the beat at 3:20 and press **Option-M**. This not only adds a marker but also opens the marker HUD. A double-tap on **M** will do the same thing.

Figure 6.26 Marker HUD

7. Click the **To Do** button to give yourself a reminder. The marker will turn red.

8. To go to a previous marker use **Control-semi-colon** and to go to the next marker use **Control-apostrophe**.

9. Add more markers at 4:27, 6:04, 7:10, 8:17, 9:15, and 10:08. Remember **Control-P** will let you type in a timecode number to move the playhead.

10. Once you have your keyframes set switch Clip Appearances to a setting that shows some filmstrip before we add our video.

See Table 6.1 for a list of useful marker shortcuts.

> **TIP**
>
> **Nudging Markers:** You can select a marker in the Timeline, and holding the **Control** key use the **comma** and **period** keys to nudge the marker left and right on the clip in 1/80th of a frame increments. In reality this precision is not going to help you much with editing your video as video can only be edited in full frame increments.

Table 6.1 Marker Shortcuts

Marker Tools	Shortcut
Add marker	M
Marker dialog	Option-M
Delete marker or markers in selection	Control-M
Nudge marker left	Control-comma
Nudge marker right	Control-period
Go to previous marker	Control-semi-colon
Go to next marker	Control-apostrophe

Connecting Clips

Now we're ready to add some clips to the project. Using the markers as timing points we can connect clips to the music on the primary storyline. Normally I would cut audio and video into the project,

but in this case I think we'll edit picture only. Let's start by marking a selection in the Timeline.

1. Move the playhead to the first marker. The easiest way is with the Timeline active to press the **Home** key and then **Control-apostrophe**.

2. Because the selection includes the frame you're on, the best thing to do is to step back one frame with the **left** arrow key and press **O** to mark the end of the selection from the beginning of the clip.

3. Press **Shift-2** or select **Video Only** or use the Edit button popup in the Toolbar.

4. In the *Audio* event find the *coffee cups* shot and mark a selection start point with the **I** key a couple of seconds into the shot.

5. Press **Q** or the Connect edit button to connect the clip and add it to the Timeline.

6. You're ready to repeat the procedure. In the Timeline (**Command-2** switches to the Timeline pane) use **Control-apostrophe** to go to the next marker, go back one frame, and add an Out point.

7. Warning: Do not mark the In point first. When you use the shortcut to move to the next marker the selection will be dropped.

8. Use the Up arrow to go to the end of the previous shot and mark the In point.

9. In the browser mark an In point early in the *cooling roast* shot and press **Q** to connect it.

10. Using the technique above add the Out point and then the In point for the next marker in the Timeline.

11. Find *luna sign* in the browser and mark an Out point just before the end, just before the camera swings down to the floor.

12. Press **Shift-Q** to backtime the shot into the Timeline, matching the end of the Timeline selection to the end of the selection in the Browser.

Continue to the other marker segments adding *dalmatian, flowering tree, cottage, sorting beans, drying beds,* and *rich and roaster,* or any other shots in any other order that you want.

ROLES

Because FCP has no tracks that act as containers for media, and objects on different layers move around to accommodate other objects, keeping the content organized becomes very difficult. To organize your material, especially your audio for mixing, and if you need to pass on your work to someone using track-based software like Logic Pro or ProTools, you need Roles to make this possible. This allows you to basically assign lanes for your clips, for your sound effects tracks, for your music tracks, for your dialogue, and perhaps even separate lanes for each character's dialogue so that the audio can be mixed and equalized separately and efficiently.

You can set the Role for a clip either when you import or in the Browser before the clip is edited into the Timeline, or you can set it in the Timeline after the clip has been edited into the project. Often Roles aren't assigned until after the clips are in the project; this is especially true if you're going to use custom Roles and Subroles, which are subsets of Roles.

> **NOTE**
>
> **Project Clips Are Separate**: If you set a clip's Role in the Browser and then edit it into the Timeline, the Role will go with it. If you assign the Role in the Timeline, the browser clip is not changed. Also if you change the Role of a clip in the Browser, the copy of the clip that's in the Timeline does not have its Role changed.

> **TIP**
>
> **Changing Browser Roles from the Timeline:** If you change a Role in the Timeline, for instance from Effects-1 to Effects-2, and then use **Shift-F** to go to the clip in the Browser, it's Role will have been changed to Effects-2 as well.

There are two types of video Roles: Video and Titles. There are three basic types of audio Roles: Dialogue, Music, and Effects. By default, any video clip imported has two Roles assigned to it, Video and Dialogue. Any music that's imported from iTunes has Music set as its Role. Often these preset Roles aren't correct, especially for B-roll, where you're more likely to want Video and Effects. If you can it's simplest to assign these on import, but sometimes you have to ingest a great deal of material quickly and it's not practical to pick and choose Roles on import. Fortunately, once the clips are in the Browser you don't have to change each one separately; you can select groups of clips and change them at once. So for instance you could select all your B-roll video that's in Keyword Collections and change their Roles to Video and Effects. There are basically two ways to change the Roles in the Browser.

1. With the Browser in List view, scroll to the right to find Audio Roles and drag it to the left next to the clip names.

2. **Shift**-click or **Command**-click to select the clips you want to change and in the Audio Roles column select the Role you want (see Figure 6.27).

3. To change the Roles in the Inspector, **Shift**-click or **Command**-click the clips you want to change and use the Audio Roles popup near the top of the Info inspector.

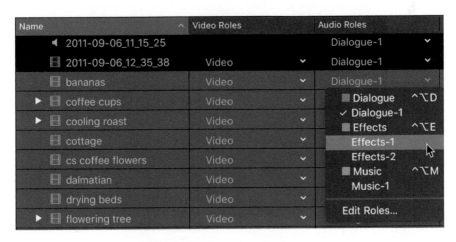

Figure 6.27 Roles in the Browser

You can use the same methods to change the Roles of clips in a project. Select them, right-click on one and from the shortcut menu select the Audio or Video Role you want; or select the clips and change them in the Info inspector.

In each of the Roles pop-ups you'll notice the option to **Edit Roles**. This brings up the Role Editor window (see Figure 6.28). There's a separate + button for video and audio. Each Role has a **Show/Hide** button next to which are buttons to add Subroles and to assign a color for the Role. Subroles will let you add separate Roles for each character or type of music or type of effect. You can also remove existing Roles or rename them. Table 6.2 gives a list of useful Roles shortcuts to quickly change Roles for selected clips.

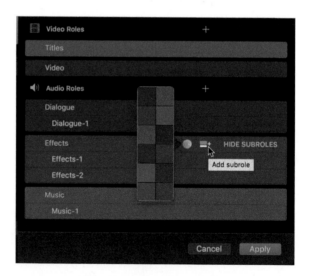

Figure 6.28 Editing Roles

Table 6.2 Roles Shortcuts

Roles	Shortcut
Video	**Control-Option-V**
Title	**Control-Option-T**
Dialogue	**Control-Option-D**
Music	**Control-Option-M**
Effects	**Control-Option-E**

Timeline Index

We used the Timeline Index briefly earlier, but let's look at it in more detail, in addition to its uses for controlling Roles. The Index can be used to search the content of your project as well as to navigate in it.

In the *Audio 2 Work* project open the Index by either clicking the button at the left end of the Toolbar or pressing the shortcut **Shift-Command-2**, which will also close it.

The index has three tabs at the top for Clips, Tags, and Roles. The Clips Index shows the list of clips used together with their timecode locations (see Figure 6.29). Notice the search box at the top. To move the playhead to a clip in the project, simply click on its name. Also notice the four buttons at the bottom that let you filter to display just video clips, audio clips, or just titles. You can also delete items from the Timeline by selecting them and pressing the **Delete** key.

Figure 6.29 Clips Index

Tags display a whole array of different metadata. If you switch back to the *Music* project where we added markers you'll see the markers listed under tags. The buttons at the bottom of the index let you see all tags, or markers, or keywords, analysis keywords, To Do items, completed items, and chapter markers (see Figure 6.30).

Figure 6.30 Tags Index

1. Click the To Do tags, the third button from the right, and you should see the one To Do item we made.
2. Click on the icon in front of the marker name, and the marker will disappear from the To Do list. It will be in the Completed list, and the marker in the Timeline will turn green.

You can also set To Do items to be completed in the marker HUD in the Timeline.

The Timeline Index becomes more and more useful the longer your project gets. It's a very handy way to navigate through your material and to keep track of things you have to do.

Finally let's look in more detail at the Roles Index. In the Index you can expand the audio Roles as we did, you can also rearrange Roles and Subroles, and switch on lanes to focus on. To look at the Roles Index in detail we'll use the *Audio 3* project. Start by duplicating it and naming it *Audio 3 Work*. Double-click the copy to open it into the Timeline.

1. Open the Index with the button or **Shift-Command-2** and go to the Roles tab.

2. Click on the first of the icons for Dialogue and Effects to expand the audio for those clips. You don't have to expand Music of course.

3. In the Index drag the Dialogue bar so it's between Effects and Music.

4. Hold the **Command** key and click the focus circles, the last of the three icons, for the Dialogue and Music Roles. This collapses the Effects lanes into narrow bars to keep them out of the way (see Figure 6.31). This allows you to work easily on adjusting the levels for the bottom two lanes.

5. Click the circle icon for Effects to collapse Dialogue and Music. All the Effects lanes are alternated to accommodate the fades between clips.

Figure 6.31 Index and Timeline with Collapsed Effects

6. To make it easier to mix however it's better to have Effects-1 and Effects-2 separated. Click the middle icon on the Effects bar in the Index to expand the Subroles (see Figure 6.32).

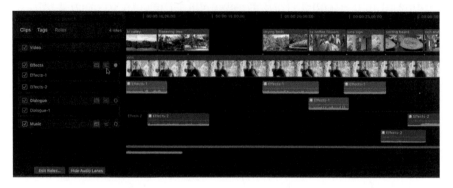

Figure 6.32 Index and Timeline with Expanded Subroles

Now the Effects Roles are expanded into four lanes, two for Effects-1 and two for Effects-2, to allow for overlap of the clips in the Subroles. Notice the faint Roles names that appear at the head of the lanes. These will track with you as you scroll the Timeline. With these tools your audio is now laid out perfectly for sending to a track-based audio application such as ProTools or Logic Pro X.

SYNCHRONIZING CLIPS

To get good sound quality many users record audio separately from the camera, using small recorders like a Zoom or even an iPhone with apps like Apogee MetaRecorder. Even though you're not using the camera audio, it's best for the camera to record an audio track. FCP has the ability to automatically sync camera and sound clips by looking at the audio waveforms of the two items. There are two items in the *Audio* event that aren't named, simply have dates. One is a video file that's in the ProRes Proxy codec, and the other is an audio file that corresponds to it.

1. Play the video file. That's me by the way. There's a handclap at the beginning to aid in syncing, though it's not necessary. If the audio is turned up to an acceptable level the sound is pretty hollow and has a lot of hiss.

2. Play the audio only file. That's much better; in fact it probably should be reduced as it's a little too loud.

3. Select both items in the Browser and use **Clip>Synchronize Clips** or right-click and select **Synchronize Clips** or use **Option-Command-G**.

4. A drop down sheet appears asking you to name the clip and asking how you want to sync the clips. The default setting is to sync automatically using audio to sync the clips (see Figure 6.33). If you click **Use Custom Settings** you have other options under the Synchronization popup. Notice the checkbox to disable the camera audio, which is really handy.

You are now ready to edit your sync clip into your project.

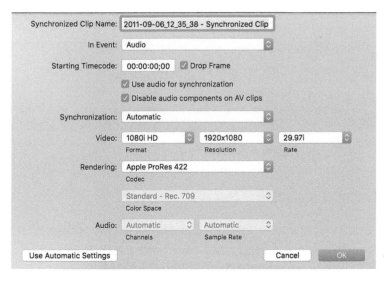

Figure 6.33 Sync Clips Dialog

> **TIP**
>
> **Formats and Sample Rates:** When recording with an external recorder make sure that you record either AIFF or WAV files, not compressed formats like MP3, and make sure you use the standard video sample rate of 48kHz not the CD sample rate that's 44.1. If you can't record in AIFF or WAV at 48k, it's best to convert the audio to those standards before syncing.

> **TIP**
>
> **Open Clip:** You can right-click on the sync clip in Browser and select **Open Clip** to open the clip container into the Timeline pane. Here you can see how the video and audio line up, and slide them independently to adjust the sync if necessary (see Figure 6.34). If the sync is difficult, sometimes it's useful to add markers to the video and audio by closely examining the waveforms or by syncing to something that happens in the video. You can also trim the beginning and end of the tracks, which will be reflected in the clip in the Browser. Note that even if the camera audio is disabled when the sync clip is created, you will still see it when the container is opened into the Timeline.

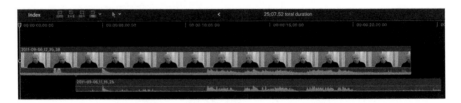

Figure 6.34 Clip Opened in Timeline

RECORDING AUDIO

Final Cut Pro has a very simplified audio recording feature that allows you to record directly into your project. It allows you to record narration or other audio tracks to your hard drive while playing back your project. Many people prefer to record narrations before beginning final editing so the picture and sound can be

controlled more tightly. Others feel that recording to the picture allows for a more spontaneous delivery from the narrator.

You can access the tool under the **Window** menu by selecting **Record Voiceover**, which brings up the panel in Figure 6.35.

You can adjust the recording level with the Input slider and name the file before you start recording. Under the Advanced disclosure triangle is the Input pop-up that allows you to select the recording device. Any connected USB microphone should work well. Make sure the connected microphone is selected as the input in Sound System Preferences. The built-in mics on MacBook Pros and iMacs

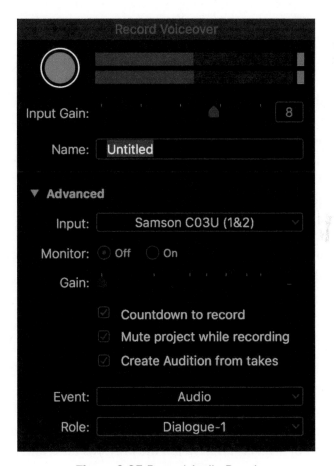

Figure 6.35 Record Audio Panel

are also recognized. From the same popup you can select whether to record in stereo or mono. There is a slider to adjust the monitoring level. It's a good idea to wear headphones when recording, especially if you want to play back the project with audio. There's a checkbox to mute the project audio, which is on by default. You can also select the event to capture into as well as set the Role for the recording. It defaults to Dialogue-1.

Notice the options to have a Countdown, which appears as 3, 2, 1 with audible beeps in the Viewer, as well as the option to create Auditions of your takes.

The controls couldn't be simpler: There is one red button that starts recording and stops recording. You can also stop recording by pressing the spacebar. When you start recording, the project starts to play back, and the recording begins after the countdown if you have that option selected. The recording is added to the project, connected to the primary storyline beginning at the point the recording started. When recording is stopped, the playhead moves back to the beginning of the recorded section, ready for you to do another take. If you have Auditions checked on, the takes will be combined into an Audition clip; if Auditions are unchecked the takes will be stacked below each other. There are benefits to both ways of working. Let's see how this works:

1. Use **Command-N** to make a new project and name it *Recording*.
2. Open the Record Voiceover window and set it up for your mic input and playback.
3. Select your microphone and name your track. Call it *voiceover*.
4. Click the record button, wait for the countdown, and read your script or a short section of this book and then stop recording with the spacebar.
5. The playhead returns to the start ready for you to record the next take. When you start again, the recording is either added to the Audition or stacked underneath the previous take, and the takes are numbered sequentially.

When you're done recording, you can select the Audition and press **Y** to open it or click the spotlight badge in the upper left corner of the clip. Listen to the takes to select the best one to use. Or if you didn't use an Audition clip, you can solo individual clips to try them. Figure 6.36 shows an open Audition clip in the Timeline, as well as a group of three stacked takes.

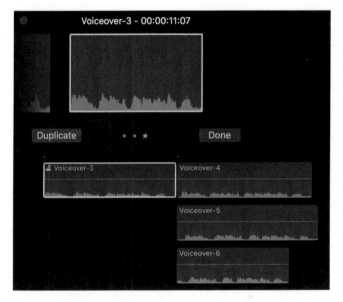

Figure 6.36 Audition and Stacked Clips

TIP

Switch Applications While Recording: A nice feature of FCP's Record Audio function is that you can switch applications while you're recording, and recording will not stop. So you can start the recording in FCP, and during the countdown switch to Pages with **Command-Tab** to read your script, and then switch back to FCP to stop the recording.

TIP

Playback Levels: Don't be fooled by FCP's vertical audio meters. These display the playback levels; they do not show the recording level.

SUMMARY

In this lesson we looked at working with sound in Final Cut Pro. We covered working with split edits, cutting with sound, meters, overlapping and cross-fading tracks, Loudness and Audio Enhancements, audio matching and surround panning, editing music, and using markers. We've seen the power of Roles and the use of the Index in creating lanes, as well as being introduced to FCP's audio recording tool. Sound is often overlooked because it doesn't seem to be that important, but it is crucial to making a production appear professionally edited. In the next lesson, we'll look at working with multicam material.

Multicam Editing

One of the features that first drew many editors to FCP, especially those working in event programming, has been its ability to edit multiple camera clips simultaneously. There's of course nothing like this in iMovie. The multicam function includes automatic synchronization based on audio or selected parameters like timecode. This function allows you to create a multicam clip that is a single container clip that holds all the angles you want to cut and switch between in your project. Multicam also supports mixed formats and mixed frame rates and allows for creation of a multicam clip with 48 camera angles, though more can be added. It's best however to avoid multiple formats and frame rates if possible, and if necessary to use proxy media to make for easier playback.

To make it easier to use multicam in FCP, it's best to set up your shoot so that it's simple for FCP to create the multicam clip. To make it easier to create the multicam clip set all the cameras in the shoot to the same date/time settings, same date, same time, and the same time zone. Though the date/time stamp can be altered for clips in FCP using **Modify>Adjust Content Created Date and Time**, it's better to set it up right to start with. Because FCP can use audio synchronization to sync the clips, it's always a good idea to make sure all the cameras are recording sound, no matter how far away or how poor the quality. Because audio analysis has to be done to sync clips with audio, for a lot of clips, or clips with difficult sound, the synchronization process can be quite lengthy. Shooting a clapperboard with a clap strike at the beginning of recording will help enable audio sync considerably.

LOADING THE LESSON

For this chapter we'll use the *FCPX6* library that is available for download from the www.routledge.com/products/9781138209978 web page by going to the eResources tab.

1. Once the ZIP file is downloaded double-click the file to open it.
2. Copy or move the *FCPX6* library to your media drive and double-click it to launch the application.
3. You can close any other open libraries if you wish.

The media files in this project are QuickTime DV and do not need to be optimized or proxied. In fact they can't be optimized as DV is a native I-frame codec in FCP.

MAKING THE MULTICAM CLIP

Before you create your multicam clip, which combines all your shots into a single multicam clip, you need to determine how the clips will be synced up. The default is to sync the clips using camera audio, which in most instances works well.

Often cameras don't roll continuously. Fortunately the assembly of the multicam clip allows you to have a camera that stops and starts and assign all the clips from that camera to have the same angle. Assigning angles for your cameras is an important first step. That way all the shots from a camera will appear as one angle with black space between the shots when the camera was not running. To set the camera angle, you can use the General or Extended view of the Info inspector (see Figure 7.1). Camera Angle does not appear in Basic view. Here you can specify Camera Angle and Camera Name for each clip or for a batch of selected clips.

If you have a camera that's stopping and starting during the shoot, select all the clips from that camera and assign them the same Camera Angle. This will make the application try to sync the clips sequentially rather than trying to treat them as separate cameras.

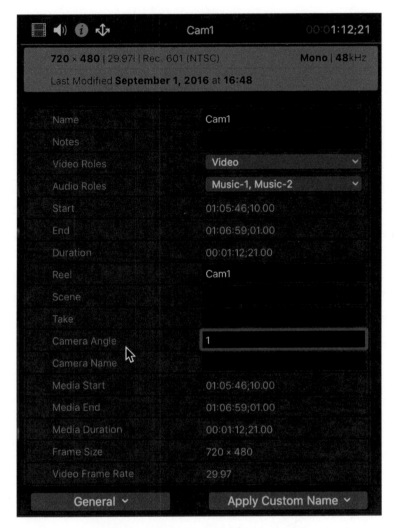

Figure 7.1 General View Info Inspector

By setting the same camera name or camera angle to multiple shots, FCP will combine them into a single angle.

If you're shooting with a single or a few cameras repeatedly, for instance when shooting music to lip sync, then you want to make sure you assign separate camera angles for each take. If you don't the application will see the same camera name, and assume they are all

the same angle, unless you specify otherwise by assigning separate camera angles.

When cameras have no names and no angles the application assumes each is a separate angle.

Let's see how to create the multicam clip:

1. In the *Multicam* event select clips *Cam1* through *Cam4* together with the audio file *Output*, leaving *Cam5*.

2. Right-click on the selected items and from the shortcut choose **New Multicam Clip** or use the **File>New>Multicam Clip** menu.

3. In the sheet that drops down name the multicam clip *Jazz* to save it into the *Multicam* event.

4. Notice **Use audio for synchronization** is checked on by default. Click on the **Use Custom Settings** button to see all your options (see Figure 7.2).

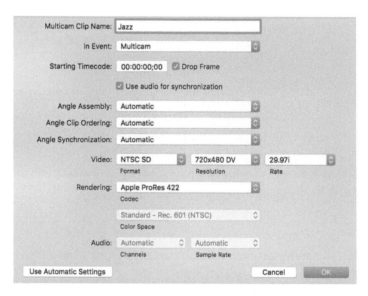

Figure 7.2 Multicam Clip Options

Angle Assembly determines how clips will be put together in the multicam clip (see Figure 7.3). Camera angle, first, then camera

Figure 7.3 Angle Assembly

name, using the information assigned in the Inspector, or from the camera metadata. If you use the Clips option to assemble, separate angles will be created for each clip.

Angle Clip Ordering is the basis for making the stack in the multicam clip, which can be changed later as we'll see. It can be Automatic, Timecode, or Content Created. Timecode is the most accurate of course as Content Created uses the date/time stamp and is usually no more accurate than one second.

Angle Synchronization can be based on Timecode, which is great if you have shot your production with multiple cameras that have slaved, frame accurate timecode. If you have slaved timecode you can switch off audio synchronization. The other options—Content Created, Start of First Clip, and First Marker on the Angle—can be used as guides for audio synchronization. So if the cameras are running with matched date/time stamps the application has a guide on what to try to base its audio sync. If you roll cameras simultaneously or close to it, the camera start can be used as a guide for audio syncing. You can also add a marker, such as on a clapperboard strike, and use that as a guide. It does not have to be frame accurate if it's being used in conjunction with audio syncing. If you have a clear clap strike to sync to, you can set a marker there and switch off audio syncing.

In the multicam clip dialog you can also set the start timecode for the clip, which defaults to zero, though many users if using time of day timecode will set that as the start timecode for the multicam clip.

You can also set the format of the multicam clip based on the most common video format, or just as in the new project dialog you can

set custom formats and custom render and audio properties. Setting the multicam clip format is useful if you want to specify a format type, especially if it's different from the majority of cameras in the multicam clip.

If you're working in a format that uses a codec that is difficult to process, your clips should be transcoded. By default, the user Playback preferences is set to create optimized media for multicam clips. Personally I don't think this is really useful for most instances. If you have a lot of clips or are having difficulty working with the media, it's really a good idea to create and use proxy media in the multicam clip. The simplest way to convert your media is to select the multicam clip in the Browser, right-click on it and select **Transcode Media**. The application will transcode all the clips built into the multicam clip into proxy and/or optimized as selected. Remember if you're working with proxy files that you have to switch your Viewer settings to proxy and when you're done don't forget to switch them back to original/optimized for output.

If you are working with clips with separate audio, such as DSLR cameras, you can use the Synchronize Clips function to combine the video and audio, and then use the synchronized clips FCP created when making the multicam clip. If this can be avoided, so if there's only a single audio track with multiple DSLRs, then it's better to simply combine the video and audio clips into a single multicam clip without synchronizing first as we did here.

TIP

PluralEyes 3: Sometimes FCP's multicam sync function just can't manage to create the multicam clip. In these instances you should try using Red Giant's PluralEyes, which is an excellent tool (www.redgiant. com/products/all/pluraleyes). It also has a free 30-day trial. You simply put your clips to sync, stacked vertically in an FCP project and export an XML file. Import the XML into PluralEyes and let it do its thing. You can then export an XML that will create an FCP multicam clip and bring it into the application.

The Angle Editor

Once you've created the multicam clip, it appears in the Browser with the little quad split icon in the upper left corner. This icon will also appear on the clip in the Timeline, and in the Angle Viewer and Angle Editor.

If you double-click the *Jazz* multicam clip it will open it into the Timeline pane in what is called the Angle Editor (see Figure 7.4). To see how your multicam clip looks, open the Angle Viewer either from the Viewer appearance popup in the upper right of the Viewer or with the shortcut **Shift-Command-7**.

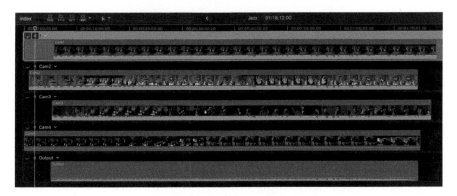

Figure 7.4 Angle Editor

In the Angle Editor, you will see all the clips in the multicam clip stacked on top of each other. When you skim the Timeline ruler in the Angle Editor you only see the monitoring angle. This can be set with the video and audio buttons at the head of each lane that allows you to set which angle you see and which you hear during playback (see Figure 7.5). You can only have one video monitoring angle, but you can switch on as many audio monitoring angles as you like. Being able to switch on two audio monitoring angles allows you to judge sync of the clips.

The Clip Skimmer is very useful in the Angle Editor. You can activate it from the **View** menu or with **Option-Command-S**. This allows you to skim each clip separately and to hear the audio from each

Figure 7.5 Video and Audio Monitoring Angles

clip separately. If you have the Clip Skimmer on an angle, **JKL** and spacebar will work to play the clip. If you are using the Clip Skimmer on an angle **Shift-V** will select that angle for video monitoring. The angle with video selected will appear in light gray. **Shift-A** on an angle that is being skimmed will toggle audio monitoring on and off.

To check audio sync from multiple angles, turn on audio monitoring for a pair of angles or more and listen to the audio. If there's an echo they're out of sync. Slip the clips in the lanes as needed to sync the audio precisely. You can nudge the clips left and right along the lanes with the **comma** and **period** keys, and in 10 frame increments with **Shift-comma** and **Shift-period**.

You can rename an angle in the Angle Editor by clicking on the name in the lane. That will not change the clip name, but will change the name in the Angle Viewer.

To change the order of the clips, grab the handle icon that appears at the end of the lane and drag the angle up or down in the lanes. This will change the order in the Angle Viewer. This is especially useful if you're working with a music clip for instance that has no video. You can drag the music to the bottom of the stack order so it's out of the way.

In addition to reordering clips, you can also combine clips that might be synced on separate angles into a single angle. Simply grab the clip, and using the Position tool, hold the **Shift** key and drag it vertically so it drops into another angle. This will overwrite whatever's in the angle so be careful how you use this feature. This is useful if you were not able to combine the clips into a single angle using FCP's Angle Assembly function, where you can set to combine the angles using the various criteria we saw earlier.

You can add another angle to the multicam clip by clicking on the drop-down menu at the head of each clip and selecting **Add Angle** (see Figure 7.6).

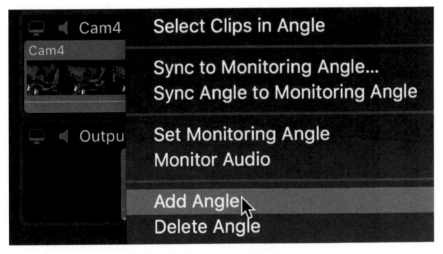

Figure 7.6 Add Angle

1. In the Angle Editor click on the triangle popup for *Cam4* and select **Add Angle**. An empty lane is created below it into which you can drag any clip you want.
2. From the Browser drag *Cam5* anywhere into the empty lane.
3. Change the angle name from *Untitled Angle* to *Cam5*.
4. Click on the video monitoring button for *Cam3* so that it's highlighted in gray.

5. From the triangle popup at the head of *Cam5* select **Sync Angle to Monitoring Angle**. This will shift the angle to sync with *Cam3*. If you have an item selected you will have an option to **Sync Selection to Monitoring Angle**.

The clip will be synced using whatever parameters were assigned when the multicam clip was created. You can also use this technique to replace an angle. Simply remove the clip that's in the lane in the multicam clip. Drop in another clip and make it sync to the monitoring angle.

Normally you use video and audio clips in a multicam clip, but you can put whatever you want in there: graphics files, stills, generators, pretty much any kind of a clip, including unrelated, non-sync clips like B-roll, that you might want to switch to in your multicam edit. You can just keep adding angles in the multicam clip. You can also disable clips in the Angle Editor; simply press the **V** key just as in the project timeline.

If you play *Cam4* in the Angle Editor you'll notice that you don't hear any audio with it, though you see a reference waveform. The audio is just incredibly low in level. If you select the *Cam4* clip in the Browser and go to the Audio Enhancements pane in the Audio inspector, turn on Loudness and push up Amount and Uniformity, you'll just be able to make out some very faint sound. This is a good example of how little audio FCP is able to work with to create sync audio and multicam clips.

EDITING THE MULTICAM CLIP

The Angle Viewer

Once you've created the multicam clip, and prepared it in the Angle Editor, it's time to edit it into a project, but before we do that, let's take a look at the Angle Viewer.

1. Make sure the *Jazz* multicam clip is selected in the Browser, and if it's not already open, press **Shift-Command-7** to open the Angle Viewer (see Figure 7.7). The multicam clip does not need to be in the Angle Editor.

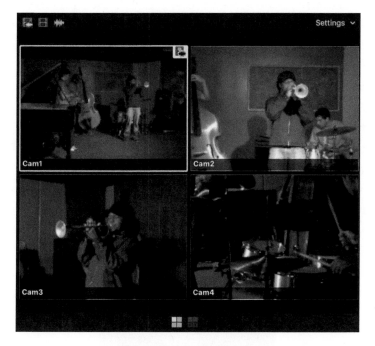

Figure 7.7 Angle Viewer

2. In the Settings popup in the upper right of the Angle Viewer you can change the display (see Figure 7.8). Notice in the Settings popup you can also turn on overlays like Timecode and change the clip name display.

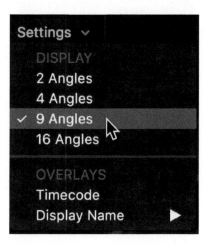

Figure 7.8 Angle Viewer Settings

3. Change the number of angles to 9. You can display up to 16 angles at a time in the Angle Viewer, though the multicam clip can hold many more.

4. If you switch back to two or four angles, you'll see multiple displays at the bottom that you can click to select. The icons give you access to the additional pages of angles you can have in the clip. Just click on the page you want to see the angles on that page.

5. If you set the number of angles to four and make the Angle Viewer narrow, this will move the display into a vertical layout (see Figure 7.9). In four-up or two-up display you can stack the clips vertically so the Angle Viewer takes less horizontal screen space, which is very useful on a laptop.

Figure 7.9 Angle Viewer Vertical Display

The Angle Viewer gives you three cutting/switching options at the top. These will effect what happens when you edit in the Timeline.

1. With the Browser multicam clip selected switch back to the nine-up display in Settings.

2. With the first of the three buttons at the top left of the Angle Viewer selected, the yellow filmstrip with audio, you are cutting or switching both video and audio together (see Figure 7.10). With the yellow button selected click on the *Output* angle. When you play the Browser you see nothing but you hear that audio track.

3. Select the second button, the filmstrip, which will turn blue.

4. Click on *Cam1* to switch the video to that angle, but leaving the audio on *Output*.

5. Play the Browser clip. You see *Cam1* but you hear *Output*.

Figure 7.10 Cut/Switch Buttons

Figure 7.11 Angle Viewer with Separate Video and Audio

The second option enables video only. When you select an angle, it will be highlighted in blue and whatever audio is active will remain in green (see Figure 7.11). Finally, if you choose the waveform icon you will be cutting/switching audio only.

You can change these options with keyboard shortcuts. **Shift-Option-1** will select the yellow video/audio button; **Shift-Option-2** will select the blue video only button; and **Shift-Option-3** will select the green audio only button, similar to the edit selection shortcuts.

You can also change the selected audio channel in Audio Configurations of the Audio inspector.

1. Open the Inspector with **Command-4**. Notice the multicam clip in Browser has only an Audio inspector and no Video inspector.
2. In the Audio Configurations only the *Output* angle should be checked on. You can check on any additional camera audio that you want to add to the *Output* angle.

Editing

So far we've only been switching. Now it's time to edit. You do not edit your multicam clip in the Angle Editor, you edit inside a project, so we'll start by making a new project and editing a portion of our multicam clip into it. You can mark a multicam clip with In and Out points just like any other clip to make a selection to trim off the beginning and end as you need and then press **W** to Insert, **E** to Append, or even **D** to Overwrite into your storyline.

1. Press **Command-N**, name the project *Jazz*, and use the default automatic settings to make the properties based on the first clip.
2. Select the multicam clip in the Browser and as before make sure the Angle Viewer video is set to *Cam1* for video and *Output* for audio.
3. In the Browser play the multicam clip *Jazz* and mark an In right near the beginning around 5:00. At this point there are only three camera angles.

4. Mark an Out at 1:09:19 before the cameras start to shut off.

5. Press the **E** key to Append the multicam clip into the empty Timeline.

6. Make sure the blue button is active, **Shift-Option-2**, because we want to edit the video only, leaving the audio untouched in the Timeline.

7. Move the playhead back to the beginning of the Timeline and click *Cam4* in the Angle Viewer, which will cut to that angle. Notice the razor blade that appears when cutting the multicam clip in the project Timeline.

8. Press the spacebar, and while the Timeline plays click in the Angle Viewer on the angle you want to cut to.

To see the angle names in the Timeline go to the Clip Appearances popup and check on Angles (see Figure 7.12). The clip name that appears in the Timeline is made up of the name of the active video and audio angles (see Figure 7.13). If both are the same you'll see the video clip name. By the way, if Angles are switched on in Clip Appearances the Rename Clip function is not available in the shortcut menu.

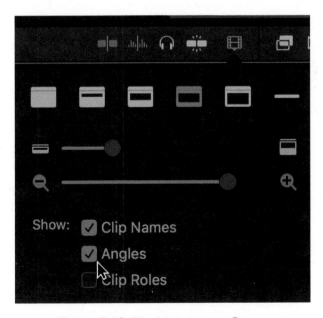

Figure 7.12 Clip Appearances Popup

Figure 7.13 Clip Name in the Timeline

After you've cut the clip in the project, notice the dotted black line in the clip at the edit points. FCP calls this type of an edit a through edit, because the multicam clip is continuous. Any through edit can simply be selected and deleted with the **Delete** key. The left side of the multicam clip will roll over the right side erasing it. Even though only the audio is technically a through edit, in a multicam clip you can select any edit and delete it.

The default behavior for the multicam clip in the Timeline is to cut the clip wherever the playhead is. If you only want to switch an angle hold the **Option** key.

1. Move the playhead in the Timeline over any of the edited clips in the storyline. Make sure you see the black dot on the clip in the playhead.

2. The Angle Viewer will show you the selected video and audio under the playhead.

3. Hold the **Option** key and click on a different video angle. The video portion of the clip in the storyline will be changed to the selected angle, but no cut will be made.

You can also edit the multicam clip in the Timeline using solely the keyboard.

1. Select everything in the *Jazz* timeline and delete it.

2. Click on the *Jazz* multicam clip in the Browser, which should still be set up with the same In and out points, and press **E** to Append.

3. Switch to the Timeline (**Command-2**) and move the playhead back to the beginning (**Home**).

4. Press the spacebar, and while the Timeline plays tap the **1**, **2**, **3**, **4**, or **5** keys to cut the video to that angle. You can do that with either the numbers across the top of the keyboard or with the keypad on an extended keyboard.

You can stop playback and undo previous edits by repeatedly pressing **Command-Z**, and then you can pick up editing where you left off by clicking the Angle Viewer or using the keyboard.

Though it's fun to do this kind of editing in real time, like you're live switching a TV show, there is absolutely no reason you have to. You can carefully play through, find your edit point, and press the shortcut to make the cut or to try different angles.

After you've made your edit you can change any shot by selecting it or putting the playhead over it and pressing **Option** and the number you want to switch to. So if the selected shot is *Cam3* and I want *Cam2*, just select the shot and press **Option-2**. You can also right-click on any shot and change the Active Video Angle or Active Audio Angle from the shortcut menu (see Figure 7.14). You can also change the active video and audio angles in the Info inspector (see Figure 7.15).

You can add any transition to the edit point. Because of the way FCP adds audio transitions, in this instance with continuous audio,

Figure 7.14 Changing Active Angle in the Timeline

Figure 7.15 Changing Active Angle in the Info Inspector

it's best to expand all the audio before applying the transitions so the transitions are applied to the video only.

When you move the pointer next to edits in the multicam clip, it does not change to the Ripple function as it normally does, it changes to the Roll function. It doesn't allow the Ripple function as this would pull the material out of sync. If you really have to ripple a clip, activate the Trim tool and then the Ripple function will again be available. The Slip function can be activated using the Trim tool but it should not be used, because, again, this tool will slip the multicam clip out of sync. The Slide function can be used as this rolls two edit points at the same time.

> **NOTE**
>
> **Audio Cut:** Often when cutting a multicam you will be cutting the picture and leaving the audio continuous. FCP does this but in the process it puts a through edit into the audio, which is sometimes audible. What's become common practice is to detach the audio from the multicam clip in the Timeline and to extend it as a split edit for the duration of the multicam so the audio is not cut at all.

> **TIP**
>
> **Hiding the Browser:** Once you have the multicam clip in the Timeline you don't really need to see the Browser or Inspector anymore. Close the Inspector if it's open with **Command-4** and close the Browser, which hides the library as well, from the **Window** menu or with **Control-Command-1**. This is especially useful when working on a MacBook Pro and will give you more space for the Angle Viewer and Viewer.

Effects

Multicam clips have a parent/child relationship. This is different from other clips you edit from the Browser into the Timeline. Normally any clip edited into the Timeline takes the Browser clip's properties and settings, but once it's in the Timeline, it is completely independent. In the multicam clip any changes made in the Multicam Editor in one clip, whether the multicam clip has been opened from the Browser or from a project, is applied to all instances that use that multicam clip. Whether it's color correction, sync adjustment, effects, they will apply to all instances of the multicam clip in any project and to the multicam clip in the Browser. This applies to changes made to the multicam clip in the Multicam Editor, but does not apply to an individual clip in the project. Selecting a clip in the Timeline and adding an effect will not affect the master multicam clip in the Browser, but any changes made in the Multicam Editor will affect everything. Doing color correction in the Multicam Editor has the advantage that every instance of a shot used will have the same color correction applied. Let's look at this:

1. In the Timeline select whatever is your first clip in the *Jazz* project.
2. Open the Effect Browser (**Command-5**), find the **Bokeh Random** effect and double-click it. The effect is applied to the first clip.
3. Skim through the Timeline and see if there are other uses of *Cam4*, or whatever your first clip was, and you'll see that no effect has been applied.
4. Switch back to the Browser (**Command-1**) and double-click the *Jazz* multicam clip.
5. In the Multicam Editor select *Cam1*, make sure it's set as the monitoring angle, and go to the Color Board (**Command-6**).
6. In the Color tab that opens, drag the puck that's farthest left up into the green, giving the image an overall nasty green tint.
7. Use **Command-[** (left bracket) to switch back to the *Jazz* project.

8. Skim through the Timeline and you'll notice that the green color has been applied to every time you have cut to that angle.

9. Right-click on one of the other angles and select **Active Video Angle>Cam1**. The shot will be switched to that angle and the green color effect will have been applied.

This is obviously an exaggerated effect, but this is the best way to do color correction for multicam clips. Simply do it in the Multicam Editor.

We opened the Multicam Editor by opening the clip from the Browser, but if you want you can also open the Multicam Editor directly from the Timeline with either the shortcut menu or simply by double-clicking on one of the shots in the Timeline.

> **NOTE**
>
> **Exception to Parent/Child Multicam Clip:** Normally any changes made to a multicam clip apply to each of its iterations. There is one exception to this. When you make a copy of a project using the **Duplicate as Snapshot** function, any multicam clip in it becomes completely independent from the multicam clip it originated from. This is one of the beauties of the **Duplicate as Snapshot** function.

Audio Configurations

Sometimes you may need to change the audio for a specific angle or even to add audio from another angle into a shot in the Timeline.

1. Select one of the angles in the Timeline and use the **Clip** menu to **Expand Audio Components** or use the shortcut **Control-Option-S**.

2. With the clip selected in the Audio inspector's Audio Configuration area you should see that *Output* is the only angle checked on.

3. In Audio Configurations check on one of the cameras and notice that the cameras have two audio channels; they're Dual Mono.

4. You can't change to Stereo in the Timeline, but you can in the Multicam Editor. Double-click one of the clips to open the editor.

5. Select one of the clips and in the Audio inspector in the Audio Configuration pane you can select **Stereo** in the popup (see Figure 7.16), which will change Dual Mono to Stereo.

Figure 7.16 Audio Configurations

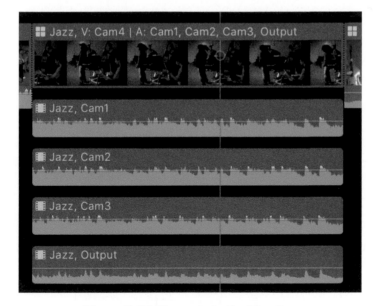

Figure 7.17 Channels in the Timeline

This is only for demonstration purposes as this is something you really don't want to do in this project. This will activate the sound for those angles, and they will appear in the Timeline (see Figure 7.17). Here you can adjust the audio levels for each angle and animate them as needed, fading them in and out. You can also extend channels to do split edits, and if necessary you can also use **Detach Audio** to give you even greater flexibility and control of your audio.

When you're done you can use **Collapse Audio Components** to close the channels, or the same shortcut used to expand them, **Control-Option-S**.

SUMMARY

In this chapter we looked at FCP's multicam editing features, creating the multicam clip, using the Multicam Editor, and working in the Angle Viewer to edit our project. We also looked at applying effects and working with Audio Configurations. In the next chapter, we will look working with 2D and 3D titles in FCP.

Adding Titles

Every program is enhanced with graphics, whether they are a simple opening title and closing credits or elaborate motion graphics sequences. This could be simply a map with a path snaking across it created in iMovie or a full-scale 3D animation explaining the details of how an airplane is built. Obviously, the latter is beyond the scope of both this book and of Final Cut Pro alone, but many titling effects can be easily created within FCP. The application has nearly 200 built in titles including gorgeous, extraordinarily high quality 3D titles. You should be aware that 3D titles really need at least 8GB of RAM and a minimum of 1GB of VRAM. To get started let's begin, as always, by loading the project.

LOADING THE LESSON

For this chapter we'll need to download the *FCPX7* library from the eResources tab of the www.routledge.com/products/9781138209978 web page.

1. Double-click the downloaded ZIP file and move the library to the top level of your dedicated media drive.
2. Double-click the *FCPX7* library to launch the application.

TITLE BROWSER

Let's look at FCP's titling options. To access the Titles and Generators Browser, click the T button at the top of the Libraries Sidebar. Many, but not all, of the iMovie titles are also available in FCP. If you open

the disclosure triangle for Titles you'll see that they're divided into categories. Most of the titles have animations or fades to bring them onto the screen and to take them off. There are two basic titles, **Basic Title** and **Basic Lower Third**, which can be called up with keyboard shortcuts **Control-T** and **Shift-Control-T** respectively.

Categories

The titles in FCP are grouped into categories. There is a search box at the top that will search either the selected category or all if you select Titles. The first two categories are the 3D and 3D Cinematic categories, which we'll look at a bit later, after we have seen the basic text controls. The first non-3D category of titles is Build In/Build Out. What is Build In/Out, you're probably asking? You need to understand that most of the titles and effects and transitions in FCP are created using Motion 5. Almost all of them involve some sort of animation to bring the text onto the screen and to take the text off the screen. The Build In function moves or fades the text into place. The Build Out function takes it away. Build In/Build Out is followed by Bumper/Opener, which contains **Basic Title**, probably because it's so basic it doesn't have any build capabilities. **Credits** has **Scrolling**, **Slate**, and **Trailer**, which has been brought from iMovie. **Elements** has titles like **Instant Replay**, which we'll see in the lesson on effects, **Speech Bubble**, and various sports related displays. **Lower Thirds** is the largest category with over 70 items including many theme-related lower thirds.

To preview the animations of a title you can either skim over it with the pointer in the Title Browser, or better yet, click on one like Dramatic and with the pointer over it press the spacebar. The preview will play in looped mode in the Viewer. Some of the animations are fairly simple, such as Fade, which uses a blur wipe to effect the text, to Fold, which has a drop zone and unwraps itself, and the ever popular Far, Far Away, taken from *Star Wars*. Some, such as Pointer List and Slide Reveal, have multiple lines of text.

If you scroll down to the bottom of each group, you'll see some titles that are under headings like Bulletin Board, Comic Book,

and Sports. Though you can use these titles anywhere, they are specifically designed to be a part of a theme. Themes will be familiar to iMovie users. There is no way to globally set a theme for a project, but the themes are grouped together in titles and in the Stylized category of the Transitions Browser.

The Basic Title appears as one line of text in the center of the image. Let's see the basic controls in the Text inspector. There are two sets of controls in the Inspector for **Title** and for **Text**. Title inspector, which has the T icon, holds the parameters published from Motion, which in this case for Basic Title there aren't any. The Text inspector, which has the paragraph icon, gives you access to the common text style functions you can use in FCP (see Figure 8.1). While in iMovie you have fairly limited text control, little more than font, alignment, style, and color, in FCP if you have far greater flexibility.

Figure 8.1 Title and Text Inspector

1. Start by making a duplicate of the *Snow* project, which should be called *Snow 1.*

2. Open the duplicate and make sure the playhead is at or near the end of the project.

3. Put the pointer over the second shot, *Mike run 3 tables,* and press the **X** key to make an edit selection.

4. Press **Control-T** to apply the Basic Title. Normally Basic Title is 10 seconds, but by adding the edit selection, the title has taken its duration from the duration of the clip.

5. Double-click the Basic Title in the Timeline. This does three things: selects the title, moves the playhead over the title, and selects the text in the Viewer ready to edit.

6. Type *snow*, lower case, and press the **Escape** key.

> **TIP**
>
> **Background:** If you place text in the Timeline over nothing, the blackness you see in the Viewer behind the clip is the emptiness of space. To make it a little easier to see some of the text types go to user **Preferences** and in the Playback tab set Player Background to Checkerboard.

As in iMovie you can make each line of text, each character, completely different, different font, color, size. You have to make sure the text you want to change is selected. It can be selected by double-clicking it in the Viewer, or drag selecting individual glyphs. You can also select the items at the top of the Text inspector. If you have a lot of text the separator between the text box and the rest of the controls can be pulled down.

Text Controls

The Text inspector gives you access to the common text style functions you can use in FCP (see Figure 8.2). Let's start there.

1. At the top is the text entry box where you can change the text. It includes a spellchecker and will offer spelling suggestions.

2. Change the font to something bold like Adobe Gothic Std or Ariel Black, which is very widely used because of its easy legibility.

3. Push Size up to about 350, which is beyond the slider range. Either enter the size into the value box or double-click in the box and use the mouse to scroll up to make it nice and large.

4. Move the Tracking value to the left, tightening the tracking a little to about –10 or –12. Not too much as we'll be adding other elements. Don't worry if it looks too tight.

5. A little lower down check on All Caps. Try the All Caps Size, which has a different effect from the font Size controls. At the end of the All Caps Size bar, use the hook icon which every parameter has, to reset it.

6. **Line Spacing** adjusts the gap between multiple lines of text.

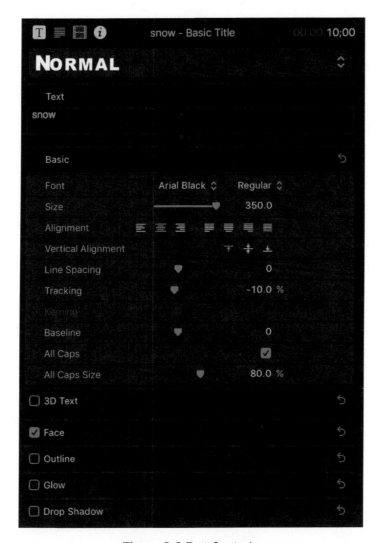

Figure 8.2 Text Controls

7. **Kerning** adjusts the spacing between individual letter pairs.

8. **Baseline** is useful if you have a single line of text, which normally sits on the center line. Large font sizes appear high in frame rather than centered. Adjust the Baseline a little, by moving the slider to the left to shift the text so the word is more centered on the screen, though usually having the text sit a little above center works well.

These are the standard controls that can all be reset with the hooked arrow button opposite Basic. There's also a **Hide/Show** button to close up the basic text controls. Notice below the basic controls the checkbox for 3D. Though neither Basic Title nor any of the non-3D category titles are not in 3D, any can be instantly changed to 3D text with the 3D checkbox.

Text Styles

Let's look at FCP's other titling controls for color and other styles.

1. First, let's turn on the **Show Title/Action Safe Zones** in the Overlays section of the View popup menu in the upper right of the Viewer.

2. Drag across the text in the Viewer to select it, grab the text's position handle in the Viewer and drag it down so the text sits on the safe title line and the alignment guide keeps it centered (see Figure 8.3). Notice the Position coordinates displayed at the top while dragging.

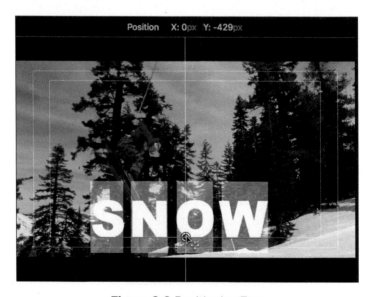

Figure 8.3 Positioning Text

3. In the Text inspector double-click Face to open it or click on the **Show** button. Here are basic color controls including an Opacity slider and a Blur slider that allow you to adjust the look and create interesting compositing effects.

4. In the Fill With popup select **Gradient** and twirl it open with the disclosure triangle (see Figure 8.4).

There are three color swatches for gradients and more can be added. The one on the top bar that's white affects the transparency of the gradient; the two on the bottom affect the colors. By adding more stops in the gradient you can make a rainbow gradient if you really want to. You can use the RGB sliders to colorize any of the selected colors—you can change the interpolation of the gradient, the type of gradient from Linear to Radial, and the Angle of the gradient. We're not going to do everything, but let's add some color to the gradient.

Figure 8.4 Gradient Controls

1. Select the lower left gradient to change its color. With it selected you can use the color swatch underneath it to access the system color picker, or you can click on the triangle next to bring up the color HUD.

2. Make the gradient start color bright yellow, and change the color stop at the end to make it bright red.

3. Click on the lower bar to add another color stop about halfway down the bar (see Figure 8.5).

Figure 8.5 Adding a Gradient Color

4. Try different colors for the middle stop, but rather than keep the color, just drag the middle stop down away from the bar so it disappears in a puff of smoke.

5. Move the red end color to the left about halfway so it's more prominent and move the central triangle back to the right so the fall off is faster.

6. Click on the white upper bar and drag the color stop all the way to the right.

7. Right-click on the white color stop at the right end and set the color to black or pull the Opacity slider to zero. You can set any color you want but only the luminance values are affected. This will make the bottom edge of the title transparent.

8. Move the black end stop a little to the left so the transparency falls off more quickly.

You can go on playing with this, but let's move on to Outline and Glow.

1. First remove the transparency control in the Gradient so the title is opaque. Do this by pulling the black end stop off the transparency bar or setting the Opacity slider to 100%.

2. Hide the Face section of text controls and open Outline and activate it with the checkbox on the left end of the bar. Outline has basically the same controls as Face except it defaults to bright red.

3. Leave the color and push up the Width to about 4.

4. Activate Glow and push up the Radius to about 17.

5. Double-click the Blur value and use the mouse scroll function to make the value about 100 to add a soft yellow halo to the image.

6. Activate Drop Shadow and make the Distance about 60 and soften it a little with the Blur slider.

Your title should look something like Figure 8.6. So this is not something you're likely to use every day, or use at all, but you may have to spend quite a bit of time tinkering with it, so you want to save it.

Figure 8.6 Snow Title

1. At the top of the Text inspector is a large button that says Normal, even if the text doesn't look it. Click on it and you get three options **Save Format Options, Save Style Options,** and **Save All Format+Style Options.**

2. Select the third one and name it *Yellow-Red Gradient with Glow & Drop*.

3. To apply the Format and Style to another title simply select it from its alphabetical location in the list (see Figure 8.7).

Figure 8.7 Saved Format and Style

If you saved format only, this would apply the basic functions to the text, font, size, tracking, alignment, and so on. If you saved the style, it would save Face, Outline, Glow, and Drop Shadow, allowing you to apply the colors and look of the title to other fonts and sizes. If you work a lot with this you can quickly build up a great many styles and formats. At some point you might want to clear some of them out. To delete custom title styles go to Home/Library/Application Support/Motion/Library/Text Styles and delete the ones you want to remove.

There are also pre-built styles available under the popups for 2D and 3D.

Title Fades

Though most titles have some kind of Build In/Out effect, even if it's a simple fade, Basic Title does not. The simplest way to fade it in and out, I think, is to select it and add a Cross Dissolve at the beginning and end with **Command-T**, if dissolve is your default transition.

It does make the title large in the Timeline and adds complexity to moving it around. Another way to fade the title in and out is to use the Opacity tools, and not the slider in the Text controls, but the Opacity fade handles in the Timeline. Every video clip and title has Opacity handles in the Timeline.

1. With the Snow title selected in the Timeline press **Control-V** to open the **Video Animation** controls.

2. At the bottom of the list of video animations controls, double-click on **Compositing>Opacity**.

3. In the upper corners of the Opacity graph, just as for audio in the Timeline, are fade handles you can pull in to add and adjust the rate of fade in and fade out of the title (see Figure 8.8).

4. Click the close **X** button in the upper right or press **Control-V** again to close the video animation HUD.

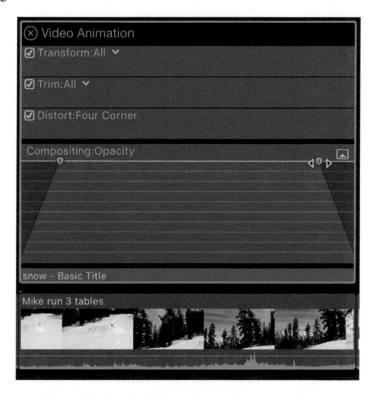

Figure 8.8 Opacity Fades in Video Animation Control

To delete a title, simply select it in the Timeline and press delete, but a great feature of FCP allows you, rather than deleting a title simply to replace it.

1. Select the *Snow* title in the Timeline.
2. In the Build In/Out group find the Highlight title.
3. Double-click Highlight to replace the Basic Title that was in the Timeline.

The title in the project is replaced, but the text remains the same. The basic attributes and style conform to the new title style, but the word *SNOW* is retained. This makes it easy to try lots of different title styles and animations, and because you saved your style settings you can easily reapply it to the text.

Bumpers, Opens, Credits, and Elements

The Bumper/Opener category contains a number of full screen titles or full screen with drop zones for video.

1. In the Event Browser find the *Kevin 3 tables* shot and Append it into the project with the **E** key.
2. In the Timeline move the playhead back to the beginning of the *Kevin 3 tables* shot.
3. In the Bumper/Opener group find Keynote and double-click it.

The Keynote title is typical of the Bumper/Opener category, and it appears with the video embedded in it, swinging open at the start to reveal title, subtitle, and bullet points. In the Title inspector (see Figure 8.9)—not to be confused with the Text inspector, which adjusts the text appearance—you have controls that will allow you to flip the text from the right to the left, to adjust the shading of the background gradient, and various other controls for the look of the title. In Background you can customize the gradient or activate the Drop Zone and put any image you wish in there. You might notice also that the color properties are keyframeable.

Figure 8.9 Keynote Controls

Every title will have different controls depending on how it's constructed. Many of them are very well designed and the adjustments make them very useful for a great deal of programming.

The Credits group includes a basic two column scrolling title template as well as the basic movie trailer template that iMovie users will be familiar with from that application's movie trailers.

The Elements group has an instant replay tag for the upper left of the screen and that always-important speech or thought bubble graphic.

Lower Thirds

The Lower Third category is an important group of title tools. There are quite a few of them, including some themed titles. They range from the silly Clouds to the popular Echo to the simple but effective Gradient – Edge. Let's put the **Gradient – Edge** lower third over the *tracking* shot.

1. Put the playhead at the start of the *tracking* shot at 27:15 in the project.

2. In the Lower Third category, find **Gradient – Edge** and double-click it.

3. Double-click the title in the Timeline and look at the Title inspector (see Figure 8.10).

Figure 8.10 Gradient – Edge Title Controls

4. The first line of text in the Viewer should be selected. Type in *TYLER SKIVINGTON* in caps.

5. Double-click the second line and type in *Bear Valley Park Crew.*

6. In the Title inspector push the Line 1 Size up to about 96 point and push the Line 2 Size to 70 point.

7. Drag the top of the Line 1 text box upward to move the title higher on the screen (see Figure 8.11).

Figure 8.11 Increasing Size of Text Box

8. Increase the Bar Width to 150%.

9. Click on the Bar Color swatch and choose a color from the wheel, or use its eyedropper to pick a color, like the skier's jacket.

10. Finally, you might want to go into the Text inspector and add a little drop shadow to both lines of text, making the drop shadows fully opaque and moving them slightly farther from the text to help separation from the background.

All of the Lower Thirds will have slightly different controls, but **Gradient – Edge** is fairly typical of the titles available.

Find and Replace

A great feature in FCP's titling tools is the ability to easily change text that perhaps was misspelled, or had the wrong title. To do this use, from near the bottom of the **Edit** menu, **Find and Replace Title Text**.

1. In the dialog that appears type in *Tyler* in the Find box.

2. Type *JOHN* in the Replace box because we want the replacement text to be in all caps (see Figure 8.12).

Figure 8.12 Find and Replace Title Text

3. Click the **Next** button to find the word and then click **Replace** to change it.

4. Close the box and Undo. His name really is Tyler.

If you had multiple instances you could check each in turn or globally replace the word.

3D TITLES

The 3D titles that were introduced in version 10.2 are quite spectacular. The titles are also amazingly complex in their capabilities, but at the same time really quite easy to use. It would be impossible to go through all the huge variations that the 3D titles allow, but we'll try to touch on the main features. The best way to find the look you want is to spend time with these tools and try different combinations of controls.

There is a total of 12 3D titles, eight in the 3D category and four in 3D Cinematic. Except for Custom 3D, all of the titles have some animation to build them in and out. While all the titles in the 3D category are over transparency, to be layered on top of your video, the 3D Cinematic titles all have backgrounds, though the backgrounds can be customized or simply switched off in the Title inspector. The Custom 3D title, like the Custom title in the Build In/Build Out category, has many parameters in the Title inspector that allow you to create your own animations to bring the text onto and off the screen. We'll look at the custom animations in a moment. Let's begin by applying a title to a shot in the Timeline.

1. Remove the Keynote bumper from the *Kevin 3 tables* shot and put the playhead towards the end of the project.

2. In the 3D category find the **Tumble 3D** title and double-click it.

3. Drag it out so it's a little longer, about five seconds.

4. Double-click the text block in the Timeline, type in the word *KEVIN*, and press the escape key.

5. Change the font to Arial Black and hide the Basic section of the Text inspector.

6. Open the 3D section, which is probably closed, and in the 3D controls push the Depth up to about 65.

The first group of controls adjusts the text shapes, depth, weight, and edges. There is a great variety of front and back edge shapes. The default back is to be the same as the front. The Front Edge popup shows the available edge options (see Figure 8.13). We'll leave it at the default Bevel, but set the Front Edge Size to about 5.

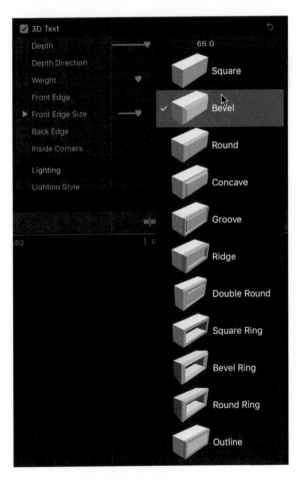

Figure 8.13 Edge Options

The next group of controls is the Lighting controls with different Lighting Style presets (see Figure 8.14). In addition to the lighting presets there are Environments, which are checked on by default. The Type popup accesses the various options (see Figure 8.15). Environments are what are reflected in the letters, so they're very important to the lighting.

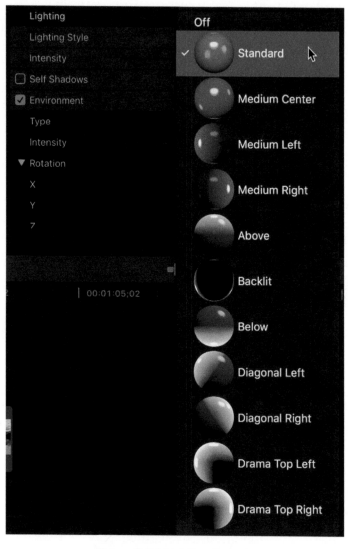

Figure 8.14 Lighting Presets

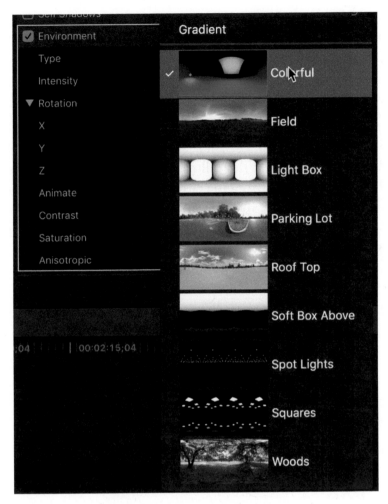

Figure 8.15 Environment Options

1. With the Tumble 3D title selected in the Timeline, try different Lighting Styles. I set it to Drama Top Left as the shadows are falling from left to right.
2. Try different Environments as well as different combinations of Lighting Styles and Environments. I used the Squares environment.

An important function of the Environment controls is Rotation. Because the environment is controlled in 3D space, rotating it along

the X, Y, Z axes will change what's reflected on the image. You should try these controls out as well. The easiest way to do this is to double-click in one of the Rotation value boxes and scroll the mouse to change the number and see how the reflection changes as the value changes. As we're going to angle the title, click on the Anisotropic checkbox.

The primary controls for positioning the title in 3D space are in the Viewer (see Figure 8.16). There are three rings—the green ring, from the circle on the left side, allows the text to be rotated around the Y axis; the red ring, from the circle at the top, will rotate the ring around the X axis; while the blue ring, from the circle on the right, rotates the title on the Z axis. The arrows allow the text to be dragged along the corresponding axes—green to raise and lower along Y, red to left and right along X, and blue to move the title forward and backward in Z space.

Figure 8.16 X, Y, Z Controls

1. Try the different rotational and position controls for the title.
2. Set it so it's rotated on the Y axis so the letters have depth and show the sides and edges.

Finally, perhaps the most important control is Materials, which changes the appearance of the faces of the letters. (Remember you can select a letter and change its materials separately from the other letters.) The Materials section has astonishing depth, and the permutations must be approaching the infinite.

1. The first control you likely will want to change is at the top of Materials, the popup that lets you select Single or Multiple (see Figure 8.17). Single treats all the surfaces with the same material, while Multiple lets you set different materials for each surface.

Figure 8.17 Multiple Surfaces

2. Try the different materials on the front surface (see Figure 8.18). But this is only the "surface" of the capabilities, as you can add layering to the selected material that includes Substance, Finish, Paints, and Distress, which will grunge the surface (see Figure 8.19). You can also make the surface a light emitter rather than a reflector.

3. There are also controls for the Finish with options such as Polish, Enamel, Brushed, Textured, and Custom Specular.

4. Finally, there are Substances such as Concrete, Fabric, Metal, Plastic, Stone, Wood, and Flat. You can add multiple layers, but be warned the more complex you make the surfaces, the more

Figure 8.18 Materials

power will be required of your computer, the more RAM you'll need and, more importantly, more graphics capabilities and more VRAM.

5. Set the front surface to whatever you like, including layers, distressing, substance, and substance color. When you have it the

Figure 8.19 Layering

way you like, click the popup in the middle of the Front surface and select **Save Material**, naming it something appropriate. Saving your work lets you apply it to other titles in other projects.

6. Select the Back surface and either use the saved material you just named or click the link button underneath it to gang it to the last surface you worked on (see Figure 8.20).

7. Set the Front Edge and Back Edge to the same **Plastic>Red Textured Plastic**. This should make the edge clearly visible. If not, try some other contrasting edge treatment.

Figure 8.20 Linking Surfaces

8. Set the Sides to **Metal>Gold**. It should be quite decorated by now.

9. Unless you have a really powerful system, to play back your title you should select it in the Timeline and press **Control-R** to render the selection.

Of course the permutations are endless, but the capabilities and rendering of the 3D titles are truly stunning.

CUSTOM ANIMATION

There are two custom titles in FCP—**Custom** and **Custom 3D**. The primary feature of the custom titles is their ability to be used to create customized animations to bring the text on the screen and off again, to build in and build out. The animation controls for the two titles are different, of course, but the principles are the same. Let's apply the Custom 3D title and see how we can use its Build In/Out tools. Unlike keyframing, the build properties are set in Motion. Here no keyframes are added because the animation goes to the title in its presentation setting and from that off the screen. Let's replace the Tumble 3D title that we added to the project.

1. Find Custom 3D in the 3D category, drag it onto the Tumble 3D title in the Timeline, hold and select **Replace**.

2. Add a second line to the text. Type in JUMPS and use the green arrow to raise the text block higher in the frame.

3. You might also want to go into the Text inspector and with the text selected, reduce Line Spacing.

4. Leave the surfaces untouched so that you don't have to render to test the animation.

5. Change the font to something bolder like Arial Black and increase the Depth to about 50 so it's easier to see the sides.

6. Rotate the title on the Y axis with the green wheel to make the 3D look more "heroic" as it tapers in Z space. Your title might look something like Figure 8.21.

Figure 8.21 3D Title in the Viewer

You're now ready to create the custom build in and out in the Title tab of the Inspector. The controls look daunting (see Figure 8.22), but it's easier than it looks. The first three controls—**Animate By, Spread,** and **Text Anchor**—affect both the build in and build out of the title. The remaining controls are broken into two equal halves— the first set from **Speed In** to **Retime In** control bringing the text onto the screen, and the same controls from **Speed Out** to **Retime Out** control taking it off the screen. When you're setting up the In

Figure 8.22 Custom 3D Title Inspector

controls, you're setting up the start of the Build In; the end of the build is where the text is when the animation is complete. Similarly, when you're applying the Build Out, you're setting its end position; its start position for the Build Out is its position on the screen. The default durations for the animations are 40 frames; you can change the speed by increasing the Retime In value that defaults to 75. The maximum is 175, which is very quick. **Animate by** gives you the option to animate either **All** or various parts of the text block. Let's build a little Custom animation.

1. **Animate by** defaults to All, which means that the whole block is handled as a single unit. You can set it using Text Anchor to **Line**, **Word**, or **Character**. Set this to **Character**, which means that each character will animate onto the screen sequentially.

2. Spread controls the spacing on sequence. Reduce the **Spread** to about 10.

3. Set **In Speed** to **Ease Out** so the animation will have some deceleration as it finishes.

The four primary animation controls are **Direction, Move, Rotate,** and **Scale**. Direction is Forwards, starting from the first character, or Backwards, starting from the last character, which looks strange. It also has Center to Ends, which starts in the middle of the line, and Ends to Center, which is the opposite. There is also Random. Move can be either Up, Down, Left, Right, Zoom Up, Zoom Down, three Random selections. There are quite a few Rotate options, which can be seen in Figure 8.23. The Scale function can either Grow or Shrink.

Figure 8.23 Rotate Options

Obviously there is a great variety of combinations to the animation controls, and I urge you to try different options, but let's set the controls for this title to give you an idea of its capabilities.

1. Set **Move In** to **Zoom Down** and watch the basic animation.

2. Change the **Rotate In** to **360 Flip**.

3. Leave **Scale** at **None** and the **Fade** and **Tracking** sliders at 0.

Let's repeat the process only in reverse to do the Build Out. The settings are basically the same.

1. Set **Speed Out** to **Ease In** so the animation accelerates.
2. Make the **Direction Out Forwards** instead of the default setting.
3. **Move Out** should again be **Zoom Down** so the title goes away into the distance.
4. Set **Rotate** to **360 Flip**.
5. Set **Scale Out** to **Shrink** to help it disappear off the screen.

That's it! You've done your first Custom animation. Though this is a simple animation, and the Custom 3D animations are fairly limited, remember that you can always right-click on a title in the Title Browser and use **Open a copy in Motion** to add an unlimited array of animation capabilities to the title. The 2D Custom title has different animation options, and actually has more capabilities than the 3D Custom title.

GENERATORS AND THEMES

Generators

The Title T button above the Libraries Sidebar also accesses the Generators browser. There is a total of 49 generators, though many of them have variations built into each one. There are also third-party generators available, many of them free, such as the 12 Classic Generators from Ripple Training that include color bars, a countdown, and a grid. For free generators and effects and other tools you should check out www.fcpxfree.com.

The built-in Generators include Backgrounds, with some motion to them, like the rippling **Curtain**, **Clouds**, **Drifting**, **Lines**, and others. Most also have other controls in the Generator inspector that usually allow some variation, especially of the color, such as **Underwater** and **Converge**.

There are 12 Textures, most of which have some kind of tint control. **Stone** lets you not only adjust the color but also change the stone type into three kinds of concrete, or from Marble to Travertine or Slate or River Rocks.

Solids are solid colors. **Custom** allows you to pick any color you want, while **Pastel** lets you select a narrow pale palette, **Vivid** has primary colors, and **Whites** has different pale shades.

The **Elements** group has only four items, but they can be very important. **Counting** will create a counter for you in which you can set the start and end numbers, so you can count up or count down.

Timecode will generate a timecode by reading the current time of the project and let you place it on top of the video.

The **Shapes** generator will put a shape over your video from basic Circles, Squares, and Rectangles, to different types of stars and hearts and arrows. You have full control over the appearance of the shape with fill color, outline, and drop shadow controls. The Transform tools, which we'll see in a later lesson, allow you to position and animate the shapes.

There is also a **Placeholder** that is a very powerful tool for not only putting a placeholder in your project, but actually building a storyboard of animatics if you wish. Let's see its controls.

1. In the Timeline move the playhead to the end of the project and double-click Placeholder in the Generators browser.
2. Move the playhead over the Placeholder in the Timeline so it's targeted with the black ball, and go to the Generator inspector.

You can set the **Framing** of the shot (Long Shot, Medium Long Shot, Medium Shot, Close-up); the number of people from zero to five; the gender (male, female, or both); and a string of different backgrounds (see Figure 8.24). You can also set different types of weather, cloudy, sunny, day, night; a checkbox to make it an interior; and a checkbox that lets you add text onto the screen. You can add more shots simply by copying and pasting (or **Option** dragging) the same Placeholder

Figure 8.24 Placeholder Backgrounds

and changing the parameters for shot size and number of people and changing the text. You can lay over the dialog and change the name of each Placeholder, either in the Info inspector, or by right-clicking on the clip in the Timeline and selecting **Rename Clip**. When you're ready, and the movie is actually shot, you can use the Replace edit function to swap out the Placeholders with real video. This is great for all types of programs that have basic formulas, like weddings and corporate videos and even commercials and narrative fiction.

Missing Items

Though there is no global change theme function as there is in iMovie, there are many more controls for customizing the project. You also can't add a global effect to a project using Project Properties as you can in iMovie, but it's simple to do in FCP, with much greater control, using an Adjustment Layer. We'll see how to add that in the lesson on effects. The Themes that are available in FCP are grouped at the bottom of the Backgrounds category.

Another item that's unavailable in FCP is the Maps function. Don't worry, though, it's easy enough to bring a map over from iMovie to FCP.

1 In iMovie make a **New Movie** with **Command-N**. Click on the **Projects** button and name the new project *Map*.

2. In the Backgrounds tab find the map you want to use and double-click it to add it to the empty project. Adjust the map properties, start and end location.

3. With the Timeline active, select **File>Send to Final Cut Pro**. If it's not open, FCP will launch and a new *iMovie Library* will appear with an event called *Map*, which contains the *Map* project.

4. To work with the map, it's simple to move the iMovie project into an existing library. Drag the *Map* project from the *iMovie Library* into the *Snow* event in the *FCPX7* library.

5. In the dialog that appears uncheck **Optimized Media** and click **OK**.

6. You can now close the *iMovie Library* and if you wish go to the Movies folder in the Finder and trash the Final Cut Pro *iMovie Library* from there.

Double-click the *Map* project in the *FCPX7* library to open it and copy and paste the map animation wherever you want.

Of course you can transfer as many iMovie maps as you want and can store them in a library project and copy and paste them into your own projects whenever you need them.

Another feature that's in iMovie that's missing from FCP is, of course, trailers. I mentioned this in the first lesson. You can bring trailers into FCP by converting them first to movies and then sending them to FCP. The trailer will have to be completed in iMovie, because unfortunately items such as titles are not editable once they reach FCP.

And where's the Sport Team Editor? Well, I'm afraid that's gone completely from FCP. It has to be done entirely in iMovie and brought over as a project into FCP.

Still Images

Often you must work with still images, photographs, or graphics generated in a graphics application such as Affinity Photo or

Pixelmator. FCP will accept images in different modes including 16-bit RGB, CMYK, and grayscale images, but not Lab mode. FCP works with a variety of different formats, JPG, TIFF, PNG, Photoshop and others. It can also import multilayered Photoshop files as well as Canon RAW files, though because of their large size, it's better to convert the RAW files to something like PNG at a size closer to the video format you're working in.

A Photoshop layered file can be edited into any project. It behaves just like a Compound Clip, though it does have a different icon.

1. Find the *Curtain.psd* file in the Browser. The easiest way is to look in the *Stills* Library Smart Collection.
2. Double-click it to open it into the Timeline or right-click and use **Open Clip**.

When the file is open in the Timeline you can access the layers and manipulate them as you like using the transform function. You can change the transparency and reorder the layer stack. You can use the transform functions, and even add effects to individual layers. You can even add other elements like titles and other graphics, however when you do that the Photoshop file can no longer be opened in a graphics application.

Changes made to imported Photoshop images inside Photoshop or other image editing applications will be recognized in FCP. You should not reorder or add or remove layers or switch off transparency. Any other changes will be updated in the FCP event and Timeline automatically.

You will not always be working with images that conform to video formats. Sometimes your graphic may be much larger, one you might want to move around or to make it seem as if you're panning across the image or zooming in or out of the image. To do this, you need an image that's greater in size than your video format. How much bigger depends on your creative needs, based on how much the

image will need to be magnified. Magnification always requires more data and a larger frame size, to keep the image sharp.

When you import a graphic file into FCP and place it inside a project, FCP will by default scale the image to fit the dimensions of the format you're working in, scaling up if the image is smaller than the project and scaling down if it's larger. Here's how this works:

1. In the Library Smart Collection *Stills,* select the image called *Sutton* and go to the Info inspector. The image is 5191×1497 pixels at 60fps, which is the maximum frame rate FCP uses.

2. Click on the preview in the Browser so that the user preference duration is selected; four seconds is the default. Then append the image into the project. Because the aspect ratio is very different from the HD frame, the image is letterboxed, showing space at the top and bottom.

3. In the Video inspector, you'll see that **Spatial Conform** is set to **Fit**. Change it to **Fill**. Then try **None**. With None set, the image is enlarged because the pixels in the image are spread out to their normal width.

4. Click in the Browser to select the *Sutton2* image and in the Video inspector set **Spatial Conform** to **None**. You can change the conform behavior for one or multiple selected clips in the Browser before putting them into a project.

5. Append *Sutton2* into the project, and you'll immediately see the image is quite a bit larger than the frame. Set it to what would be the default **Fit** and the image will appear with pillarboxing because it's in 4:3 aspect ratio.

6. Finally, click in the preview to select the *Sutton3* image in the Browser and in the Inspector set its **Spatial Conform** to **Fill**.

7. Append *Sutton3* into the project, where the image will fill the frame.

8. Now with the clip selected in the Timeline set the **Spatial Conform** in the Video inspector to **None**. The image is much

smaller than the frame. The system displays the image at the normal size, but there aren't enough pixels to fill the frame, much less provide additional space to support zooms.

Because FCP is scaling the *Sutton3* image to fit inside the frame, it may not be very sharp. Unfortunately, there is no easy way to tell how much scaling is being applied to an image. Generally, it's not considered a good idea to scale up an image over about 110% to 115%. This image is clearly being scaled a lot further than that.

> **TIP**
>
> **Still Image Duration:** If you drag a still image into a project from the Finder or the media browser, it comes in at the default four-second duration, or whatever the user preference is set to. If you select a still in the Browser, the selection is four seconds, and that's what's edited into the Timeline. But if you drag a still from the Browser to the Timeline without making a selection, or drag a group of still images from the Browser into the project, they will all be 10 seconds in length. If you need to change the durations of the stills in the Timeline, simply select them, double-click the **Dashboard** for the duration dialog or press **Control-D**, type in a time value, and press the **Enter** key. All the selected stills will have their durations changed. You can also right-click on the selected images and use **Change Duration**.

SUMMARY

In this lesson we looked at FCP's Title Browser, starting with its Build In/Out titles and the basic text controls and text styles. We learned how to do simple fades using the video animation controls. We worked with Lower Thirds and the find text and replace feature. We looked at the features available in 3D titles and created a simple Custom 3D animation. We also saw Generators and how they can be used. We also looked at how FCP handles graphics files and still images. In the next lesson, we will look at the effects available in the application.

LESSON 9

Adding Effects

In this lesson we look at and work with Final Cut's effects. FCP offers a great variety of excellent effects, including great color correction tools, which we'll look at in the next lesson. These effects rely heavily on the graphics card for processing. What this means is that on slower computers, you won't get very good performance with them and that on some marginal computers, they won't work at all, especially if you're working with UHD media.

In addition to the effects included with the application, other programmers are creating effects to add to Final Cut Pro, such as CoreMelt (www.coremelt.com) and MotionVFX (www.motionvfx.com). In addition there are many free effects that have been created using Motion. As mentioned before an excellent source of these effects is at www.fcpxfree.com.

While earlier lessons may have used concepts and tools that were familiar to iMovie users, as we go farther into the book we will use concepts and techniques that are very different to the capabilities of iMovie.

LOADING THE LESSON

For this chapter we'll need to download the *FCPX8* library from the eResources tab of the www.routledge.com/products/9781138209978 web page. We'll also be using the *FCPX7* library that we used in the previous lesson.

Once the files are downloaded and unzipped, copy or move them to the top level of your dedicated media drive. Double-click the *FCPX8* library to launch the application.

You probably thought there were an awful lot of titles. Well, there are even more effects—more than 230 of them. Truth be told, some of these effects aren't very useful, but a lot of them let you do some pretty amazing things with video. In this lesson we'll look at some of the useful FCP effects.

There is a short project in the library that we will use to apply some effects.

1. Find the *Effects* project in the Browser and use **Command-D** to duplicate it.

2. It's a good idea to rename the duplicate something like *Effects Work* and double-click it to open it.

APPLYING AN EFFECT

Effects are accessed from the Effects Browser, which can opened by clicking the Effects button, the second from the last button in the Toolbar, or by pressing **Command-5**. The effects are divided into two main groups, video and audio. Each of these have categories within them, like Basic and Blur under video, and Distortion and Echo under audio.

Effects are applied to clips in the Timeline; they cannot be applied directly to clips in the Browser (see the Note below called **Applying Effects to Browser Clips**). Applying an effect in Final Cut Pro is really easy, but before you apply an effect you can preview it with your video.

1. Put the playhead over the first clip in the Timeline so it's targeted by the black dot.

2. In the Effects Browser select the Color group and skim over **Black & White**.

3. Try skimming over some of the others.

4. Click on the **Tint** effect and press the spacebar.

The effect appears not only on the little icon in the Effects Browser, but will also appear full size in the Viewer. The clip will play in looped mode so you can see the effect.

To apply an effect, simply double-click it.

1. Select the first clip in the project and go to the Distortion category of effects to double-click **Background Squares**, applying it to the shot in the Timeline. You could also drag the effect onto the clip.

2. To access the effect controls go to the Video inspector where the effect should be surrounded by a box, and if necessary click the **Show** button at the end of the effect name (see Figure 9.1).

Figure 9.1 Effect Controls in the Inspector

It's just as easy to remove an effect.

• Click on the effect name in the Inspector so it's surrounded with a yellow box and press the **Delete** key

You can also switch off the effect, while leaving it in place.

- Click the blue checkmark next to the effect name to toggle the effect off and on.

This allows you to leave an effect in place while you toggle its effect on and off to see what it's doing to the picture.

Any number of effects can be added to a clip, but the order in which the effects are applied to the clip can be important.

1. With the Background Squares effect applied to the first clip, make sure the clip is still selected in the Timeline.

2. In the Blur category of effects find **Gaussian** and skim over it to see the result of the two effects applied together.

3. Double-click the Gaussian effect to apply it to the clip.

4. Push up the Gaussian amount to about 70 so it's very blurry. The Background Squares are hardly visible. By the way, notice the Blur Boost function that allows you to create super-blurry effects, which is great if you need to completely mask out a face for instance.

5. Drag the Gaussian effect in the Inspector so it's above the Background Squares and see the result in the Viewer as in Figure 9.2.

Because the Gaussian blur is applied to the image before the Background Squares, the clip is blurred first, but the squares show sharp edges as they are applied after the blurring effect.

Figure 9.2 Viewer and Effect Ordering

NOTE

Applying Effects to Browser Clips: Though you can't apply an effect directly to a clip in the Browser, you can right-click on any clip and select **Open Clip**. Once the clip is open, video and audio effects can be applied in the clip container just as if the clip were in a project. Once applied to the clip in the Browser, every time you put a part of the clip in a project, the effect will be applied. This is especially handy for clips like interviews where you might be using many segments.

TIP

Default Video Effect: Because you often have to reapply the same effect, it's handy to be able to create a default video and audio effect. Simply right-click on the effect you want and select **Make Default Video/Audio Effect**. You can then use the keyboard shortcuts **Option-E** for the default video effect and **Option-Command-E** for the default audio effect. If you use Motion to create a custom variation of an effect, that custom version can be assigned as the default.

TIP

Wide Effects Browser: If you're working on a large screen and want to try out a lot of different effects, especially if you have a great many third party effects, you can grab the left edge of the Effects Browser and drag it out to give you quite a wide space to view all the content. You can also close the Categories sidebar with the button at the bottom left for an even larger pane.

NOTE

Motion 5: One feature that's very different about the effects in FCP is that they are created using Motion 5. Most of the transitions, titles, and effects in FCP can be altered by right-clicking on the item in the media browser and selecting **Open a copy in Motion**. It makes Motion 5 an extraordinarily powerful add-on to FCP, but one that requires a substantial learning curve.

Copying and Pasting

Effects can also be copied and pasted from one clip to another. There are actually three ways to do this, each of which gives you different control options. The first way is the simplest.

1. Select the first clip, with the two effects applied to it, and copy it (**Command-C**).
2. Select the second and third clips in the Timeline and use **Edit> Paste Effects** or the keyboard shortcut **Option-Command-V** to paste the same effects with the same settings to those clips.

For more control you can use the Paste Attributes function.

1. Undo the last action with **Command-Z** to remove the effects applied to the second and third clips.
2. Just to be sure, select the first clip and copy it.
3. Select the second and third clips in the Timeline and use **Edit> Paste Attributes** or the keyboard shortcut **Shift-Command-V** to bring up the Paste Attributes dialog (see Figure 9.3).
4. With the two effects checked on, click the **Paste** button.

Figure 9.3 Paste Attributes

These two functions allow immediate copying and pasting of effects, but you sometimes might want to save a custom preset of effects for use later. If a clip has effects applied, at the bottom of the Video and Audio inspectors are **Save Effects Preset** buttons. This brings up the dialog in Figure 9.4. Here you can select the effects and other attributes you want to save, assign a name, pick the effect category you want to save it in, or create a new category that will appear in the Effects Browser under either the Video or Audio sections. Notice at the bottom of the dialog the two selections for keyframe handling, either to maintain the timing or to stretch to the length of the clip the effect is being applied to.

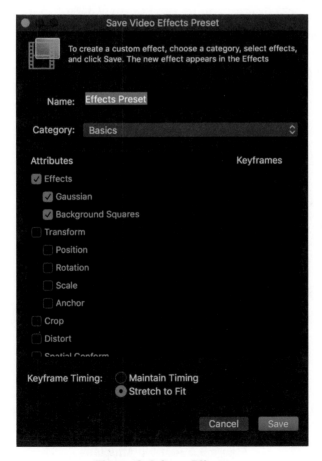

Figure 9.4 Save Effects

Removing Effects

Effects can also be removed equally simply. If you which to remove all the applied effects from a selected clip or clips, you can use **Edit>Remove Effects**, which is the reverse of the Paste Effects functions. The keyboard shortcut for this is **Option-Command-X**.

For more control of effects and other parameters, like Paste Attributes, you can use **E**dit>**Remove Attributes**.

1. Select the clips with the pasted effects and use the **Edit** menu or the shortcut **Shift-Command-X**.

2. In the dialog that appears you can select the effects or other parameters you which to delete (see Figure 9.5). The Transform and other parameters can be reset to their default state.

3. Let's leave the effects there and Cancel the dialog.

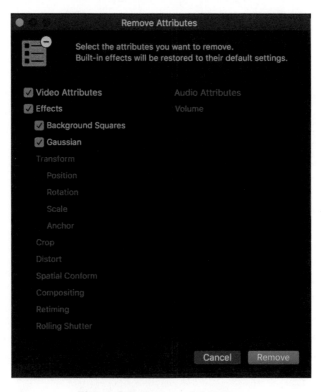

Figure 9.5 Remove Attributes

Animating Effects

Many effect values can be animated just like audio parameters by adding keyframes so they can be altered over time. Let's do a simple animation of the blur value on the second clip in the Timeline. There are two ways to do this, either entirely in the Inspector or in the Timeline; we'll do both starting with the Video inspector.

1. Make sure that the playhead is at the beginning of the second clip and is over the clip so it's targeted by the black spot. You can also select it if you wish, but it's not necessary.

2. In the Video inspector move the Gaussian Amount down to zero.

3. To the right of the slider and the value box is a diamond button with a plus. Click it so that the diamond turns gray and remains visible, indicating a keyframe has been added (see Figure 9.6). You can also use the triangle popup menu opposite Gaussian to add a keyframe to all the parameters.

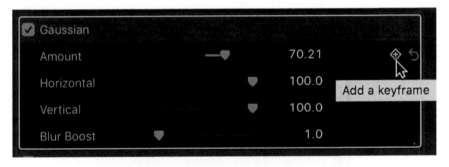

Figure 9.6 Adding Keyframe

4. Move the playhead forward one second in the Timeline and drag the Amount slider up to 70, or type that number in the value box. Another keyframe will automatically be added, and the clip will now become blurry over its first second. An arrow button also appears, allowing you to jump back to the previous keyframe.

5. Move forward one more second into the Timeline and click the Amount keyframe button to add another keyframe. If you don't change the value, the effect will remain blurry for that one second.

6. Now go forward one more second and drag the Amount slider down to zero. The clip will now get blurry over one second, stay blurry for one second, and then go back to being clear.

Let's do a similar animation to the first clip in the Timeline, but we'll do it entirely using the Timeline controls.

1. Select the first clip in the Timeline and press **Control-V** to open the Video Animations control.

2. With the controls open double-click Gaussian Amount to reveal the keyframe graph (see Figure 9.7).

3. Before we do the animation go to the Video inspector and click the hooked rest arrow opposite Amount in the Gaussian effect.

4. In the Timeline Video Animation graph drag the Amount line all the way down to the bottom to zero.

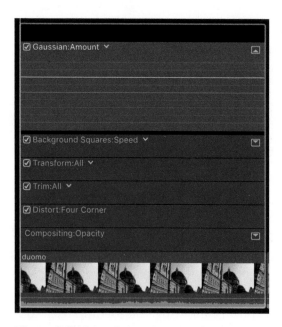

Figure 9.7 Video Animations Keyframe Graph

5. Hold the **Option** key and click on the line right at the start to add a keyframe. Zooming into the Timeline will make it easier.

6. Move the playhead forward about 15 frames and make sure Snapping is turned on with the **N** key.

7. Put the pointer on the line and holding the **Option** key click on the line to add a keyframe diamond.

8. Drag the diamond keyframe up in the graph to about 70 (see Figure 9.8).

9. Move forward another 15 frames then **Option** click on the line to add another keyframe to the Timeline.

10. Move forward 15 frames again, **Option** click a fourth time to add another keyframe.

11. Drag the first keyframe at the beginning and the fourth keyframe down to zero to complete the animation.

12. Close the Video Animation popup with **Control-V** or the **X** button in the upper left corner.

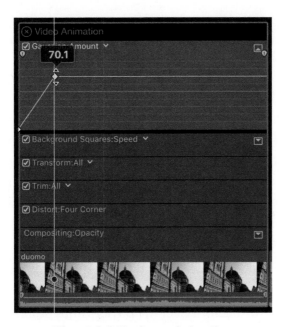

Figure 9.8 Keyframe Animation

Many effects have parameters like these that can be animated. If you ever get into trouble with your effects, it's often simplest to reset them in the Video inspector. There's a popup at the end of every control that lets you reset it, and there's an overall reset button for each effect, as well as an overall reset button for all applied effects (see Figure 9.9).

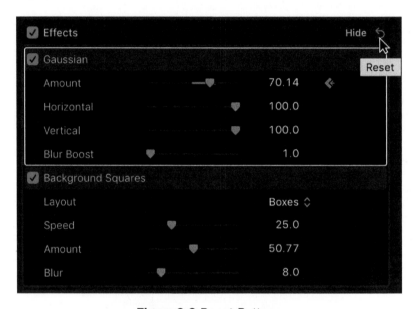

Figure 9.9 Reset Buttons

Animating Masks

Effects in FCP have two kinds of masks that allow you to constrict the area that the effect is applied to. There are Shape Masks and Color Masks and both are animatable. Both can be animated either in the Inspector or in the Timeline as we did above. Let's look at applying masks first, and then we'll see how to animate the mask in the Video inspector.

1. Make sure that the playhead is at the beginning of the second clip and is over the clip so it's targeted by the black ball.

2. In the Video inspector select the **Background Squares** effect and press the **Delete** key to remove it.

3. Open the **Gaussian** triangle popup to select **Reset Parameter**. The Amount will move to the default 50.

4. You can add a mask either from the Mask button opposite Gaussian, or from the triangle popup at the right end (see Figure 9.10). Select **Shape Mask**.

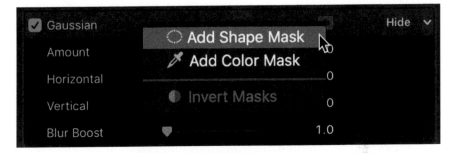

Figure 9.10 Adding Effect Masks

5. From the same button or popup select **Invert Mask**. The inside of the mask is now clear and area around it is blurred. The mask controls are in the Viewer (see Figure 9.11).

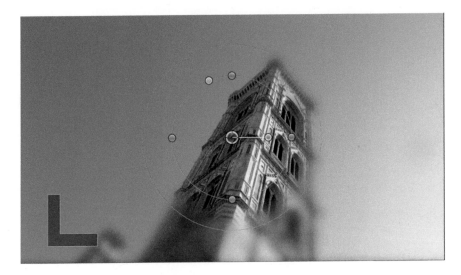

Figure 9.11 Mask Controls

6. The outer ring controls how quickly the blur falls off. Pull it in so blur transitions pretty quickly, but not a sharp line.

7. You can drag anywhere in the mask or with the center button to position it. Move the mask so it's centered on the upper floor window on the right side of the tower.

8. Pull in one of the green buttons on the side of the mask to tighten it, and use the stalk sticking out of the center button to rotate the mask.

9. To the left of the top green button is a gray button that lets you make the mask more rectangular. Pull the button out so the mask looks something like the mask in Figure 9.12.

That's how you set up the mask. It's really quite quick and easy to do. Now to animate it. The camera moves in the shot, and the position

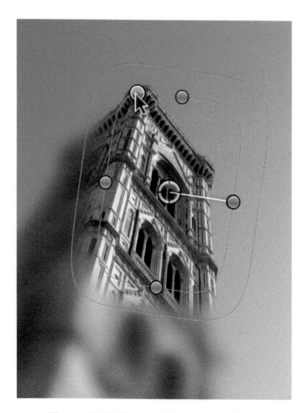

Figure 9.12 Rounded Rectangle Mask

of the tower changes. To animate the mask it would be no more than a few clicks to do using a tracking tool like CoreMelt's TrackX, but if you don't have that, it's relatively easy to animate the mask as you step through the shot.

1. Move the playhead over the second clip to about 4:08, where the motion begins, making sure that the clip is targeted with the black ball.

2. You can add a mask keyframe in three places. First, using the popup opposite the Gaussian effect as in Figure 9.13. There is also a similar popup opposite the Shape Mask in the inspector, or the diamond button opposite the Shape Mask that turns solid when a keyframe is applied. The difference is when using the first method, all the Gaussian parameters are keyframed not only the Shape Mask parameter; when using the second two only the Shape Mask is keyframed.

3. Move forward to about 5:05 and adjust the position of the mask so the center follows the window, and rotate the mask so it

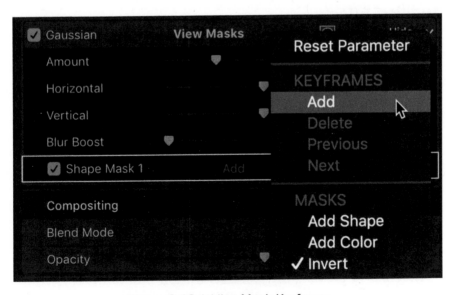

Figure 9.13 Adding Mask Keyframe

matches the angle of the tower. The fewer keyframes you have to add in the animation, generally the smoother it is.

4. Go forward to about 6:02 and reposition the center point again and adjust the angle.

5. Step forward to about 7:00 and adjust the center again. Click off the Shape Mask in the Inspector so the controls disappear in the Viewer and play your animation make. It should move smoothly as the tower changes position. To get the Shape Mask controls back in the Viewer, click the dotted circle button opposite Shape Mask.

The process of animating masks in the Timeline using the Video Animation HUD is done exactly as we did in the previous section.

> **TIP**
>
> **Removing Masks:** To delete a mask, select it under the effect it controls and press **Delete**.

Audition Effects

We looked at the Audition function in earlier lessons. Auditioning is most commonly used with the Replace edit function, but it is also a great tool for trying out different effects as well as different settings of the same effect. Let's apply an effect and make some variations to try out.

1. Select the fourth clip in the project, the first use of *posing with doors* and in the Effects Browser go to the Color category.

2. Find **Colorize** and double-click it to apply it. The effect in its default settings maps white to bright red.

3. You can duplicate the clip as an Audition, either by using **Clip>Audition>Duplicate as Audition** or **Duplicate from Original,** or pressing the shortcuts **Option-Y** or **Shift-Command-Y**. In this case use **Duplicate as Audition,** which

creates a new copy of the treated clip. Using **Duplicate from Original** creates a new copy in the Audition container of the untreated clip.

4. The Video inspector will now display a copy. Use the Remap Black control to change the color from a deep red to a deep blue, creating a duotone effect.

5. Click open the Audition HUD with the badge in the upper left corner or with the **Y** key.

6. Click the **Duplicate** button to duplicate the copy. This time change the white to a bright yellow-orange, giving you three available options in the Audition HUD to choose from as in Figure 9.14.

This is a very powerful tool for trying out different effects in the Timeline and storing them for possible use.

Figure 9.14 Effects Audition HUD

Keying

We're not going to go through all the effects in FCP, there are far
too many of them, but I do want to show you the **Keyer** controllers.
Keying is used to selectively cut out areas of the image. The most
efficient way to do this is chromakeying, the technique of removing
one specific color from an image. The two most commonly used
colors for chromakeying are blue and green, green more than blue.
On the other hand, if your subject has to wear green for St. Patrick's
Day, you'll have to use blue.

The key to keying is to shoot it well. Poorly shot material just will
not key really well. For chromakeying, the background blue or green
screen must be evenly lit and correctly exposed so that the color is
as pure as possible. Video has many limitations of color depth and
saturation that make good keying difficult. An example of a
poorly lit and difficult to key shot can be found in the *Effects*
event called *green screen*. There are folds in the green fabric that
make the lighting uneven, yet FCP's **Keyer** effect can handle it
quite well.

1. In the *Effects* event find the *duomo* shot and Append it into the
 Timeline.
2. Put the pointer over the shot in the Timeline and press the **X** key
 to mark a range selection in the Timeline.
3. In the *Effects* event find the shot called *green screen* and use
 Shift-Q to backtime the connection to the primary storyline.
4. Select the *green screen* shot in the Timeline and find the **Keyer**
 effect in the Keying category.
5. Double-click the Keyer effect to apply it.

Try playing the clip in Full Screen (**Shift-Command-F**). It's
remarkable how good a key it automatically creates, but you can still
see the folds in the fabric.

To see this better, click the three little buttons next to the View
control that changes from Composite to Matte to Original. The

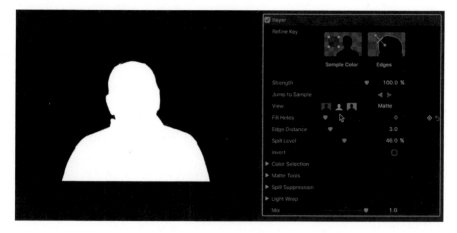

Figure 9.15 Keyer Matte View and Controls

Matte view (see Figure 9.15) gives a black and white representation of the matte, what's being keyed out displayed as luminance values. What's white is opaque and what's black is transparent.

Although the automatic key is a great way to start, let's see how to manually set the Keyer.

1. Begin by resetting the Keyer with the hooked arrow button and pulling the **Strength** slider down to zero.

2. Opposite **Refine Key** click the **Sample Color** button.

3. Drag a selection with the tool in the green portion of the image.

4. Switch the **View** to the Matte display.

5. Using the **Sample Color** tool again, draw a rectangle through any area in the background that's showing white.

6. Click back on the first button in **View** to see the Composite image.

7. Use the **Edges** button to refine the edges of the foreground subject. This is especially useful on images with a lot of motion blur.

8. With the Matte button active, move through the clip and select further Sample Colors at different frames.

This is a very complex and changing image. To do it properly across its entire length requires sampling multiple portions of multiple

frames over the course of the shot. Notice the **Jump to Sample** button. You can take sample colors in different frames, and this allows you to quickly move between the frames.

Fill Holes is a handy tool if you have small portions of the keying color isolated inside the foreground.

Edge Distance fine-tunes the image when there are wispy edges like hair that are being cut off.

Spill Level is important if the green from the background is spilling onto the subject. It adds magenta into the image to help counteract any green cast.

Twirl open the **Color Selection** area that has advanced chromakeying tools to improve color sampling and edge quality. In addition to the color wheel, where you can drag the lines to adjust the color selection if necessary, there are also separate luma controls below it and sliders to control roll-off (see Figure 9.16).

Figure 9.16 Color Selection

The Color Wheel graph allows you to select the core color of your key, and using the angle controls allows you to adjust the edge transparency. You can use the Color Wheel separately to select your color or in conjunction with the original tool set. The Color Wheel has two modes: the default, **Scrub Boxes**, which lets you adjust the limits of the color selection; and the **Manual** button, which gives you precise control of the core color selection.

> **TIP**
>
> **Zoom into Color Selection:** You can zoom into the Color Selection wheel for more precise control by holding the **Z** key and dragging across it. **Shift-Z** will reset it to the normal size.

Together with the Color Selection tool you also have **Matte Tools**, which allow you to adjust the selected area (see Figure 9.17). The key controls here are the **Shrink/Expand** slider and the **Erode** slider

Figure 9.17 Keyer Matte Controls

at the bottom. These allow you to adjust the edges of the matte, tightening it or expanded if need be. **Soften** blurs the edges of the matte which can be very useful.

Spill Suppression lets you knock down reflected light from the screen that falls on the subject. The **Spill Levels** slider above the Color Selection wheel is on by default and set to 46%. You adjust the amount of spill suppression with the **Spill Levels** slider, while the suppression controls adjust the contrast and tint effect. By default a little magenta is applied to the image to counteract the green. You can adjust the color of the suppression with the **Tint** slider.

Light Wrap takes the background luminance from the underlying image and tries to adjust the edges of the foreground object to match that.

It takes a great deal of practice and skill to use these tools effectively, but they are very powerful additions to the Keyer.

Masks

We've seen how masks can be added to individual effects, but there is a separate Masks category that allows you to add different types of masks to an image, from an easy to use **Vignette** to **Shape Mask** and **Draw Mask**. Most of the masks use the basic controls we saw in the effect mask, however Draw Mask is different and allows for precise masking. Let's see how to use that.

1. Begin by selecting the *green screen* clip in the Timeline and deleting it. We'll put the mask on the *duomo* clip on the primary storyline.

2. Select the *duomo* clip and from the Masks category, double-click the **Draw Mask** effect or drag it onto the clip. In the lower left of the Viewer will appear **Click to Add a Control Point**.

3. Click to add the first point where the tower meets the building as in Figure 9.18.

4. Follow the line of the tower up and add another point just off the top of the screen, add another off the screen beyond the upper

Figure 9.18 Draw Mask Control Point

right corner, and the fourth off the screen beyond the lower right corner.

5. Add a fifth point where the building begins as in Figure 9.19.

6. Carefully add points around the small cupola. To create a curve, mouse down to make the point and drag out the point as in Figure 9.20. You can drag a point to move it. You can also **Option**-click on the line to add additional control points.

7. Work your way along the building until you meet up with the start point and click to close the mask (see Figure 9.21).

Figure 9.19 Fifth Control Point

Figure 9.20 Draw Mask Curve

Figure 9.21 Closing the Draw Mask

8. In the Effects controls in the Video inspector click the Invert Mask checkbox (see Figure 9.22).

This is one type of Draw Mask, which uses Bezier control points and which works best for this type of mask. You can change the mask type using the Shape Type popup (see Figure 9.23). You can also create Linear Masks, which is an easy way to create precise

Figure 9.22 Draw Mask Controls

Figure 9.23 Shape Types

linear shapes, especially by entering control point values in the list. The third type of mask is a B-Spline, which is great for creating organic mask shapes.

1. Add a second Draw Mask to the *duomo* clip and change the **Shape Type** to **B-Spline**.

2. Add control points to create a rectangular shape that will follow the line of the tower, and click the Invert Mask checkbox again.

3. Right click on the Control Points on the mask, giving you the options for changing now the Control Point is handled, from Linear to Smooth or Very Smooth.

4. Change them to create an egg shape as in Figure 9.24.

Figure 9.24 B-Spline Mask

You can spend a great deal of time tweaking any mask to get the exact shape, but what often helps is adding a little Feather and Falloff control to soften edges. Of course these also allow very soft-edged masks. Notice also the Fill Opacity control that can be used to create interesting effects, darkening an area of the screen perhaps where you want to overlay text and then fading the opacity back

up as the text ends. All of the properties, including the Control Points, are keyframeable. Remember the popup triangle at the end opposite Draw Mask allows you to add a global keyframe to all parameters, and a single keyframe button will keyframe all Control Points.

AUDIO EFFECTS

Many of the audio effects are the province of the serious audiophile, which I confess I am not. There are so many audio effects in part because of some redundancy between FCP effects, Logic effects, and Mac OS X effects, both of which have been ported to this application.

In the *FCPX8* Library Projects Smart Collection there is a project called *Audio* that we will use to apply some effects.

1. Select the *Audio* project in the Smart Collection and use **Command-D.**

2. Rename the duplicate something like *Audio Work* and double-click it to open it.

You can apply an audio effect just like you do a video effect. You can preview it by playing or skimming the effect in the Effect Browser. Let's look at some of the audio effects in FCP.

The **Distortion** category of effects includes such popular favorites as **Car Radio** and **Telephone.**

1. Select the last clip in the *Audio Work* project.

2. In the **Distortion** category of audio effects find **Telephone.**

3. Press play to preview the effect and hear the way the voice has been reduced to the narrow telephone frequency range.

4. To apply the effect, double-click it.

5. To access the Telephone controls go to the Audio inspector (see Figure 9.25). The Effects section is near the bottom and may be covered with the drawer for the Audio Configurations pane that can be pulled down out of the way.

Figure 9.25 Telephone Controls

6. Try different telephone types from the preset popup.

7. Click the Channel EQ and Compressor icons to bring up HUDs that show you what's being done to the audio, and give you even further control of the effect. Different presets will have different controls. **Smooth Analog,** for instance, uses Channel EQ, while **Cordless** voice enhance uses the AU Bandpass effect.

8. The Amount slider will adjust how strong the Telephone effect is. As you adjust the slider, notice how it alters the EQ and Compressor controls.

9. With the clip selected in the Timeline press the / (forward slash) key to play just the selection.

> **TIP**
>
> **Looped Selection Playback:** The easiest way to try different effects is to loop the playback so the sound keeps playing over and over. Toggle Looped Playback on and off with the shortcut **Command-L** and play a selection by pressing / (forward slash).

There is a huge number of powerful and varied distortion effects. From the Logic subgroup try the **Clip Distortion** effect, which itself has a great many distortion presets. In fact, all of the Logic effects have many presets. It will take you hours to try them all out. **Ringshifter** alone has three submenus of presets with a total of 30 effects. Have fun!

> **TIP**
>
> **Soloing:** If you have multiple layers of audio it's useful to Solo the audio. You can do this by clicking the Solo button next to Snapping in the upper right of the Timeline, or by pressing **Option-S** for soloing.

The **Echo** group has nine effects, all with a subtle difference in the tonal quality they apply, and many such as the Logic effects **Delay Designer** with many more presets for you to try and to adjust further with the Delay Designer HUD.

1. In the *audio* keyword collection find the jazz piece called *music*.

2. Append it to the project with the **E** key.

3. Select the music in the Timeline and press the **/** (forward slash) key to play a little of it.

4. Stop playback and select one of the Logic effects in the Echo category like **Delay Designer** or **Stereo Delay**.

5. Press the spacebar to hear the effect.

6. Double-click the effect to apply it and use the **/** (forward slash) key to play the music while you try different presets.

Some of the most used effects are in the EQ category. The category, as with most audio categories in FCP, is divided into three sections. The FCP section is basically handy presets for one of the available equalizers, usually **Fat EQ**, which gives the widest range of controls.

The Logic subgroup of EQs simply gives you direct access to **AutoFilter, Channel EQ, Fat EQ**, and **Linear Phase EQ** all set flat for you to adjust as desired. Personally, I like the frequency dragging controls of the Channel EQ HUD the best (see Figure 9.26). Channel EQ now comes with a huge number of great presets.

In the **Levels** category of effects, the Logic **Adaptive Limiter** at its default settings applies a little compression to the audio that's very useful. It has the overall effect of providing a little gain without increasing background noise. Because of this boost in the gain it

Figure 9.26 Channel EQ HUD

might be necessary to pull down the level a few decibels. On music such as the jazz piece in the project, try the Adaptive Limiter with the Add Density preset.

The **Modulation** category has mostly special effects for music such as **Tremolo, Flanger, Chorus,** and **Vibrato.** The Logic Tremolo is pretty extreme even in its default settings. You probably don't want to use any of these on voice, but they make some interesting sounds for music.

Spaces creates different types of room reverberation.

1. Select the *looking up* clip in the project and press / (forward slash) to play it.

2. Stop playback of the clip and in the **Spaces** group of audio effects click on **Cathedral.**

3. Press the spacebar to play the clip with the effect.

4. Try the **AUMatrixReverb.**

The best tool for creating room acoustics is Logic's **Space Designer**. In addition to having its own design HUD, it has a staggering number of presets (see Figure 9.27) for all types of large, medium, and small spaces, with different types of rooms and halls, from Michaelis Nave to Villa Bathroom, and everything in between.

Figure 9.27 Space Designer Presets

Strangely, in the **Voice** category most of the Final Cut effects are comic effects, like **Alien, Cartoon Animals, Robot,** and **Helium.** In special cases you might find **Disguised** useful.

One useful effect in the Logic group is **DeEsser** for voices that are too sibilant. **Vocal Transformer** has some interesting presets as well.

There's a lot to try, so take your time and play with the different effects. Try them with your own recordings and see what you can do to enhance them.

RETIMING

Retiming or speed effects aren't really effects in the true sense, but they're used as special effects, so I've included FCP's Retiming functions in this lesson.

Constant Speed Changes

Retiming can be accessed from either of two menus or in the Timeline itself. You can access Retiming using:

- The Retime menu in the Dashboard under the Viewer (see Figure 9.28)
- The **Retime** submenu in the **Modify** menu
- Or by selecting a clip in the Timeline and pressing **Command-R** for the retiming bar

To work with the Retiming tools we're going to use some of the winter clips from the previous lesson.

1. Start by closing the *FCPX8* library. Right-click on it and select **Close Library.**

2. If no library is open you can click the **Open Library** button and located the *FCPX7* library.

3. Find the *Retime* project in the *Snow* event and open it into the Timeline pane.

4. Select all the clips in the Timeline and from the Retime menu in the Dashboard under the Viewer select **Slow>50%.**

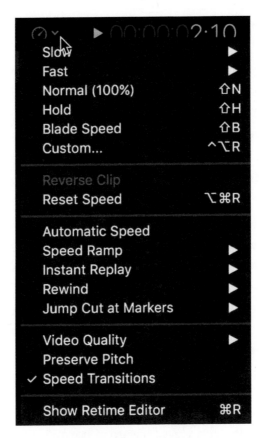

Figure 9.28 Retime Menu

All the shots will have been slowed down to half speed and will appear in the Timeline showing the orange retiming bar. You're not confined to the slow and fast speeds that appear in the Dashboard menu.

The Retiming bar acts very much like the Speed Editor in iMovie. Dragging the end allows you to shorten and lengthen the clip by making it slower or faster. To make the last shot in the project a bit faster grab the drag handle at the end of the Retiming bar and pull it to the left to speed up the clip. Pull it till the speed indicates 60% in the Retiming bar.

To make the clip play backwards, select it and from the Retiming menu select **Reverse Clip**. The Retiming bar in the Timeline will

have backwards arrow marks on it and the speed will be displayed as –60% in this case.

1. Select the middle clip in the project and use the Retime menu to reset its speed or press **Option-Command-R**.

2. Click on the disclosure triangle next to the speed in the Retiming bar and select **Fast>2x**.

The clip will be shortened, the Retiming bar will appear in blue, and the speed will be indicated as 200%, twice normal speed. There are other special retiming effects you can apply.

1. With the fast middle clip still selected from the Retime menu choose **Instant Replay>50%**. The clip plays twice, once at double speed and then again at normal speed, and you'll automatically have an Instant Replay title added.

2. Select the slow first clip and from the Retime menu choose **Rewind>2x**. The clip plays, rewinds at twice normal speed, and then plays again.

3. Select the first segment of the clip that's at half speed and click the disclosure triangle to choose **Normal (100%)** or click on the orange bar and press the shortcut **Shift-N** to reset that segment of the clip. Now the clip plays forward at normal speed, rewinds at double speed, and then plays forward in slow motion.

To reset all the clips back to normal so that we can look at other features, select them all and use **Option-Command-R**. Then press **Command-R** to close the Retiming bars in the Timeline. You'll probably want to remove the title as well.

> **NOTE**
>
> **Pitch Shifting:** You may have noticed that at the bottom of the Retime menu **Preserve Pitch** is checked on by default, which is probably what you want. Though the clips may change speed the audio is automatically adjusted and pitch shifted so it does not sound like Mickey Mouse when it's speeded up nor does it become deep and drawn out when slowed down. In fact voices are quite understandable when speeded up or slowed down.

Custom Speed Settings

From the Retime menu in the Dashboard you can select **Custom**, or from the popup in a clip's Retiming bar, or use the shortcut **Control-Option-R**. A dialog appears above the clip allowing you to set a specific speed percentage (see Figure 9.29).

Notice you have the option to ripple the project or not ripple the project. If you uncheck the default ripple, the clip will either be cut off if you slow it down, or, if you speed it up, the project will be filled with a gap clip to keep the project duration constant.

You can dial in a specific speed, or a specific duration. So if you want a clip to be four seconds, you can make the Duration four seconds, and the speed of the clip will be adjusted to accommodate that.

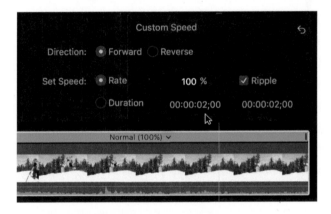

Figure 9.29 Custom Speed Control

> **NOTE**
>
> **Automatic Speed:** The **Automatic Speed** function in the Retime menu allows you to set the frame rate of a clip to its original frame rate regardless of the frame rate of a project. What this means in practice is that 120fps GoPro or iPhone media can be put in a standard 29.97fps project, have **Automatic Speed** applied to it, and become a very clean, slow motion shot. Using a high frame rate camera is really the best way to achieve good looking slow motion.

Speed Blade and Transitions

Another retiming feature is **Speed Transitions**. To apply these you will have to have separate speed segments so the speed isn't constant. You can do this by using the **Range Selection** tool (**R**) and dragging a selection. Then apply a different speed to the selected range. This will automatically apply Speed Transitions. Another way to create speed segments is to use the **Speed Blade** function.

1. Move the playhead over the first clip in the project and open the Retiming bar with **Command-R**.

2. Change the speed to 50% with the Retiming bar popup.

3. With the playhead at one second into the project press **Shift-B** to use the Speed Blade to split the Retiming bar.

4. Move forward to about 2:15 and press **Shift-B** again to cut the Retiming bar again, creating a separate speed segment.

5. Click the triangle popup in the middle speed segment and select **Custom**.

6. Click the **Duration** button to activate it and type in *200* for two seconds, leaving ripple checked on. The speed segment is lengthened and speed transitions added to ramp the speed down from 50 to 37 and then back up to 50% (see Figure 9.30).

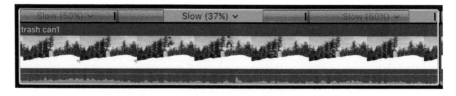

Figure 9.30 Speed Transitions

Speed Transitions are added to the clip by default to smooth the speed change. They can be switched off in the Dashboard's Retime menu. The handles in the Speed Transition that look like the Ripple tool can adjust the length of the transition (see Figure 9.31). A ripple

handle similar to that on a transition appears on the speed transition that allows you to shorten or lengthen the segment (see Figure 9.32).

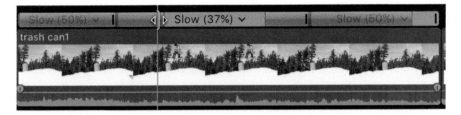

Figure 9.31 Adjusting Speed Transition

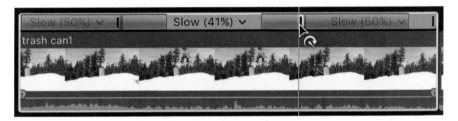

Figure 9.32 Rippling Speed Segment Duration

Retime to Fit

Another feature in FCP is the ability to use the Replace function and force a clip to change speed to match the duration, what's called **Retime to Fit.**

- In the *Snow* event find *Mike run 3 tables* and make a selection from about 4:20 to 7:00, about two seconds long

- Drag the selection onto the third clip in the project, hold till the clip goes white, and select **Replace with Retime to Fit**. Because the clip that was in the Timeline was about four and half seconds, the clip is slowed down to accommodate the length of the original clip in the Timeline

You don't have to replace a whole clip. You can mark selections in the Timeline, either inside a clip, or that bridges one or more clips, and use the **Retime to Fit** function to span the gap.

Speed Tools

We have seen the **Instant Replay** and **Rewind** features. FCP also has the ability to create speed ramps. These ramp the speed from zero to the set speed or ramp the speed down from the set speed to zero. You do this using the Speed Ramps:

1. Select the second clip, press **Command-R** to open the Retiming bar, and with the popup set the speed to **Slow>50%**.

2. From the Retime menu in the Dashboard, select **Speed Ramp> to 0%**. The clip is broken down into segments, each getting progressively slower over the course of the clip (see Figure 9.33).

Figure 9.33 Speed Ramp>0%

3. With the second clip selected, put the playhead right where the skier's hand touches the trash can. Then, from the Retime menu, select **Hold** or press **Shift-H**. A hold frame is created that's two seconds long. The clip plays in normal speed, stops, and then plays forward.

4. Drag the handle on the end of the red retiming bar for the hold segment to adjust the duration of the freeze.

5. In addition to the **Hold** frame you can also create a separate freeze frame. Click on the red Hold bar to select the hold area and press delete to remove it.

6. Use E**dit>Add Freeze Frame** or **Option-F** to cut a freeze frame into the Timeline.

Sometimes, rather than adjusting the duration of a clip and how a speed ramp occurs, you really need to adjust the speed transition based on a specific frame. Let's see how to do that.

1. Reset the speed of the last clip, *Mike run 3 tables*, back to normal speed using **Shift-N**.

2. Hold the **R** key and drag a range selection on the clip beginning just as the skier lifts off until he reaches the peak of his jump, about 27 frames. When you release the **R**, the pointer will return to the Select tool, or press **A**.

3. From the Retime menu, select **Slow>50%**. The middle segment is slowed down.

4. Drag out the end of the orange/gray transition segment in the Retiming bar to make the speed of the middle segment even slower.

5. Once you have the speed as you like it, double-click the orange/gray transition segment and, in the HUD that appears, you can click the **Edit** button for **Source Frame**.

6. A frame icon appears at the end of the segment (see Figure 9.34). Drag it to adjust the end frame. The speed of the segment doesn't change, but the last frame before speed resumes is altered.

Figure 9.34 Edit Source Frame

Another option you'll see in the Retime menu is the **Video Quality** submenu. You have three quality options: **Normal**, **Frame Blending**, and **Optical Flow**. Normal simply duplicates or discards frames as needed. Frame Blending creates intermediate whole frames as needed and generally should be used for slow motion effects. Optical Flow will produce the best results. It's based on analysis of the image content, calculating frames based on what's moving in the frame to create the smoothest motion. This should be used for extreme slow motion effects. This can be very slow to render, however.

> **TIP**
>
> **Connecting a Freeze Frame:** Sometimes you might want to use a freeze frame from the Browser in a project or use a frame from the Timeline elsewhere in the project. If you're starting in the Timeline, move the playhead to the frame you want and press **Shift-F** to match back to the same frame in the Browser. Then simply use **Edit>Connect Freeze Frame**, which uses the same shortcut as **Add Freeze Frame, Option-N**. The frame appears as a connected clip in the Timeline and can be moved to wherever you want to use it.

STABILIZATION

Stabilization is usually added to clips when they are in the project, which minimizes the amount of analysis the application has to do. You can however stabilize a whole clip in the Browser.

1. To analyze the clip in the Browser, you could select the *hand held trash can* clip in the *Snow* event and right-click to choose **Open Clip**.

2. Select the video portion in the Timeline and in the Video inspector click on **Stabilization** to have FCP begin analyzing the clip.

3. Once analysis is complete, you'll have three options for stabilization: **Automatic, InertiaCam,** and **SmoothCam** (see Figure 9.35). Try different options, as which works best is entirely dependent on the content. The **Tripod Mode** option will only appear if the image is already pretty stable and you want it to look locked off. It's not available with this media.

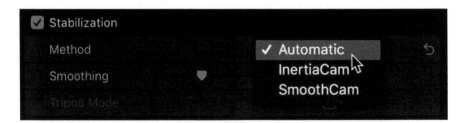

Figure 9.35 Stabilization Options

Timeline stabilization is done the same way, except you don't have to open the clip in the Timeline as it's already there. Every video clip has the Stabilization option in the Video inspector. It just has to be turned on.

SUMMARY

This is just the tip of the iceberg of some of the video and audio effects in FCP. I urge you to look through them and explore their capabilities for yourself. In addition to the Effects Browser content, we also looked at working with Retiming and with Stabilization. One important effect we haven't talked about is Color Correction, which we'll look at in the next lesson.

Color Correction

Color correction is perhaps the most important effect in FCP. Despite its simplicity, it's a powerful tool with professional features. In addition to this effect there are a number of third party color correction tools to further enhance your work, excellent tools such as Hawaiki Color and Color Finale Pro.

For this lesson we'll use the *FCPX8* library that we used in the previous lesson on effects. If you haven't downloaded the material you will need to get it from the eResources tab of the www.routledge.com/products/9781138209978 web page.

Before we get started let's make a new project to work with.

1. Use **Command-N** to make a new project, leave the default settings, and call it *Color.*

2. In the *fix* Keyword Collection in *Effects,* select all the clips and Append them into the Timeline. They will go into the project in the same order they are in the Browser.

COLOR CORRECTION

Good exposure and color begins in the shooting. It's always easier and better if you do it correctly from the beginning rather than trying to fix it in postproduction. That means lighting the scene well, exposing it correctly, setting your white balance correctly, and not leaving the camera's auto exposure and white balance to do the guessing.

While corrections in iMovie are pretty automatic, one click enhancements, FCP has some of those simple tools, but also advanced tools for maximum control of the image. One simple feature that's missing in FCP is an eyedropper white balance or flesh tone selection tool.

Video Scopes

To adjust your color you need to understand using FCP's Video Scopes to accurately assess the luminance and chrominance of your clips. You can access the scopes from the menus using **Window>Viewer Display>Show Video Scopes**; from the popup in the upper right of the Viewer, or with the keyboard shortcut **Command-7**. You can also switch to the Color & Effects Workspace from the **Workspaces** menu or use the shortcut **Shift-Control-2**.

The scopes have a number of different displays that can be selected from the appearance popup in the upper right corner of the scopes (see Figure 10.1). The primary scope for video is the

Figure 10.1 Selecting Scopes

Waveform, which is used to adjust the luminance levels. This is selected by choosing **Waveform** in the Scopes, and **Luma** under Channels. When using the Color & Effects Workspace the application opens four scopes into the pane. You can change the configuration and number of scopes in the View popup in the upper right (see Figure 10.2).

Figure 10.2 Video Scopes Configurations

Let's look at each of the scopes. Figure 10.3 shows the *silhouette* shot on the right and its waveform on the left. This is a representation of the luminance values in the image, displayed just as it is on the screen, reading across the image from left to right. The bottom of the trace is zero, which is black, while the top is 100. Notice the bright areas in the image exceed 100 units or IRE, which is common for

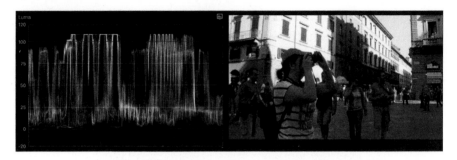

Figure 10.3 Waveform Monitor and Image

consumer cameras. Your target for peak white is 100, while zero is your target for pure black. You can see in the waveform the bright vertical sections in the trace that correspond to the bright areas of the wall behind the woman. The Waveform Monitor is your guide to setting your exposure and your video levels and is a critical tool in the color correction process.

With the Settings Display in the appearance popup still set to the Waveform, under Channels select **RGB Parade** (see Figure 10.4). This is an important tool for color balancing. It displays three separate views of the image showing the amounts of red, green,

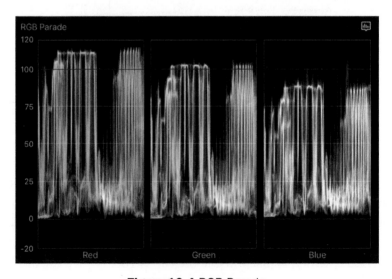

Figure 10.4 RGB Parade

and blue in the image. Ideally you want to have equal proportions of red, green, and blue in the shadow areas of your image, black being the absence of color. If the three colors are balanced in the shadow areas they are neutralized and the image shows no color cast in the shadows. This image has a slight elevation in the blue levels at the bottom of the display, slightly higher amounts of blue than of red and green, which is made worse if you apply the Balance Color function. On the bright end, you also try to balance the reds, greens, and blues so that equal quantities appear in the highlights, so that white is white and not some shade of a color. Similarly anything that's gray in the image should also show equal proportions of red, green, and blue.

Another scope often used by those familiar with working with still images is the **Histogram** (see Figure 10.5). This shows the percentages of different luminance and colors in the image. Pure black is zero and is on the left. Peak white is 100 and is on the right. Notice again the excess luminance values, and the large amounts of

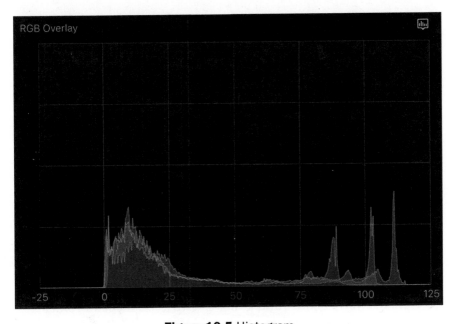

Figure 10.5 Histogram

red from the very bright walls. Apart from that, you can see from the Histogram that this image is fairly high contrast—large amounts in the low end of the scale and the high end, and not so much in the midtones. Figure 10.6 is the Histogram of the fourth shot in my project, the very dark *ms musician*. As you can see from the image and the Histogram, almost all of the luminance values and even most of the color values are to the left, and almost nothing is to the right of 50%.

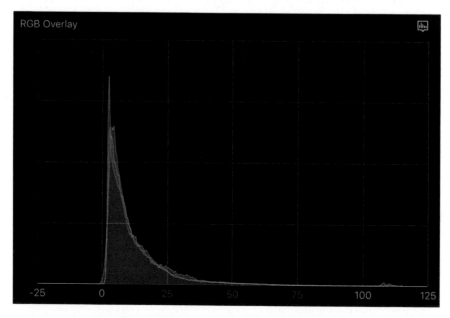

Figure 10.6 Histogram of Dark Image

The another important scope used in video is the **Vectorscope**, which displays the color values in the image. Figure 10.7 shows the Vectorscope display about half way through the *silhouette* clip. This is not a representation of the image at all, but a display of the amount of the different colors that are in the image. You can see a faint color wheel ringing the scope and the target boxes for pure colors that would be hit by a SMPTE color bar chart, starting with red, just to the right of twelve o'clock, and going clockwise to magenta, blue, cyan, green, and yellow. Notice the diagonal line that goes from

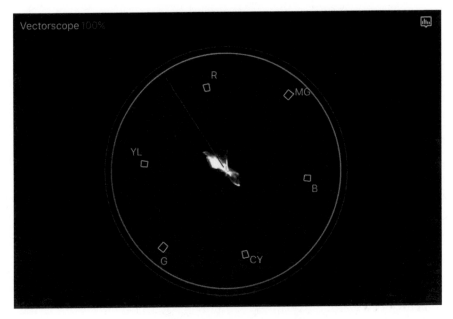

Vectorscope 100%

Figure 10.7 Vectorscope

the upper left to the center of the scope. This is the flesh line. Any human skin in the image, if lit by neutral light, correctly balanced, will fall on this line. If it doesn't, you have a color imbalance.

> **NOTE**
>
> **Multiple Scopes:** If you're working on a laptop it's usually easier to work with single scopes, switching between them as needed. If you have a large screen having the space to have multiple scopes open at once is great. An important reason to see multiple scopes is that, because FCP works in video using RGB, luminance changes will have some effect on the color, which is not the case if working in YUV color space.

> **TIP**
>
> **Zoom into Vectorscope:** You can right-click inside the Vectorscope to zoom into the display to make it easier to see the trace.

Range Check

Range Check is a feature introduced in the 10.3 upgrade of the application. What it does is display in the Viewer areas where there are luminance or chrominance values that exceed video standards. It displays diagonal striping over the offending areas of the image (see Figure 10.8). You activate it from the bottom of the View popup at the upper right of the Viewer. Notice you can choose between Luminance, Saturation, and Both. I find the striping a little annoying to leave on all the time, but it's a good final step to check through your video when it's ready for delivery. Turn it on and look through your shots to make sure everything is up to broadcast standard. Range Check will adjust based on whether your output specifications are Rec. 709 or Rec. 2020. It's interesting to switch between the two and see how much more tolerant the wide gamut specification is.

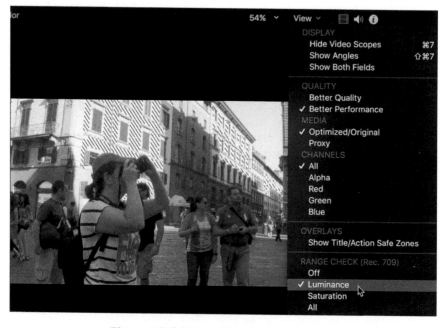

Figure 10.8 Range Check in the Viewer

Color Board

The primary tool for color correction in FCP is the **Color Board**, which is inside the **Color Correction** effect in the **Color** category. The quickest and simplest way to apply the effect is to put the playhead over the clip you want to adjust, make sure it's targeted with the black ball, and use the keyboard shortcut **Command-6**. This opens the Color Board in the Inspector (see Figure 10.9).

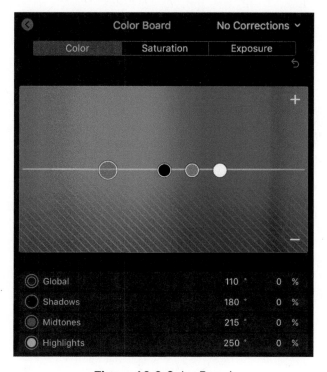

Figure 10.9 Color Board

The effect isn't applied yet. You can see No Corrections in the upper right, but as soon as you make a change, any change anywhere in the board, the Color Correction effect is added to the clip.

The Color Board has three tabs: the first that we see when we open the tool, is the **Color** tab; the second is the **Saturation** tab; and the third is the **Exposure** tab.

Usually you begin with the Exposure tab, setting your luminance values before you adjust the color. Exposure has four buttons or pucks, which can only move vertically (see 10.10). On the left, the larger puck controls the overall exposure of the image, raising

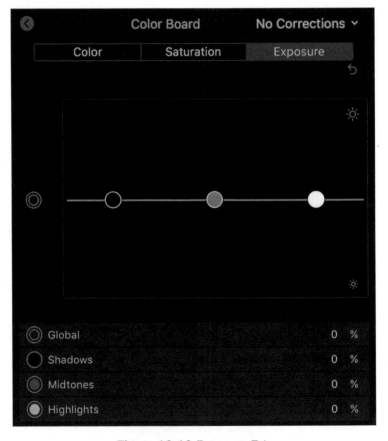

Figure 10.10 Exposure Tab

and lowering the brightness. Inside the Exposure board are three separate pucks to raise or lower the Shadows, Midtones, and Highlights. These are not sharply defined regions but ones that have considerable overlap.

The Saturation tab looks almost identical to Exposure and controls the amount of color in an image, whether it's colorful or washed out, or even black and white. Again there are four pucks—the large one on the left controls the overall saturation, while the three others control how much color there is in Shadows, Midtones, and Highlights.

The Color tab also has four controls. The larger puck adjusts the overall color in whatever hue you want. Here the pucks move not only vertically, but also horizontally. If you want to add more blue to the overall look of an image, you take the large puck, move it to the blue section of the Color Board and push it upward. Up will add more of a certain color, and down will remove a certain color. The three smaller pucks let you change the color values in specific luminance ranges, Shadows, Midtones, and Highlights.

Using the Color Board

If you watch television or go to the movies you know that color in video and film can be anything you want it to be. The only goal you should try to maintain is to make sure your images are within specification. Fortunately you have an effect, the Broadcast Safe effect, which makes this easy for you. We'll look at this shortly.

That said, let's start our color correction with the *cheese* shot. The order of clips in your project may be different from mine, where it's the second shot. Regardless, find the shot and target it with the playhead.

1. With the shot targeted press **Command-6**.

2. If they aren't open already, open your Video Scopes and switch to the Waveform set in Channels to Luma.

3. In the Color Board go to the Exposure tab.

4. The overall luminance levels of this shot are a bit compressed, nothing at zero, nothing at 100. Pull down the Shadows puck to bring the blacks down to zero.

5. Push the Highlights up a little to bring the whites to 100 IRE.

6. Push up the Midtones a little to brighten the look of the image and add a little pop to it. After you adjust the mids you'll probably have to adjust the Shadows and Highlights again.

The process of color correction is a constant ping-ponging of pushing and pulling, raising one value and pulling down another to offset it in some areas.

Let's switch to the Saturation tab and the Vectorscope. The saturation for the image is pretty good. I might just push up the overall chrominance level a little to give it a little more vibrancy.

And now we come to Color. Again the color isn't bad, except for a slight blue cast in the highlights and a little too much red in the shadows.

1. Switch the Color Board to the Color tab and switch your scopes to the RGB Parade in the Waveform.

2. Take the Shadows puck over the right side in the red and pull the red down a bit to even out the RGB values at the bottom of the parade.

3. Take the Highlights puck and put it to blue and pull it down a little, again bringing the RGB values closer in line.

4. Finally, to warm the image a little, take the Midtones puck over to yellow and push it up a little. The Color Board and the image might look something like Figure 10.11.

Notice that the upper right of the board says Correction 1. This is a handy popup if you have multiple corrections applied to a clip— you can switch between them here rather than going to the Video inspector. In the Video inspector you'll see that the Color Correction effect has been applied to the clip.

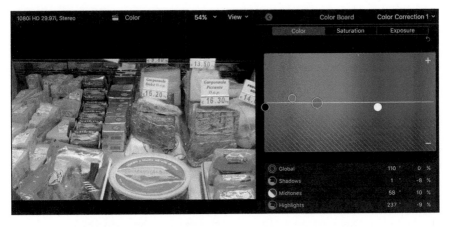

Figure 10.11 Corrected Color Board and Image

TIP

Nudging the Pucks: The pucks can be moved around the Color Board with the arrow keys. Select a puck and use the **left** or **right** arrow keys to move it horizontally, and the **up** or **down** arrow keys to move it vertically. This lets you move the puck with much greater precision than you can simply by dragging it.

At the bottom of the Color Board the display shows you the color values you're using, also indicating with the icon that Shadows are in negative red, Midtones in yellow, Highlights in negative blue, and Global is unchanged.

If you want to reset the Color tab, click the hooked arrow button in the upper right. There are separate resets for Color, Saturation, and Exposure. To see a before and after look, or to reset the entire Color Board, go back to the Video inspector with the triangle button in the upper left and use the reset button opposite Color Correction 1. To toggle a before and after click the blue checkbox next to the effect.

> **TIP**
>
> **Reset:** To reset a single puck such as the Shadows puck or any of the pucks, click on the puck to select it and press the **Delete** key. The puck will return to the mid line in its default position.

White Balance

Let's look at an image with the opposite problem, a white balance with too much yellow. We'll work with the clip called *statue dutch*, my last clip in the project. This shows a fairly common problem with consumer cameras. They often read a scene's color as either too warm or too cold. In this instance the camera made the image overly yellow, tinting the sky. Let's fix this using the Color Board.

1. With the playhead over the clip press **Command-6**.
2. Start in the Exposure tab of the Color Board. Using the Waveform displaying Luma as a guide, take down the Shadows a unit or two with the Down arrow, and the Highlights, so the white sky in the upper left of the scene is touching 100 IRE.
3. Push up the Midtones to brighten the shot to taste, probably 6–12%.
4. The shot is fairly weak in color, so using the Vectorscope as a guide, push the overall Saturation up about 20–25%.
5. Using the RGB Parade with the Color tab, watching the bottom of the three traces, move the Shadows puck to the left side and pull it down just a little to neutralize the blacks. I used 6°, and went to –4%. You can type the values in the boxes underneath the Color Board.
6. Move the Highlights puck to the left side to yellow-orange around 39° and pull it down a little to about –8%.
7. Finally warm up the mids with a little yellow, something like +2% at 52°.

There is no right way to fix this as long as you set your exposure correctly, neutralize the blacks, and take some of the yellow out of the sky.

Silhouette

Silhouettes can be very hard to deal with. Let's look at the *silhouette* clip in the project.

1. Put the playhead near the end of the clip when the woman is holding the camera to her eye and is pretty much in silhouette against the pale wall.
2. In the Exposure tab start by pulling down the Highlights so it peaks at 100.
3. Push up the Midtones quite a bit to bring out the detail in her face, anywhere from 20–35%.
4. This will bring up the Shadows a lot, so pull down the Shadows puck to bring down the blacks to zero.
5. In the Saturation tab push more color into the Mids and Highlights and take a little out of the Shadows.
6. In the Color tab pull the Global puck down in blue just a bit to take a little of the blue cast off the woman's arm and the walls.

> **TIP**
>
> **Applying a Filter to Multiple Clips:** If you have a correction set that you want to apply to a number of clips with the same name in the Timeline, such as for an interview that recurs in the project, set the filter for the first clip, and then copy it. In the Timeline, use **Command-F** just as in the Browser to search for all the clips with the same name. The Timeline Index opens for you to type in the name of the clip in the search box. This will filter all the clips in the Timeline with the same name. Select all the clips using **Edit>Paste Attributes (Shift-Command-V)** to paste the same settings to all the clips with the same name.

Night

Let's look at the night shots. These are especially difficult because of the extreme low light conditions. One of the problems, which really cannot be fixed, is that increasing the luminance levels will bring out a huge amount of grain. This can be improved to some degree by optimizing the media from the native AVCHD to ProRes. You can also improve this considerably with third party software like Photon Pro or Neat Video. Be warned: these are very processor intensive and very slow to render.

1. To optimize the media select the three night shots in the *fix* Keyword Collection and use **File>Transcode Media** or right-click on the selected clips and choose **Transcode Media**.
2. In the dialog that appears check **Create optimized media**.

As the material is converted to ProRes, the clips in the Timeline will be replaced with the ProRes files and used for the color correction. The grain will still be pretty bad, but with a little work you might be able to save shots that are otherwise unusable. Let's start with the *ms musician* clip in the Timeline.

1. With the Waveform Monitor open use **Command-6** and start in the Exposure tab by pushing the Highlights a little beyond 100 IRE.
2. Use the Midtones puck to push up exposure to about +25–33% to bring something back to the picture.
3. This will raise the Shadows, so pull the Shadows puck down to zero.
4. Generally night scenes are not heavily saturated and often have a slight bluish cast, a little colder than normal, so in the Color tab push the Highlights puck up about +20% right in the middle of pure blue.
5. Finally, take the Mids puck and put it right below the Highlights and pull it down just a bit, about –4%, to counter the highlight light and to take a little of the blue out of the musician's skin.

That's perhaps as good as can be salvaged without additional software. What would help it of course would be a better camera, with higher resolution, that did not exhibit the tremendous amount of grain introduced in the low light conditions.

Try your hand with color correcting the *night shot* clip. The Midtones are where most of the work needs to be done, but don't push it too much or the image will be muddy. It is night after all, so it's supposed to be dark. Use Broadcast Safe to clip off any excessive Highlights. In the Color tab, try to neutralize the greenish cast a bit, by bringing down the green in the Midtones, which reduces the saturation a bit, or by pushing in some magenta, which is the complementary color to green, the color opposite it on the Vectorscope.

> **TIP**
>
> **Optimizing Project Clips:** Often you will want to optimize only the clips you're working with in a project and not any unused clips. Rather than rooting out each clip individually, use the Browser Filter HUD to search for Used media. With the Browser showing only the media in the active project, you can select all the clips and optimize them. You can also make it a Smart Collection, call it *Used*, and put it in Library Smart Collections, so anytime you need to see the active media in a project inside the Browser simply select the *Used* Library Smart Collection.

Broadcast Safe

Broadcast Safe is an effect that should be added to the *ms musician* shot. It's used to clip off any high luminance levels that appear on a clip.

1. Click on the *ms musician* clip in the Timeline to select it, or put the pointer over it and press **C**, and open the Effects Browser with **Command-5**.

2. With All Video & Audio selected type *broad* in the search box at the bottom. The **Broadcast Safe** filter will appear.

3. Double-click it to apply the effect to the clip. If you have the Waveform open you'll see the bright street lights that are exceeding 100 IRE being rounded off by the filter to 100 IRE.

The Broadcast Safe effect can be something of a magic bullet and works well at the default setting. In the effect controls you'll see you have separate options for reducing the luminance, the most common usage, or reducing the saturation (see Figure 10.12). There is also a popup to select whether you're applying NTSC, North American standards, or PAL, European standards.

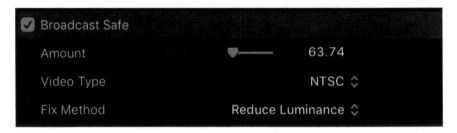

Figure 10.12 Broadcast Safe Controls

A common way to apply Broadcast Safe is to apply it globally to an entire project. You can select all the clips and double-click the filter to apply it to everything. This method is fine if you only need the default settings, but if you're working to PAL standards you'll need to make a Compound Clip.

1. Select all the clips in the project and press **Option-G** to convert them to a Compound Clip.
2. With the Compound Clip in the Timeline selected double-click the Broadcast Safe effect.
3. In the Video inspector you can set the Broadcast Safe controls as you need.

The effect will be applied globally to all the clips in the project. If you have the Waveform open and skim across the project you'll see that the bright night shots which we haven't corrected will also have their luminance values chopped off so as not to exceed 100 IRE.

Generally the process of converting the project to a Compound Clip and applying the Broadcast Safe effect is the very last step before you export or share your finished work.

Another way to apply Broadcast Safe or other global effects to a project is to use an Adjustment Layer on top of all your video. An Adjustment Layer is an empty container layer in your project, actually an empty title, which you can add effects to that will apply to everything underneath it. It's ideal for the Broadcast Safe effect. You can download an Adjustment Layer from my website at www.fcpxbook.com/tips/adjustment-layer.html and add it to your effects. Add the Adjustment Layer on top of all your video, but underneath your titles, and apply the Broadcast Safe effect to the Adjustment Layer.

Balance Color

FCP has automatic color balancing tools that can be activated in three different ways:

- Using the **Modify>Balance Color** selection in the menus
- Using the keyboard shortcut **Option-Command-B**
- Selecting **Balance Color** from the Enhancement (Magic Wand) menu in the Dashboard

When **Balance Color** is applied, the clip is automatically adjusted based on a mathematical formula. For some users this will be their one stop to color correction, and it will be good enough. If you are used to working with Sony cameras, the look it produces is probably acceptable. Their cameras tend to look like these results. For me this feature is a little desaturated, but more importantly it seems to have a bluish cast to it.

1. Move the playhead in the Timeline toward the end of the *silhouette with doors* clip and select the clip.
2. Press **Option-Command-B** or activate Balance Color however you prefer.

The arm of the woman holding the camera has for me a decidedly bluish cast to it. There should really be no blue in human flesh tones unless the light has a bluish tone, such as at dusk. Normally flesh

tones do not exhibit any blue. Also I find the color a little weak. That said, the tool is very good at making an instant correction of problem footage, but for most shots you would be well served to color correct your images manually. Not only will your video look great, but it's great fun to add special color looks and effects to your video.

Match Color

The **Match Color** function in FCP can be very useful. Sometimes it just seems to have almost magical properties, though sometimes it doesn't work as well as you might like. There are three ways to apply Match Color:

- From the menus select **Modify>Match Color**
- From the Enhancement menu in the Dashboard select **Match Color**
- Finally, by using the keyboard shortcut **Option-Command-M**

Match Color works very much like the Match Audio function we used in the earlier lesson.

1. If you have made the project into a Compound Clip to apply the Broadcast Safe effect, that's not a problem. Simply double-click the Compound Clip to open it into the Timeline.
2. Select the *ls duomo tilt* clip by **Option**-clicking on it. This selects the clip and also moves the playhead to it.
3. Activate Match Color in one of the three ways above.
4. A two-up display appears. The one on the right is the image you want to fix, on the left is whatever is underneath the skimmer.
5. I like the warmer tones of the *campanile dutch* shot. Move the skimmer over the clip and click on it. The Match Color effect will match the shot on the right to the shot on the left (see Figure 10.13).
6. Click on **Apply** in the dialog to apply the selection.

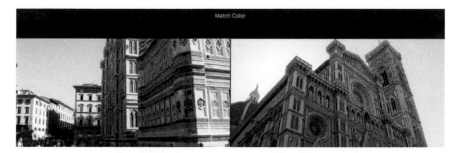

Figure 10.13 Match Color Display

For an even warmer look try the *silhouette with doors* shot. The effect is quite remarkable. Unlike the Broadcast Safe effect, the Match Color function is not so much of a magic bullet, and sometimes doesn't work that well.

Match Color is only selecting a specific frame to compare, so you might want to experiment by clicking in different sections of the shot, like beginning, middle, or end, for better matching values. Both Match Color and Balance Color are treated as effects, though they aren't in the Effects Browser. You can rearrange the order of the effects and move the Balance and Match effects before or after any other effects.

Unfortunately, the Match Color function, like Balance Color, does not actually use the Color Board to make the correction. It simply makes mathematical calculations and applies them based on which frame you click in the sampling clip, so nothing it does is reflected in the Color Board. It would be great if it did use the Color Board so the user could tweak the settings applied.

Looks

Looks in film and video are created by talented, creative colorists, who bring magic to the movies. Some looks, such as **Bleach Bypass** and **Orange & Teal**, have become popular to the point of cliché. There are quite a few effects that behave as looks in the **Looks** category of the Effects Browser. These are usually extreme effects like

X-Ray and **SciFi** and **Numerik.** In addition there are Looks available in the Color Board, and more importantly you can make and save your own. Let's see how this works.

1. You should be back inside the *Color* project with the single Compound Clip. As we're going to do more work on the project, let's break the Compound Clip apart. Select it and use **Clip>Break Apart Clip Items** or the keyboard shortcut **Shift-Command-G.**

2. Select the *silhouette with doors* shot and do a little basic correction to it in the Color Board starting in the Exposure tab.

3. Pull down the Highlights a little, say –5%.

4. Pull down the Shadows a little, about –1%.

5. Push up the Midtones about +10%

6. Increase the Global Saturation by +10%.

7. Increase the Global Color in yellow-orange in the image about 38° +5%.

8. After tweaking the image, go to the popup in the upper right of the Color Board and select Add Correction (see Figure 10.14).

Figure 10.14 Adding Second Correction

Color Correction 2 will be added beneath Color Correction 1 in the Video inspector. Generally the basic color correction for an image—setting its luma and chroma levels, and matching it to other clips—should be done in one grade or correction, and any additional special looks or secondary color corrections should be done in additional grades that can be tweaked separately and switched

on and off as needed. This also allows you to try different looks. Remember you also have the Audition feature that allows you to make duplicate copies of clips to which you can apply separate looks and grade effects.

1. To access existing Looks presets click on the Presets popup menu in the lower right of the Color Board for a list you can choose from (see Figure 10.15).

2. Select **Summer Sun**. It's a warm, bright, high contrast look.

Figure 10.15 Color Looks Presets

Like most of the presets it is very extreme. It's designed for all material so it uses extreme settings. All of them need to have their luminance levels fixed. The best way to fix it is to apply the Broadcast Safe effect, which clamps the levels without affecting the quality of the look across the central dynamic range of the shot. It works very well to rein in these extreme looks without ruining their effect, clamping both the high luminance values and the superblack below zero.

Notice in the Presets popup that in addition to the available presets you can create your own by pushing the pucks around and then using the **Save Preset** selection in the menu. You get to name your preset, and it appears in the preset menu. The presets are stored in your home library. In the Finder hold the **Option** key and use the **Go** menu. The custom presets are at ~/Library/ Application Support/ProApps/Color Presets. In the *ProApps* folder is also where Effects Presets, Export Presets, and Share Destinations are stored.

You can also get additional looks. Check out Denver Riddle's great Luster Grade presets at www.colorgradingcenteral.com.

SECONDARY CORRECTION

So far we've only done primary color correction, fixing the overall luma and chroma of an image, even adding looks that effect the whole image. Sometimes, however, you want to only correct part of an image—make the sky more blue, make the yellow more yellow, highlight an area of an image, like an actor's face, to make it pop. This is done on every shot in primetime television and in the movies.

Shape Mask

As we saw in the previous lesson, when applying an effect to a clip there are two ways to make a selection to restrict the effect using either a **Shape Mask** or a **Color Mask**. A Shape Mask is just

that—a shape we create that defines the area of our correction, while the Color Mask is a specific color range that we select that we want to affect. You can use multiple shapes and color masks on every image, but let's try just a few and look at how these masks work.

Shape Masks are usually areas that are greatly feathered to gently blend the effect into the rest of the image. We'll start with the *cs statue* clip in the *secondary* keyword collection.

1. Append the clip into the *Color* project. Let's do a basic grade to adjust its levels.

2. In the Exposure tab of the Color Board reduce the Shadows by –3 or 4%.

3. Reduce the Highlights –7 or 8%.

4. Increase the overall Saturation +20%.

5. Use the popup in the Color Board to add a second Color Correction.

6. Switch to the Video inspector and opposite Color Correction 2 click the mask button to select a Shape Mask.

As before, the on screen controls appear in the Viewer. The inner circle is the area that will be affected by your controls. The outer circle is the falloff from the control. You want to make the falloff so smooth that the enhancement effect is not noticeable. What we want to do is make a mask that allows us to brighten the statue while subduing the rest of the image so the statue is the focus of the attention.

1. Draw out the top of the circle so it's a tall, narrow oval, with plenty of falloff, and position it around the statue similar to Figure 10.16.

2. Use the right pointing arrow in Color Correction 2 to go to the Color Board and try these adjustments:

3. Push up the Exposures Midtones about +15%.

4. To increase the contrast, pull down the Shadows to –5%.

5. Increase the Highlights +6%.

Figure 10.16 Shape Mask

This alters the area inside the Shape Mask. By increasing the contrast and brightness, and if there was color in the image by increasing the saturation, you emphasize that part of the image.

To help the emphasis you want to darken the outside, reducing the contrast and the saturation to de-emphasize that area. Notice at the bottom of the Color Board two buttons, one for Inside Mask and the other for Outside Mask.

1. Click on Outside Mask. These are entirely separate controls, a completely separate Color Board from the one for Inside Mask.

2. To reduce the contrast we'll push up the blacks and pull down the whites.

3. Push Shadows up +5%.

4. Pull the Highlights down –5%.

5. Pull down the Midtones a lot to about –19%.

If the falloff is sufficient the brightening of the statue will be imperceptible, or at most the audience will think that a fortuitous shaft of light fell on the statue at that moment.

A commonly used technique with photographers is to use a graduated filter to reduce the brightness of the sky in the upper parts of an image, which can be overly harsh, drawing the viewer's eye to it rather than focusing on the subject. Let's do something similar to a portion of the *ws duomo* shot in the *secondary* keyword collection.

1. Select about the first four seconds of the *ws duomo* shot, before the camera pans left, and Append that into the Timeline. The cathedral is too bright in relation to the rest of the image.

2. Activate the Color Board and make a correction such as pulling down the Exposure Highlights.

3. Go to the Videos inspector and add the Shape Mask, dragging out a highly feathered horizontal rectangle as in Figure 10.17.

Figure 10.17 Large Horizontal Rectangle Shape Mask

4. In the Exposure tab pull down the Shadows just a little, down –12 or 14%.

5. The Highlights that you lowered already should be about –8 or 9%.

6. Pull down the Midtones to about –8 or 10%

A separate Shape Mask could be used to reduce the brightness of the sky and the building on the right side of the frame.

> **NOTE**
>
> **Animating Shapes:** As with the Shape Masks we used in the Effects lesson, these masks can also be keyframed and moved, which is useful if the image pans so the mask follows the point of interest.

Color Mask

Sometimes you don't want to adjust an area on the image; you want to adjust a color, or range of colors, make a color pop, or take out the color from everything else in the frame. Fixing the color itself is the easiest part of the process. The hard part is making the Color Mask and carefully selecting, adding to, subtracting from, and feathering the mask. For this we'll use the *duomo* clip from the *secondary* keyword collection. Append it into the storyline. What we want to do is to punch up the blue in the sky.

1. **Option**-click on the clip to select it and move the playhead over the clip.
2. From the Effects Browser **Color** category double-click the **Color Correction** effect.
3. Click on the Masks popup and select **Add Color Mask**.
4. Move the pointer over the Viewer where the pointer will change to an eyedropper. Click and drag a small area of the sky above the dome (see Figure 10.18).
5. Click the **View Masks** button on Color Correction 1 to see a black and white representation of the mask.
6. Even with the mask view on you can make a selection. Hold the **Shift** key and drag another selection of the sky to add it to the selection. Repeat until you have most of the sky selected, but none of the building.
7. If you select too much hold the **Option** key while dragging a selection to remove a color range from the selection.

Figure 10.18 Using the Eyedropper to Make a Color Mask

8. Use the Softness slider or the scroll wheel in the value box to adjust the feathering on the mask.

9. With the Color Mask selected, in the Color tab of the Color Board push the Highlights to a nice sky blue and raise them up.

10. Set Global to about 222° and +30–35%.

11. Set the Exposure Highlights down about –15%. This will reduce the pale area in the upper right of sky.

12. In the Outside set the Overall color puck up in yellow a percent or two to warm it up and help the contrast with the blue of the sky.

That's it. The pale blue has become the vibrant blue that the chamber of commerce always wants.

Using these tools I think you can see the great range of techniques that can be used and their power in shaping and controlling the way you use light and color in your productions.

SUMMARY

In this lesson we looked at the tools for color correction in FCP starting with working with the video scopes for manual correction

and using them to work with the controls in the Color Board. We saw how to white balance clips and to fix a number of common color correction problems. The Broadcast Safe effect was used to keep video from exceeding legal luminance levels. We used the automatic Balance Color function and the Match Color function to make two clips have the same color and tonal quality. We worked with the preset Looks to create special visual effects. Finally, we saw the power of FCP's multiple secondary correction tools, including the extraordinary control of shape and color masks. Next, we'll look at the transform functions in FCP and use their animation capabilities.

Animating Images

Final Cut Pro has considerable capabilities for animating images, allowing you to move them around the screen, resize, crop, rotate, and distort them at will. All of these properties can be animated, which allows you to enhance your productions and create exciting, interesting, and artistic scenes.

LOADING THE LESSON

One more time, let's begin by preparing the material that you'll need. For this lesson we'll use the *FCPX9* library. If you haven't downloaded the material you will need to get it from the eResources tab of the www.routledge.com/products/9781138209978 web page.

Start by opening the *FCPX9* library, which has an event called *Motion* and a project called *Motion*. Inside the event, you'll see the media we're going to work with. In this case they're entirely still images. We could use video clips, but for the purpose of this exercise, and to keep the library smaller, it's easier if the media is stills. We'll also be working with still images to create motion on the image.

Before we begin, let's duplicate the *Motion* project.

1. Select the project in the event or in the Library Smart Collection and use **Command-D** to duplicate it.
2. You can rename it to something like *Motion Work* to distinguish it from the original project.
3. Open the duplicate project.

TRANSFORM

FCP has three different functions for positioning and animating images, video or stills, around the screen. The three functions are **Transform**, **Crop**, and **Distort**. There are four ways to access these functions:

- The popup in the lower left of the Viewer in the Dashboard (see Figure 11.1)
- Right-clicking on the clip in the Viewer itself and selecting the function you want from the shortcut menu
- By using one of the keyboard shortcuts: **Shift-T** for Transform, **Shift-C** for Crop, and **Option-D** for Distort
- Or, by using the Transform, Crop, or Distort controls in the Video inspector when the clip is selected or targeted in the Timeline

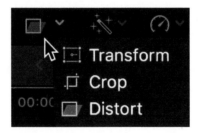

Figure 11.1 Transform Popup

The easiest way to use these functions is directly in the Viewer with some handy on screen controls. For precision you also have access to numeric controls in the Video inspector. Using the on screen controls together with the Inspector controls you can manipulate your images with precision and ease. Furthermore, all of these properties are animatable.

Scale

The first Transform function we'll look at is **Scale**.

1. Target the first image in the *Motion Work* project with the playhead and activate the Transform function by pressing **Shift-T**. The Transform popup becomes blue and the image is outlined in white with round, blue dots on the edges.

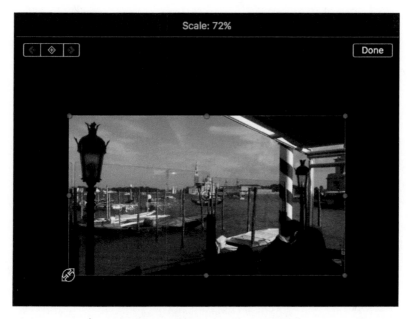

Figure 11.2 Scaling an Image

2. To Scale the image, grab a corner and drag (see Figure 11.2). The image scales proportionately around the center. Notice at the top of the Viewer the Scale percentage is displayed while you're dragging.

3. If you drag one of the sides, the image's aspect ratio will change, squeezing the image and distorting it (see Figure 11.3). This scales the image separately on the X axis and the Y axis.

4. If you hold the **Shift** key and drag a corner you can Scale on both the X and Y axes as you alter the aspect ratio. These numbers will be reflected at the top of the Viewer as well as in the Scale values in the Inspector (see Figure 11.4). You will probably have to expand the Transform section by clicking **Show** and twirling open the Scale values to see the X and Y changes.

5. If you hold the **Option** key and drag a corner you can Scale around any opposite corner, which remains pinned in its original position.

7. If you hold the **Option** key and drag a side handle the image will stretch or squeeze from the opposite edge, which remains pinned.

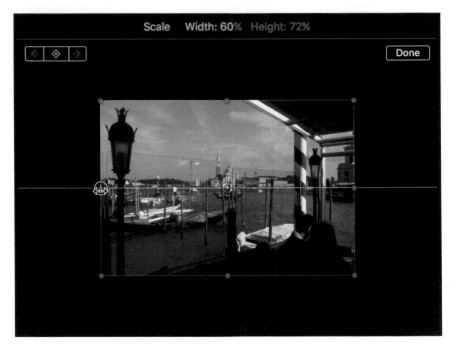

Figure 11.3 Changing the Aspect Ratio

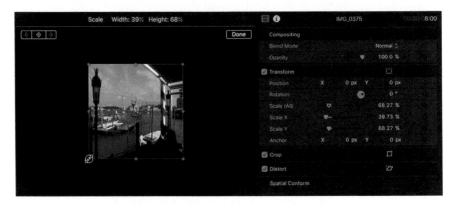

Figure 11.4 Scale Values in the Inspector

You can Scale an image larger than it is, but it's usually not a good idea to scale upward much above 110 to 115 percent. Higher than that and the image will start to soften and eventually show pixelization.

Although the sliders and value boxes in the Inspector give you precise control, the easiest way to Scale or control the other Transform parameters is in the Viewer.

> **TIP**
>
> **Controlling Values:** Remember if you double-click a value box to highlight it in the Inspector, you can use the scroll function on your mouse to increase or lower the value with precision while watching the change in the Viewer. If you don't like or have a scroll wheel mouse, you can simply drag up or down within a value box to scale or adjust other any parameter.

Rotation

Rotation is controlled in the Viewer with the wand sticking out from the Anchor Point or with a dial and value box in the Transform section of the Video inspector. There does not appear to be a limit to how many times you can rotate an image, which means if you animate the rotation value the image can keep on turning.

1. To rotate the image in the Viewer grab the handle and pull (see Figure 11.5). Notice the angle display at the top.

2. Hold the **Shift** key to force the rotation to snap to 45° increments.

The farther out you pull the handle, the easier it is to rotate with precision. With the handle close to the anchor point, which is in the center of the image, you can rotate very quickly.

Notice the dot on the right edge of the rotation circle. This indicates the last position of the image in its rotation. The first time you rotate a picture it indicates what's horizontal, but the next time you rotate the image it shows what its last angle was in the rotation circle. The information at the top of the screen displays not only the angle from horizontal, but the angular displacement from the previous position.

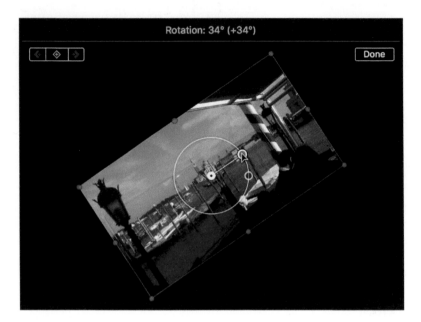

Figure 11.5 Rotating the Image

Position

You can change **Position** in the Viewer or with specific values for the X/Y coordinates in the Inspector. FCP counts the default center position, 0, 0, as the center of the screen and counts outward from there, minus X to the left, plus X to the right, minus Y downward, plus Y upward.

You can grab the image anywhere and drag it around the screen to position it, but if you drag it with the center Anchor Point the image will snap to yellow center guides as you drag it (see Figure 11.6). Again the X, Y coordinates appear at the top of the Viewer as you drag. More precise values appear in the Inspector.

> **TIP**
>
> **Precision Drag:** Hold the **Option** while dragging in any X or Y or Rotation value boxes in the Video inspector to change incrementally by 10ths or 100ths of a unit.

Figure 11.6 Positioning the Image

Anchor Point

Most people think of the **Anchor Point** as the center of the image. Though this is not strictly true, the default location for the Anchor Point is the center of the image. Think of the Anchor Point as the place on the image that everything moves around: the image scales to the Anchor Point; it rotates around the Anchor Point; and when you position the image you are repositioning its Anchor Point on the screen. Let's see what happens when you change the Anchor Point's location. First, we'll reset the Transform function.

1. To reset the image back to its default state click the hooked arrow opposite Transform in the Video inspector.

2. Double-click the X value of the Anchor Point in the Inspector and using the scroll on your mouse change it to –640, or type in that value, or mouse-drag within the X value boxes.

3. Change the Anchor Point Y value to 360. The Anchor Point is now in the upper left corner of the image, which should be off the lower right edge of the screen as in Figure 11.7. (See the Note on Pixel Values below.)

Figure 11.7 Changed Anchor Point

4. Grab the Anchor Button in the upper left corner of the image and drag it to the upper left corner of the Viewer so the alignment guides snap it to position (see Figure 11.8).

5. Double-click the Scale value in the Inspector and change the value to 75%. The image scales around the upper left corner.

6. The rotation handle is attached to the Anchor Point so it's also in the upper left. Pull it out and drag it downward. The image pivots around in the upper left corner of the screen as in Figure 11.9.

The Anchor Point is a powerful tool for animating images. The Anchor Point itself can be animated, which can create interesting image animations.

After you have finished working with the Transform function, or any of the other image manipulation functions, make a point of clicking the **Done** button in the upper right of the Viewer to close the function.

Figure 11.8 Positioning with Alignment Guides

Figure 11.9 Rotating Around the Anchor Point

> **NOTE**
>
> **Pixel Values:** The numbers given in steps 2 and 3 above are based on the pixel values of the image, 1280 x 720. If you have the FCP Editing preferences Inspector Units set to percentages rather than pixels, you should use values of X –88.9 and Y +50. I am not sure why there are discrepancies, but there seem to be. Generally I'd recommend using pixels rather than percentages.

CROP

The **Crop** function is really three functions in one. It lets you cut off the edges of the image, leaving it smaller in the screen; or you can cut off the edges of the image proportionally and leave it filling the frame; and, finally, you can change the image's size in the screen by animating the scale, the so-called Ken Burns effect that iMovie users are familiar with. Be careful with the last two functions as they act to scale up the image, which can make it look a bit blurry or even pixelated, especially if it has to be recompressed later for delivery on the web.

Trim

Let's leave the first image and work with the Crop tools on the second image *0748*.

1. Target the image with the playhead and press **Shift-C** to activate the Crop function, or use the popup in the lower left of the Viewer. The three separate Crop functions can be selected using the buttons that appear at the bottom of the Viewer (see Figure 11.10).

Figure 11.10 Crop Function Buttons

2. If it isn't selected already, click on the **Trim** function and notice the square corner tabs and the dotted line around the image.

3. To crop the image, drag a corner tab, or one of the side tabs to pull in the edges and crop off part of the image (see Figure 11.11). Notice the Crop values displayed at the top of the screen.

4. Once you've create a cropped area, you can drag the area around the screen to change the selection. The dragged selection will snap to the guides, which can be helpful.

5. To maintain the proportions of an image as you crop it, hold the **Shift** key. If you start holding the **Shift** key the crop selection will remain 16:9. If you make the selection square and then hold the **Shift** key the crop selection will remain square.

6. If you hold **Shift-Option** while dragging the corners of the image, it will be cropped proportionately on all sides.

You can also control the Crop function with precision use of the value boxes in the Crop section of the Video inspector. Here is where it can be really useful to switch Editing Preferences to Percentages.

Figure 11.11 Trimming the Image

This makes it easy to trim an exact value off each side, say 20% off top and bottom and 10% off left and right.

In the Crop section of the Inspector notice that you can also switch the crop type from Trim to Crop to Ken Burns using the Type popup.

The area outside the cropped selection normally appears as black, or emptiness, but it's often easier to see what's in the Viewer using either the checkerboard or white background from Playback Preferences. Regardless of what you set, the background is simply empty and will export as black or transparency. If you want the image to appear with a colored background you should use one of the Generators.

1. Select the image in the Timeline and use **Option-Command-Up** arrow to lift it out of the primary storyline so it's a connected clip.

2. Find the Generator you want to put underneath it, perhaps Underwater from the Backrgounds category, and drag it onto the Gap Clip in the storyline, hold and select **Replace from start** from the shortcut menu.

3. Click the **Done** button in the Viewer to finalize the Crop function.

Crop

The **Crop** tool, in the Crop function, works a little differently. For one thing, no matter how you drag it, the image is always cropped proportionately. It does this so that when you're finished cropping the image and click **Done,** the image will fill the screen.

Let's work on the third image in the project *0755.*

1. Activate Crop with **Shift-C** and select the middle of the three functions at the bottom of the Viewer. The image is now outlined not with a dotted line but with tabs in the corners to drag on the image.

2. Drag in the upper right corner to tighten the image, cropping a little from the right and the top of the taxi driver's cap.

3. Grab the selected area and drag it up so there is a little more headroom (see Figure 11.12).

4. Click **Done** and the image will fill the screen.

Figure 11.12 Cropping the Image

Remember this is scaling the image up so there will be some softening, so use this cautiously. As you drag notice the coordinates that appear and most importantly the Scale value that is displayed at the top of the Viewer. This is important so you don't scale much more than 115%.

This Crop function is a handy tool, though, if there's something on the edge of the frame that you need to cut out, like a microphone tangling into the shot.

You can also, if you wish, drag beyond the edges of the image, which will create empty space around the image. This is an excellent way to give the image some breathing room, and of course dragging it in this Crop function will create a proportionately equal amount of space around the whole image.

> **TIP**
>
> **Switching Off Alignment:** If, when dragging the crop selection, it sticks to the alignment guides, hold the **Command** key to override it.

Ken Burns

While the **Ken Burns** function does crop your image, it is primarily an automatic animation tool. It's used in many Apple applications, in iMovie of course, but also in Photos for slideshows and by the operating system to create small animations on screen saver images. The effect produces a zoom into or out of the image. The duration and speed of the zoom is controlled by the length of the clip. The animation takes the whole length of the clip, so a short clip will have fast zoom, while a long clip will have a slow zoom. Let's apply the Ken Burns effect to the fourth image in the sequence.

1. Target the last image *0778* and select Crop from the **Transform** popup or press **Shift-C** to activate the Crop function.

2. Click the third of the three buttons in the bottom of the Viewer, the **Ken Burns** button. The image will appear in the Viewer with two boxes marked (see Figure 11.13): the green start box on the outer edge of the image, and the red end box about 15% into the image.

Figure 11.13 Default Ken Burns Effect

3. At the upper left of the Viewer click the button with the two chasing arrows. This swaps start for end. The effect will now zoom out.

4. Press the play button next to the swap button to see the effect. It plays just the clip in looped playback mode. Press the spacebar to stop playback.

5. Because we swapped start for end, to adjust the start position you may need to move the end position box so you can access the start box underneath it. Push the red end box off to the left.

6. Make the green start box smaller by dragging the lower right corner inward and position the box so it's focused on the statue in the upper left.

7. Make the end box a little smaller and slide it back so the end position is approximately center on the image, similar to Figure 11.14. Notice the arrow that indicates the direction of the zoom motion.

8. Play the animation and click **Done** when you're finished.

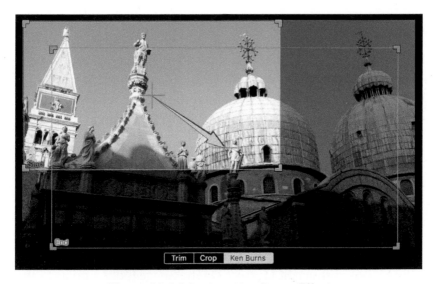

Figure 11.14 Custom Ken Burns Effect

Though you can zoom in further, especially if you're working with large format still images, for video that matches your frame size 15% is probably as far as you should go.

Notice that the motion has easing—it starts slowly and accelerates, and then decelerates as it comes to a stop. For shorter animations you might prefer to have a more punchy motion. You can select **Ease In**, **Ease Out**, or **Linear**, which has no easing on either end, by right-clicking anywhere in the image to access the shortcut menu (see Figure 11.15).

Figure 11.15 Easing Controls

Distort

The **Distort** function will let you skew an image almost as if you're twisting it in 3D space. It gives the image 3D perspective that can create interesting effects. Let's reset the second image in the sequence, *0748*, and we'll look at the Distort function on that.

1. If you had put a background underneath the image let's collapse it back into the primary storyline by selecting it and using **Option-Command-Down** arrow.

2. With the image selected click the Crop reset button in the Video inspector to reset it.

3. From the **Transform** popup in the Viewer select **Distort** or use the keyboard shortcut **Option-D**. The image looks similar to the Transform function, except the drag tabs are square instead of round.

4. Grab the upper right corner and start dragging it to distort the image (see Figure 11.16). Try pulling other corners or the center of an edge. The corners will display as displacement values in the Distort section of the Video inspector.

5. You can also drag the image to position it, though this is a Transform, but you do not need to switch to the Transform function to do it. The X, Y values will appear in the Position section under Transform.

6. Again when you're done, don't forget to click the **Done** button.

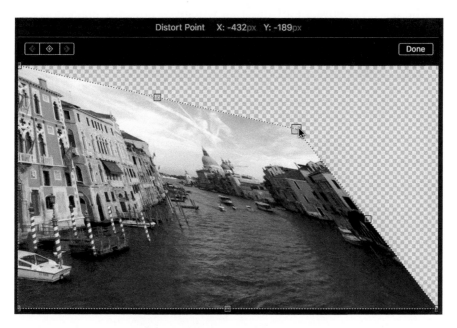

Figure 11.16 Distorting the Image

MOTION ANIMATION

Straight Motion

Final Cut Pro allows you to create many different types of animation for both motion and effects. Many of the parameters in the Inspector

can be animated including all the Transform functions. It's quite simple to make an animation. Let's do a straight motion animation.

It's easy to set a motion keyframe in FCP. You can either use the keyframe button in the Viewer, or keyframe the parameters in the Inspector. Let's work on the last image, *0078*.

1. Begin by resetting the image parameters by clicking the reset buttons in the Video inspector.

2. Next set the duration of the image. Select it, press **Control-D**, and type *500* and *Enter* to make it five seconds long.

3. In the Viewer go to the Zoom pop-up menu and set it to display the screen at 50%, or a value that will give you some black space around the edge of the screen.

4. Using the Scale section under Transform in the Video inspector, set the **Scale (All)** value for the image down to 50%. If you prefer you can switch on Transform in the Viewer and drag the corner of the image so it's 50%.

5. With the Transform function activated, **Shift-T**, drag the image so it's in the top left hand corner of the screen as in Figure 11.17.

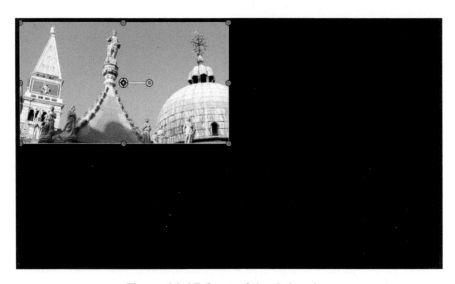

Figure 11.17 Start of the Animation

6. To move the playhead so it's one second after the beginning of the clip put the playhead at the beginning, press **Control-P** and type *+1.* (that's plus one period) and press **Enter**, to move the playhead forward.

7. Click the keyframe button in the upper left of the Viewer. This sets a global keyframe at the point for all the Transform values, Position, Rotation, Scale, and Anchor Point.

8. Go to the point one second before the end of the clip in the Timeline.

8. Change the Scale value to 75% and drag the image across the screen so it's in the lower right corner of the screen as in Figure 11.18.

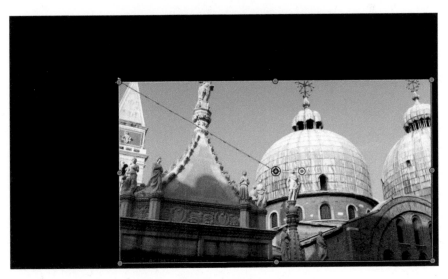

Figure 11.18 End of the Animation

Notice two things: one, the red dashed line that appears on the screen indicating the motion path; and, two, the keyframe button indicating that another keyframe has been added automatically. The other thing you may notice as you play the animation is that it has *easing*. This is the default behavior for all Position animations in FCPX. Scale

animations do not have easing, unfortunately, nor is it possible to apply easing. To change the easing options for the Position animation, right-click on one of the keyframes in the Viewer and you'll see options available in the shortcut menu (see Figure 11.19). The default is Smooth, or you can select Linear. Notice the other options to delete a point, or to lock a point, which is useful when you want to hold a position point. To delete a keyframe you can, in addition to the shortcut menu, go to keyframe with the arrow buttons next to the keyframe and then click the keyframe to remove it.

Figure 11.19 Keyframe Shortcut Menu

That's it; you've created your first motion animation with keyframes. The possibilities are endless. To see what you can do with these tools, watch the opening titles for most any television shows and see how motion graphics animations can be used to enhance your work.

If you want to move the keyframes to speed up or slow down the animation, it's easiest to do in the Video Animation controls (**Control-V**) in the Timeline. Select the parameter whose keyframes you want to alter (see Figure 11.20), and then drag the keyframes farther apart or closer together. Here all the transforms are being dragged together, in this case both Position and Scale. To move them separately, select the keyframed parameter, by clicking on the triangle. You can also add additional keyframes by **Option**-clicking on the animation line.

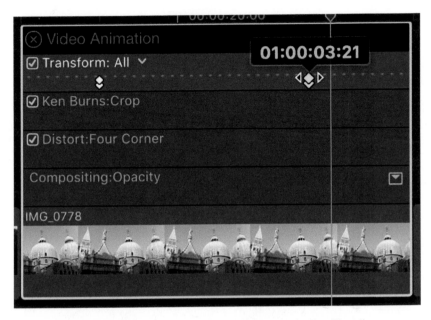

Figure 11.20 Video Animation Keyframes in the Timeline

TIP

Changing Duration: You can also change the duration of a clip by selecting it (or multiple clips) and then double-clicking the timecode in the Dashboard. This will change the display to a duration value, and you can type in the length you want.

Curved Motion

You can create a curved path in two ways: one, add a keyframe to the linear motion; or, two, create a curved path by simply using Bezier handles on the end keyframes.

You can add a keyframe by **Option**-clicking on the motion path, or by right-clicking on the path and selecting **Add Keyframe**. When you click on a keyframe in the Viewer, the object moves to that keyframe, so when you **Option**-click to add a keyframe, the object leaps to the new keyframe. Let's add a keyframe to the motion path we created.

1. First, move the playhead back near the beginning of the *0778* clip so you can more clearly see the motion path.

2. Using either method, **Option**-clicking or right-clicking on the path, add a new keyframe about half way along the path.

3. Drag out the new keyframe to create a curved path (see Figure 11.21). Notice the Bezier handles that stick out from the keyframe, allowing you to control the curve.

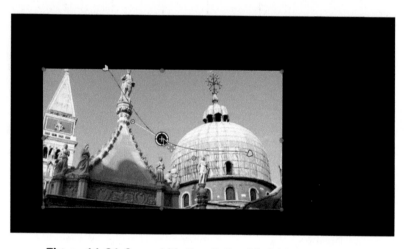

Figure 11.21 Curved Motion Path with Added Keyframe

There are Bezier handles on the end keyframes as well, but they are normally hidden. Let's use the second method of creating the motion, which doesn't create an intermediate keyframe, but uses only the end keyframe handles.

1. Use **Command-Z** to Undo as many times as you need to return to the original motion path without the added keyframe.

2. Move the playhead in the Timeline so that you can easily see the keyframes on the ends of the motion path.

3. Click on the keyframe at one end of the motion path, and the image will leap to that keyframe.

4. To make it easier to see the Bezier handle move the playhead so the image moves away from the keyframe.

5. Drag out the Bezier handle attached to the end keyframe to curve the motion path.

6. Click on the keyframe on the other end of the motion path and repeat the process to bend the curve further (see Figure 11.22).

Figure 11.22 Using Bezier Handles

You can also use this method to create an S-curve path by dragging the Bezier handles in opposite directions. Generally you'll get a smoother motion on most motion paths using the two end handles rather than an intermediate keyframe.

> **NOTE**
>
> **Playback Quality:** Most experienced FCP users usually work with FCP's background rendering switched off. Because you're then playing back unrendered material, playback quality is compromised. The images look great when playback is paused, but not so much while you're playing your animation. To see full quality make sure the Viewer's View options in the upper right corner are set to **Better Quality** and that the media has been rendered.

> **TIP**
>
> **Starting Off-Screen:** If your animation starts off the screen, generally you set the offscreen keyframe to Linear so the image arrives on the screen already at full motion and doesn't appear to accelerate as it comes on. Unfortunately if you change a keyframe to Linear it no longer has a Bezier handle, and any curved motion path has to be created using additional keyframes.

SPLIT SCREEN

A split screen is used for many purposes: to show parallel action, such as two sides of a phone conversation, or showing a wide shot and a close-up in the same screen. It's easy to do if the video was specifically shot for a split screen. For a phone conversation, for instance, it should be shot so one person in the conversation is on the left side of the screen and the other person is on the right side.

Let's do a simple split screen using the images we have in the project, but first, let's reset them all.

1. Select all the images, and in the Video inspector click the reset buttons for Transform, Crop, and Distort.

2. Let's stack two images on top of each other. Take the third image, *0755*, and drag it on top of the second, *0748*, so it connects to it. With snapping on, it should snap right into place. The magnetic timeline will close up the gap for you.

4. **Option**-click the Connected Clip to select it and move the playhead over it.

5. Activate the Crop function (**Shift-C**) and select **Trim**.

6. Grab the right side tab and drag it to the middle. It should snap to the center line.

7. Select the image on the primary storyline and use **Shift-T** to switch to Transform.

8. Slide the image to the right by dragging the Anchor Point button so it stays on the center line and frame it as you like.

A separator bar between the halves of the split screen is really useful. You can easily create this using the Generators. There are many based on different colors and tonal values; the Custom generator in the Solids category probably gives you the most flexibility for a single color.

1. Select either of the two stacked clips in the Timeline and press the **X** key to make an edit selection.

2. Select the Custom generator in the Solids category and press **Q** to connect it on top of the two clips, taking its duration from the edit selection.

3. Select the Custom generator and activate Crop and the Trim function.

4. Crop the left and right sides of the generator to create a narrow, vertical black bar. Drag it so it snaps to the alignment guides (see Figure 11.23).

5. In the Generator inspector use the color swatch to select the color of your choice, perhaps using the eyedropper to pick a color from the images.

You can of course make much more complex splits screens with multiple images and multiple picture-in-picture effects simply by

Figure 11.23 Split Screen with Separator Bar

stacking more and more layers of clips. For real complexity and ease of use for this type of effect I would suggest looking at plugins like Tokyo Split Animator and Screen Splitter 2.

MOTION CONTROL

Motion control is another term for the Ken Burns effect, also called pan and scan. It's a technique that's very useful on large-size still images. While the Ken Burns effect using the Crop function works well, it is limited to animation that you want to last the duration of the clip, though you can split the clip allowing you to create multiple separate Ken Burns effects. The technique works, but is not very flexible, and making changes usually means rebuilding the effect from the beginning, Often you'll want to hold on an image and then push in or pull out and then hold again at the end. Often you'll want to make animations on still images or large graphics such as maps that are quite a bit larger than your frame size. Let's see what happens in FCP when we do a large scale animation.

In the *Motion* event find the *0773* image and Append the whole 10 seconds of the clip into the project. By default the image will be made to fit the project. If you look in the Info inspector you'll see that the image is 2,592 × 1,936 pixels in size, much larger than the size of the project we're working in, which is 1,280 × 720 pixels. This is no more than a medium resolution image. Because the default Spatial Conform is Fit, if an image that is tall and narrow—a vertical shot— is placed in a project the application will scale it so it fits vertically in the frame. In this case the image is a different aspect so it shows pillarboxing, black bars on the left and right side of the image.

There are a couple of different ways to create the motion control effect, animating either the Transform or Crop functions. Let's look at using Transform first:

1. Select the image in the Timeline and in the Video inspector find Spatial Conform and set the popup to None. The image will now fill the frame.

Figure 11.24 Spatial Conform Set to None

2. Activate the Transform function to see the size of the image in relation to the screen (see Figure 11.24). It may be necessary to scale down the Viewer to see the edges.

4. Move the image in the Viewer down in the frame so the top edge is near the edge of the screen as in Figure 11.25.

5. Move the playhead in the Timeline about two seconds in from the start of the clip and click the keyframe button in the Viewer. This is your start position.

6. Move forward in the Timeline about five seconds.

7. Drag the corner of the image to scale it down till the sides are near to the sides of the Viewer, and slide the image up so the top of the image remains aligned with the screen.

8. Skim through the animation watching the top edge of the frame. You'll see that the motion does a slight S-curve, perhaps dipping into the frame, and then coming back again.

9. You'll need to go back to the start keyframe and adjust the start position to give you a little wiggle room so the edge of the image does not move into the frame.

Figure 11.25 Position for Start of Animation

This movement during the zoom occurs because the motion animation of scaling is different from that of position. Position is a linear animation, while scaling is logarithmic. When an image is at 100% it fills the screen, but when it's at 50% it's only a quarter of the size of the screen. For large movements, or with multiple movements, across an image, this behavior can be quite unpleasant.

Another way to do this animation is to use the Crop function. It makes a clean motion, but it looks a little mechanical as it has no easing. A good feature of using the Crop function for this is that the Viewer displays what the Scale value of the image is. Let me show you how to construct this animation.

1. Start by appending another copy of *0773* into the Timeline. Leave its Spatial Conform as Fit. If you change it you'll get unexpected results with the Crop function.

2. Move the playhead to about two seconds from the end of the clip. This will be your end position. It's common to build animations backwards, starting from the final position.

3. Activate Crop and select the middle Crop button. The Crop function will display the clip fitted into the frame with a proportional selection indicated that will fill the frame.

4. Move the selection area to the top of the screen so the top edge lines up with the top of the Viewer as in Figure 11.26. Notice the Crop and Scale values displayed at the top.

5. Click the keyframe button in the Viewer to set the end point for the animation.

6. Move the playhead to about one second after the start of the image.

7. Drag the corner of the image to reduce the size of the selection. Make it small enough so the winged lion is centered in the frame and clearly visible as the focus of interest. Watch the Scale value as you don't want to push Scale more than 100–105% (see Figure 11.27).

8. When you have it cropped and the selection positioned as you like click **Done**.

Figure 11.26 Crop Selection for End of Animation

Figure 11.27 Cropped Tight on the Image

The animation will start zoomed in on the winged lion and pull back to as far as it can go within the image without showing any black around the edges.

Which option you use probably depends on the situation. Sometimes one might work better than another. For smaller movements simply scaling and positioning will work fine but for larger movements you may want to resort to the Crop function to eliminate the weaving.

> **TIP**
>
> **Motion 5:** While you can do a lot of animation within FCP, for complex animation and motion graphics work with great precision and speed you really should consider using Motion. A great third party utility, Automatic Duck's Xsend Motion from Red Giant, lets you send an FCP project, exactly as it is in the Timeline, with effects and generators and titles to Motion for animation.

SUMMARY

In this lesson we looked at Final Cut Pro's animation capabilities. We used the Transform function to Scale, Rotate, and Position the image. We also looked at Anchor Point behavior and how it affects an image's motion. We cropped the image using the Trim function to resize the image, the Crop function to reframe the clip, and the Ken Burns feature to create simple animations. We distorted the image, and then animated it on the screen, in both straight and curved motion paths. We also looked at making basic motion effects like split screens. Finally, we looked at the problems of motion control across large format images. In the next lesson we'll look at more compositing techniques.

Compositing

Compositing is the ability to combine multiple layers of video in a single screen and have them interact with one another. This capability adds great depth to FCP. Compositing allows you to create a montage of images and graphics that can enhance a mundane portion of a production.

Good compositing work can raise the perceived quality of a production and is used for a great deal of video production work on television—commercials, of course—but also on news programs and for interstitials, the short videos that appear between sections of a program. Be warned, though, that compositing and graphics animation are not quick and easy to do. Most compositing is animated, and animation requires patience and skill.

LOADING THE LESSON

For this lesson we'll use the *FCPX10* library. If you haven't downloaded the material, we would need to get it from the eResources tab of the www.routledge.com/products/9781138209978 web page.

OPACITY

In the previous lesson and in the lesson on titles we saw how to stack elements in the FCP Timeline as layers. These layers can often be enhanced by combining them so they meld together. One of the simplest ways to do this is to use the Opacity function (see Figure 12.1).

Figure 12.1 Opacity Controls

Any visual element in the Timeline can have its opacity adjusted. This is perhaps easiest done in the Video inspector. Right at the top in the Compositing section is the Opacity slider. You can use this to set the opacity level you want and keyframe it. Remember, you can also double-click in the value box to use the mouse scroll wheel to adjust the opacity visually, and you can also mouse down on the value box and drag up and down to change the levels. These are very tactile ways to make adjustments while seeing the result in the Viewer. Of course there is also a keyframe button that allows you to change the opacity over time, to ramp it up or ramp it down.

The other way to adjust the opacity is in the Timeline itself, by selecting the item in the project and using **Control-V** to activate the Video Animation controls. Double-click the Opacity function at the bottom of the controls and drag the level line up and down to make adjustments just as you do with audio (see Figure 12.2). As with the audio level line you can also **Option**-click to add Opacity keyframes to animate the levels.

Figure 12.2 Opacity Animation Controls in Timeline

BLEND MODES

While Opacity is the simplest way to blend the layers, it's often better to combine elements such as text or generator items with images using **Blend Modes**. If you're familiar with Photoshop or other graphics applications, you probably already know that in a blend or compositing mode the values of one image are combined with the values of another image. Final Cut has 26 compositing or blend modes, including stencils and silhouettes.

Any video element in the Timeline can have a blend mode applied to it. The Blend Modes are part of the Compositing section at the top of the Video inspector. From the **Blend Mode** popup you get to select the compositing type you want (See Figure 12.3). The default

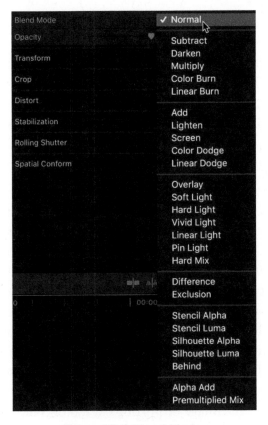

Figure 12.3 Blend Modes

of course is Normal, which is the way the clip appears without any composite mode applied. The Blend Modes are listed in groups. The best way to see the composite modes is to try them out. Before you start to work with Blend Modes or do any heavy text and compositing work, I think it's a good idea to switch off background rendering. You don't really need your system constantly rendering as you make changes. Most often the material will play in real time. There may be occasional dropped frames, but they're not a great inconvenience and playback does not stop. To switch off playback rendering go to **Final Cut Pro>Preferences** and in the **Playback** tab uncheck the box for **Background render**.

Compositing Preview

To help you see what the Blend Modes do I've created a project with the same clip on it and the same underlying Generator repeated again and again. Each copy of the clip has a different Blend Mode applied to it. There's a lower third on each clip that identifies the Blend Mode applied to the video clip in the stack. I left out a few that have specific uses and wouldn't show anything if composited on video. Let's begin by looking at the Blend Modes available in FCP. Open up the project called *CompositeModes*.

At the start you see the image with Normal, or no Blend Mode, followed by a couple of seconds that show the underlying generator. The Blend Mode popup divides the options into groups. The first group of Blend Modes darkens the image—Subtract, Darken, Multiply, Color Burn, and Linear Burn. The result depends greatly on the image content. The names often give an indication of how the Blend Mode works. For instance, Subtract subtracts the pixel values of the image above from the image below. The burn modes, Color and Linear, can create interesting effects and are often seen in text compositing. The second group of Blend Modes will usually act to brighten the image. Add adds together the pixel values in the images, and often makes the image or portions of it blow out. Some, such as Screen, in the brighten group, and Multiply, in the darken group are

often used to create transparency in an image, which we'll see in a moment. The contrast group affects the image gamma and they are not unlike lighting effects. The Vivid, Linear, and Pin Light modes can work well in combining images. The next group has Difference and Exclusion that have some of the most pronounced effects on the image as they work with the color values of the image and change the hue. The transparency group of stencil and silhouette are used to affect the transparency of underlying images. We'll look at those in detail later. The Behind mode simply allows you to take an image that's at the top of a layer stack and put it as if it was at the bottom of the stack. It means I can add a background layer on top and have it appear as if it was at the bottom. As you look through the project you'll see that some of the differences, especially within each group, can be pretty subtle. These are wonderful tools for controlling and combining images, especially text over video. To look at some of the composite modes, especially their specific uses we'll start by making a new project and naming it *Composite*.

Screen and Multiply

One of the most useful composite modes is **Screen**, which will remove black from an image. It screens out portions of the image based on luminance values. Pure black will be transparent, and pure white will be fully opaque. Any other shade will be partially transparent. This is great for creating semitransparent shapes that move around the screen, and it is useful for making animated backgrounds. Many 3D and other animation elements are created against black backgrounds that can be screened out. Also stock footage such as muzzle flashes, smoke, and fire are shot against pure black that can be screened out. Let's try the Blend Mode, and you'll see how it works, compositing the Lens Flare generator on top of another scene:

1. Let's put in the background layer first. From the *Composite* Events Browser find the *Kabuki3* shot.

2. Press **Shift-2** to do a video only edit. We don't need the sound for these compositing exercises.

3. Append the shot into the *Composite* project.

4. Zoom into the Timeline and move the playhead about half way through the shot.

5. In the Browser find the *LensFlare* shot and connect it into the project at the playhead and play it. All you see in the middle of the shot is the lens flare moving across the black screen. The underlying shot is hidden.

6. **Option**-click the *LensFlare* shot in the Timeline to select it and move the playhead over it.

7. From the top of the Video inspector change the Blend Mode popup to Screen. Voila! We see the flare moving across the image.

8. Next move the playhead back to the beginning of the project, and connect the *Multiply* graphic to the project.

9. Select *Multiply* in the Timeline and change its Blend Mode to Multiply.

Instantly, the white background will disappear, and the black text will appear over the video and the lens flare.

These two effects can be seen in the assembled project in the *FCPX10* library called *BlendingFun*. A number of the other effects we do are also in this project.

> **NOTE**
>
> **Lens Flare Size:** The LensFlare movie is a little undersized and you can see the edges at the brightest part. Not a problem, just use the Transform function to scale up the image a little.

Animated Text Composite

One of the best and most common uses of composite mode is with text, especially animated text that's moving on the screen. The blend mode will allow the text to interact with the layer underneath, giving texture to the text. Let's continue to work with the *Composite* project.

1. To start, let's trim off the excess of the *Multiply* graphic so it's the same length as the *Kabuki3* shot.

2. Next append *Village3* into the project to be our background for the text.

3. Because FCP has so many prebuilt text animations, we'll not use our own animation, just use one of the title templates. Put the playhead a short way into the *Village3* shot and connect the **Drifting** title on top of it.

4. For this type of thing we want to use a large, chunky font, and make it a bright color. I like Arial Black for this. In the either the Title or Text inspector set both lines to this font.

5. Set both Line Sizes to 250, big and bold, and pick a fairly bright red for both. Remember you can use the eyedropper in the Apple color picker to pick the color from one swatch and add it to the other.

6. For the text type the word *DAMINE* in the first line. It's the name of the village, and for the second line type *JAPAN*. To keep the bold effect, type in all caps.

7. Finally, in the text's Video inspector change the Blend Mode. I used **Multiply** in Figure 12.4, but you should try others, like the Dodge or Burn Blend Modes.

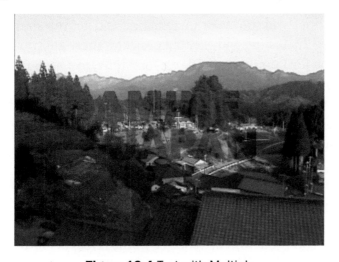

Figure 12.4 Text with Multiply

These kinds of compositing techniques are used constantly in motion graphics. Even if you don't use a Blend Mode, simply adjusting the opacity of your text so the face has a little transparency will create interesting effects.

This effect is also in the *BlendingFun* project.

NOTE

Unrendered Playback: If you have background rendering switched off while you do compositing work, you might notice a little wobbling or shimmer as you play the titles back. This is because the computer is playing back the unrendered title and trying to produce it in real time. To render the title, select it and press **Control-R** for render selection. Playback will be a lot smoother now.

STENCILS AND SILHOUETTES

Travel mattes, or traveling mattes, are a unique type of Blend Mode that uses the layer's transparency or luminance value to define the underlying layer's transparency. To do this we use the **Stencil** and **Silhouette** Blend Modes. These allow the application to create a great many wonderful motion graphics animations. We'll look at a few that I hope will spur your imagination and get you started on creating interesting and exciting projects. There are two Stencil modes, one for **Luminance** and one for **Alpha**, just as there are two Silhouette modes, one of each type. In these modes, the layer to which the composite mode is applied will give its shape and transparency from either the Luminance value or the Alpha (the transparency) value of the layer to the layers beneath it. A Stencil mode on a layer will reveal only what's inside the selected area, while a Silhouette mode on a layer will show what's outside the selected area, basically punching a hole through the layer or layers underneath it. In the project, any animation or change in the layer with the Blend Mode will be reflected in the layers below it. This makes Stencils and Silhouettes extraordinarily powerful tools.

These concepts are harder to explain in words than they are to demonstrate, so let's make a new project that we'll use to see how these compositing tools work.

1. Find the *TransparencyModes* project and duplicate it with **Command-D**.

2. Name the new project *TransparencyModes Work*.

3. Open the duplicate project, select the *Stencil* text clip on top, and in the Video inspector set the Blend Mode to **Stencil Alpha**.

All you see is the bamboo and the grass (see Figure 12.5). The text itself is gone. Its only purpose is to provide the transparency information for the layers below it.

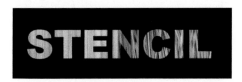

Figure 12.5 Stencil Alpha Layer

4. Select the *Stencil* layer and the *Natural* layer beneath it and convert them to a Compound Clip with **Option-G**. Now you only see half of the word because the layer with the grass is cropped.

5. Undo that and select *Stencil, Natural,* and *Wood* and convert them to a Compound Clip.

Now you see the word divided into wood and grass, but the Stencil Alpha mode is only affecting those two layers and for the first time you can see the *Metal* layer beneath (see Figure 12.6).

Figure 12.6 Stencil Alpha in Compound Clip

Let's look at what happens with the Silhouette Alpha mode.

1. In the *TransparencyModes Work* project select the *Silhouette* text block and in the Video inspector change its Blend Mode to **Silhouette Alpha**. You will see the bamboo and the grass with the word *SILHOUETTE* punching a hole through the layers (see Figure 12.7).

Figure 12.7 Silhouette Alpha Layer

2. Select the top three layers, the text, the wood, and the grass and convert them to a Compound Clip. You'll see the text has cut a hole, but only through the first two layers, revealing the metal plate underneath (see Figure 12.8).

Figure 12.8 Silhouette Alpha in Compound Clip

Here we are using just text, but you can use the transparency channel of any image to create interesting effects. I think you can see the potential here of this powerful compositing tool.

The Stencil and Silhouette Luma modes work similarly. They use the luminance information of an image to either cut out the area surrounding the stencil, or cut through the area of the silhouette. Let's try the Stencil Luma on the first stack.

1. Double-click the Compound Clip in the first stack to open it into the Timeline.
2. Select the text layer and in the Inspector change the Blend Mode to **Stencil Luma**.

The luminance value of the text is being used, and as it is not fully white, it will show some transparency. Only what is pure white will be opaque and pure black (or transparent) will be transparent in the underlying layers.

Switch back to the *TransparencyModes Work* project with **Command**-[and you will see the stencil effect with the word ghosted on top of the metal background. If the red of *STENCIL* were pink or paler, the text would be more distinct on the metal. Inside the Compound Clip make the color adjustment in the Inspector>Text>Face section and see what happens. Try also the Silhouette Luma mode on the Silhouette Compound Clip.

Organic Melding

A common technique that always works well is to use luma maps to create effects that allow images to meld into each other organically. Usually, this is done by creating a grayscale image with motion in it that is used as the luminance map. Let's do this in the *Composite* project that we were working on earlier:

1. To build this effect, start by making sure you're set to do a video-only edit (**Shift-2**).

2. Next, append the *Kabuki1* clip to the end of the project. It's only five seconds long, so, if necessary, zoom into the Timeline. Hold the **Z** key and drag a box around the clip.

3. Move the playhead back to the beginning of *Kabuki1* and press the **X** key to mark the clip as an edit selection.

4. Connect *Archer1* to the storyline.

5. To add the luma map, we'll use the **Underwater** generator from the Backgrounds category. Move the playhead to the beginning of the stack, select **Underwater** and connect it with **Q**.

Before we composite, there's a small problem we have to take care of first. The Underwater generator is quite long and the speed of the watery motion is determined by the length of the clip, so we don't want to shorten it. That would make motion very quick and not at all what we want. There is a way around this. Basically, we "nest" the generator in a Compound Clip all its own, so its motion happens there, and then we shorten the Compound Clip like this:

1. Select the *Underwater* clip and press **Option-G** to make it a Compound Clip. Name it *Underwater* and save it.

2. Shorten the Compound Clip to make it the same length as the other two clips in the stack.

Next, we need to create a luminance map out of this. The luma map will act to control the opacity of the image so it blends with the image underneath. To do this, we'll adjust the Compound Clip luminance values, remove the color, and increase the contrast so that the motion has more effect on the images and gives a better definition to the effect:

1. Select the Compound Clip and press **Command-6** to go to the Color Board.

2. In the Saturation tab, pull the Global puck all the way down to zero to make the image grayscale.

Figure 12.9 High Contrast Generator

3. In the Exposure tab, set the **Shadows** down to −**33%**, the **Midtones** down to −**60%**, and to increase the contrast, push the **Highlights** up to +**66%**, or something similar that exaggerates the contrast (see Figure 12.9).

4. Go to the *Underwater* Compound Clip's Video inspector and set the Blend Mode to **Silhouette Luma**.

5. Finally, to complete the effect, to blend the compound with the layer underneath it, select the *Underwater* Compound Clip and *Archer1*, and use **Option-G** to combine them into a new compound, naming it *Underwater Archer*, making a compound within a compound.

What immediately happens is that you see the underlying *Kabuki1* clip and the two blend together based on the luminance and the motion of the Underwater generator (see Figure 12.10).

This is in the *BlendingFun* project in the Browser.

Figure 12.10 Silhouette Luma Effect

VIDEO IN TEXT

I hope by now you're seeing the huge range of capabilities that these tools make possible. For our next exercise, we're going to make an even more complex animation with traveling mattes, the ever-popular video-inside-text effect, the kind of technique that might look familiar from the opening of the old TV show, *Dallas*. One of the features of FCP that makes this easy to produce is the application's ability to make resolution independent projects.

To look at what we're going to do, open the *MasterTitle*. That's what we're going to build. It might look like only two layers, but in fact it's much deeper and more complex than that.

Getting Started

We'll begin by making a new project using a custom size.

1. Press **Command-N** to make a new project, name it *Stage*, and click the **Use Custom Settings** button.

2. Change the **Video** to **Custom**, make the **Resolution** 1500 by 480, the vertical height of the DV clips, set the frame rate to 29.97, and the Color Space to Rec. 601 (see Figure 12.11).

Figure 12.11 Custom Settings

3. With the playhead at the beginning of the project press **Control-T** to add the default **Basic Text**.

4. Basic Text defaults to 10 seconds, which is too long, so let's shorten it to five seconds.

5. Select the text and press **Option-G** to make a Compound Clip, which we will called *Stage Clip*.

Why not just make a Compound Clip in the Browser to start with? Why make the project first? To be honest it's a bit of a work around. If you make a compound in the Browser with a custom resolution as we've done, you can only set the frame rate to 23.98. By making the project first and creating the Compound Clip inside it, the compound keeps the project's frame rate, which you can see by selecting the compound and looking in the Info inspector.

Making Text

Next, we need to make the text. We need to make it big and bold so that we can fill each letter with a piece of video. We don't need to worry about the title safe area because the text will be animated across the screen.

1. Double-click the Compound Clip in the Timeline to open it and then double-click the text block to select it.

2. Type in the letters *DMA* or your initials or any three letters you want. (DMA stands for Digital Media Academy, which I helped found at Stanford some years ago.)

3. In the Text controls, set the font to **HeadlineA**, set the **Size** to **1280**, and the **Baseline** to about **-440**.

4. To help create separation between the letters set the tracking to about 7%. Your text should look something like Figure 12.12.

Figure 12.12 Text Inside Custom Compound Clip

TIP

Distorting the Text: If you use a different font or one that's a bit more squat like Arial Black, you can use the aspect ratio distortion feature of the Transform Scale function. This allows you to scale an object in X and Y axes independently. Activate **Transform** in the Viewer and hold the **Shift** key pull down from the bottom or side as needed. You can also scale X and Y separately in the Video inspector.

Separating the Letters

You now have the base layer for the text. It's very important that you do not move the text, change its position or size on the screen once you have it set. We're going to make multiple copies of the text that all have to line up exactly:

1. Holding the **Option** key, drag a copy of the text directly above it to make a new Connected Clip.

2. Repeat twice. Hold the **Option** key and drag another copy of the text up so that you have a total of four layers, one for each letter and one extra (see Figure 12.13).

Figure 12.13 Text Stacked in the Timeline

3. To separate the text, we're going to crop each title so that it only shows one letter. Start by drag-selecting all the text layers except the bottom one and pressing the **V** key to disable them.

4. Select the bottom text on the primary storyline and activate the **Crop** function with **Shift-C**, making sure it's set to **Trim**.

5. Drag the right-edge crop handle to crop all the letters except the *D*, or whatever your first letter is.

6. With the first layer selected, press **V** to disable it, and then press **Command-Up Arrow** to select the second layer. Press **V** to enable it.

7. Crop from the left and right so that only the *M*, or your middle letter, is visible.

8. Hide the second text layer and reveal the third as you did a moment ago.

9. On the third layer crop from the left side so that only the third letter, *A* in my composition, is visible.

10. Leave the top layer disabled and click **Done** in the Viewer when you're finished cropping.

Adding Video

We're now ready to put in the video. We'll start by working with one text layer and then add in each one sequentially till the three letters

are filled with a different piece of video. First, let's lift everything from the primary storyline:

1. Select the text block on the primary storyline that has the letter *D* and use **Option-Command-Up** arrow to lift it, leaving a Gap Clip in its place.

2. Use the **V** key to switch off all the text layers except the bottom one.

3. Make sure editing is set to Video Only with **Shift-2**.

4. Select the Gap Clip in the storyline, then find the *Kabuki1* clip in the Browser and press **Option-R** to **Replace from Start**.

5. In the Viewer with *Kabuki1* selected, switch on the Transform function (**Shift-T**), scale the image, distort the aspect ratio, holding the **Shift** key drag a corner, and position it as you like so that it covers the area underneath the letter *D* (see Figure 12.14).

Figure 12.14 Video Ready to be Composited with First Letter

6. Select the text layer *D*, and in the Video inspector, set the Blend Mode to **Stencil Alpha**.

7. Select the two layers, the *Kabuki1* video clip, and the text layer with the letter *D* and combine them into a Compound Clip with **Option-G** and name it *D*.

8. Select the *M* layer and use the **V** key to enable it and then press **X** to make an edit selection.

9. Find the *Kabuki3* clip in the Browser and press **Q** to connect it to the top of the stack.

10. Drag the clip down so it's between the second text layer and the *D* Compound Clip (see Figure 12.15).

Figure 12.15 Timeline Stack with Two Video Clips

11. With the *M* text selected in the Video inspector change the Blend Mode to **Stencil Alpha**. Everything will disappear except the letter *M*.

12. Select *M* and the *Kabuki3* video layer and combine into a Compound Clip with **Option-G**, naming it *M*. Now you'll have both the *D* and the *M*.

13. Make an edit selection for the letter *A*, use **V** to enable it, and connect the *Archer1* clip into the Timeline.

14. Drag the video down so it's between the *A* text and the *M* Compound Clip.

15. With the playhead over the stack, select the *Archer1* clip and the Transform function in the Viewer, Scale, Position and squeeze the aspect ratio, so it fits nicely under the letter *A*.

16. Select *A* and set the Blend Mode to **Stencil Alpha**.

17. Select *A* and *Archer1* and combine them into a Compound Clip called *A*.

Congratulations! You've got through the hardest, most tedious part of building this composition. Your Timeline should look something like Figure 12.16. You've composited three tracks of video with three tracks of text, blending them together to create a composition that shows three images simultaneously in the screen within the constraints of the text.

Figure 12.16 Project Timeline After Compositing Video

We're almost there—just one more refinement before we animate the image.

Edging

The last thing that helps this type of composition is to add an outline edge. It helps to separate the text from the underlying image. We'll

add an edge that borders the letters. That's what that last layer, which has been hidden until now, is for.

1. Make the top text layer visible. It should completely cover all the underlying layers.

2. In the Text inspector turn on **Outline** and set the **Width** to about **10**. The default red works well for this.

3. Uncheck **Face** to switch it off. The Viewer should look like 12.17.

Figure 12.17 Composition with Edging

Animating the Text

To animate the composition, we need to make a project with background video. We'll use *Village1* for the background.

1. Make a new project with the default settings, leaving it set to have the first clip define the project properties, and name it *MasterTitle*.

2. Find *Village1* in the Browser, select the first five seconds, and Append it into the Timeline.

3. With the playhead at the beginning of the Timeline, find the Compound Clip called *Stage Clip* and use **Q** to connect it to clip on the primary storyline.

4. With the Compound Clip selected in the Video inspector change **Spatial Conform** from **Fit** to **None**.

5. With the Compound Clip selected turn on the Transform function with **Shift-T** and set the Viewer to a comfortable size that allows you to see the outline of the Compound Clip (see Figure 12.18).

Figure 12.18 Compound Clip in the Viewer

6. Drag the Compound Clip with the Anchor Point to the right so it snaps to the alignment guide until the first letter *D* is off the right side of the frame.

7. With the playhead at the beginning of the project click the keyframe button in the Viewer to set a keyframe for the Transform functions.

8. Go to the last frame of the video, **down** arrow, **left** arrow, making sure you see the sprocket hole overlay on the right edge of the frame.

9. With the Anchor Point drag the Compound Clip straight across the screen till the last letter *A* disappears off the left side, making sure that the Anchor Point snaps to the horizontal alignment guide.

Over the course of the five seconds, the text and the video inside it will travel from right to left over the top of your background video.

There is a huge amount you can do with Blend Mode compositing tools. Play with them and have fun!

SUMMARY

That brings us to the end of this lesson on compositing. We looked at Final Cut Pro's Blend Modes, including a pre-built preview to show off the various effects. We worked with the Screen and Multiply Blend Modes because of their unique properties. We worked with some of the most powerful Blend Modes—the Stencil Alpha and Luma, and the Silhouette Alpha and Luma functions— which allowed us to use one image to cut through multiple layers of video. It also has the ability to let clips meld organically with each other. Finally, we built a complex multilayer project of video within multiple letters of a title, all animated against a video background. With that we're almost ready to export our material from Final Cut Pro out into the world, which is the subject of our final lesson.

Outputting from Final Cut Pro

The hard, technical part of nonlinear editing is at the beginning, setting up and setting preferences, importing, organizing, adding metadata; the fun part in the middle, hopefully, is the editing; and the easy part is the outputting at the end. Well, we're finally up to the easy part: sharing. Basically, when outputting, you're delivering your media in some digital form, whether it's heavily compressed for low-bandwidth web delivery or a high-resolution HD or higher format for your digital master.

For this chapter I am using a library called *FCPX11*, which you can download from the eResources tab of the www.routledge.com/products/9781138209978 web page. You could use your own media as well, but there are some export features in FCP that need your project set up in a specific way. The *FCPX11* library has a single event with a project.

SHARING

The options for sharing from FCP are similar to those from iMovie; there are just more of them, with one exception. There is no Theater from where you can play your project, nor is there a direct way to share to iCloud, though you can access iCloud through iTunes of course. A project can be shared either from an open Timeline or directly from the event in the library that's holding it. Also any selected clip or Compound Clip can be exported directly from

the Browser. You can also share a section of a clip exported from the Browser or a section of a project exported from the Timeline, simply by marking a selection on the clip or on the project's primary storyline, either with the Range Selection tool or with **I** and **O**. Note, however, that currently you cannot mark a selection in a project and export just that selection from the Browser; you have to mark the selection in the Timeline and export from the Timeline pane.

With the exception of the XML export function and the **Send to Compressor** function, which are only in the **File** menu, all of FCP's other outputting options are in the **Share** submenu or more commonly accessed from the **Share** button at the far right end of the top bar.

Send to Compressor opens that application and gives you access to all its options. Compressor offers far more options and control over your recompression process than is available in FCP. In addition to the **Send to Compressor** option, you can also export using Compressor settings, which we'll see later. For an overview of working with Compressor take a look at the Compressor article on my website at www.fcpxbook.com/articles/compressor41/.

XML export is straightforward and allows exporting color grades, effect parameters, and audio keyframes. You can export an XML file of a project, an event, and even an entire library. The small XML files contain an enormous amount of information. An exported XML project file can be imported into Logic Pro X for audio sweetening and mixing. This includes keyframed volume and pan information. The XML can also be used together with the X2Pro utility (www.x2pro.net) to get your audio to ProTools.

Destinations

The **Share** button offers a number of basic exporting options that can be added to as a user preference (see Figure 13.1). The default export is **Master File** and has the keyboard shortcut **Command-E**. What appears in the Share button is controlled by the **Destinations** preferences, which we skipped in the chapter on preferences. You can access these preferences from the FCP preferences in the **Final**

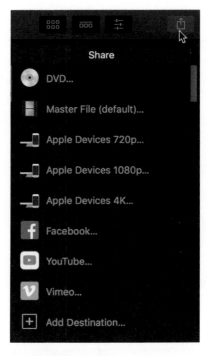

Figure 13.1 Share Button

Cut Pro menu or from the selection at the bottom of the **Share** button, the **Add Destinations** option.

The **Destinations** preference lets you add or subtract items from the list in the sidebar (see Figure 13.2). So if you never upload to YouTube or Facebook, you can right-click on them and delete, or select and press the **Delete** key. To add a function to the **Share** menu drag it from the pane on the right into the sidebar.

Here also you can change the default destination from Master File to whatever you want from the shortcut menu (see Figure 13.3), and the keyboard shortcut **Command-E** will go with it, which is very handy if you have one format you're always going to use.

When you select a destination like Vimeo or YouTube, you can click on **Sign In** (or **Details**) and enter your username and password. This is handy if you have multiple Vimeo or YouTube accounts. You can have a separate destination for each.

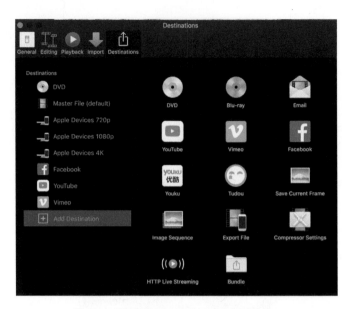

Figure 13.2 Destination Preferences

Figure 13.3 Destinations Shortcut Menu

In the Destinations preferences you can add items like still image export, called **Save Current Frame**, and **Blu-ray** burning and others. Blu-ray and DVD output accept chapter markers created in the project. These markers also export to QuickTime. You can also add an **Export File**, which is a Master File setting that you can customize, rename, and make the default if you wish, such as an MXF preset as in Figure 13.4.

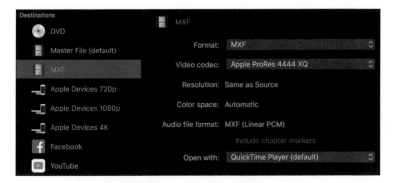

Figure 13.4 MXF Preset

You can also add **Compressor Settings,** which lets you include any specific settings from Compressor, either the Apple presets or custom presets you have created. In addition, you can create a **Bundle**, which is a folder that holds multiple presets that you can select to batch process on a project. To create the Bundle you simply drag the share selections you want into the folder, or **Option**-drag a duplicate. You can have a Vimeo setting in the sidebar and a duplicate setting in the bundle, which you can name anything you want. When you select the bundle you'll see all the settings included as well as having the option to change them (see Figure 13.5).

Figure 13.5 Destinations Bundle

Export

Once you're ready to share and you select the option you want from the **Share** popup, the Info pane appears. The name assigned is the name of the project, but you can change the name to anything you want. This is the name that appears at the top of the QuickTime player, or in iTunes, or Vimeo or YouTube. This is NOT the name of the file on your hard drive, which you assign when you assign the save location. The name of the file can be something like *CDL161027*; nobody but you will see that unless you send them the digital file. They will see the name in the Info pane. Here you can also enter a description, and creator name, as well as **Tags**. In **Description** you can add in information such as copyright or whatever you want. The tags that appear here are the keywords on the clips in the project. They can be changed here, or they can be assigned before exporting in the Share inspector (see Figure 13.6). You can access the Share inspector in the Project Properties (**Command-J**) or by selecting the project in the Browser. You can also change the name here to a specific name other than the default project name. The name you want to use may be different from the name you're using in the application. You can change the Description and the Creator. You can remove or add tags as you like. Tags carry through to web sites and make it easier for search engines to locate your video when it's online.

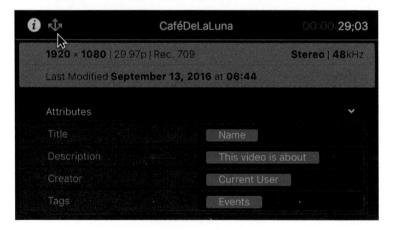

Figure 13.6 Share Inspector

If you're exporting a bundle, at the bottom left, you can toggle between the settings to access them and modify them if you wish (see Figure 13.7). This display will also show if you are exporting a segment of the project, the duration of the export, and at the end what the approximate file size is. You will also see a small button that shows the export file's compatibility with different devices and systems (see Figure 13.8).

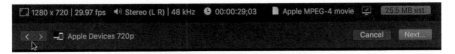

Figure 13.7 Confirmation Display

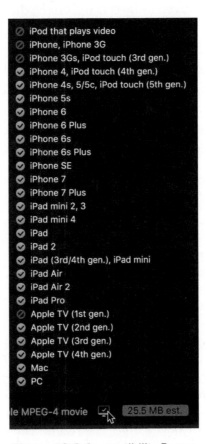

Figure 13.8 Compatibility Popup

In the Settings tab of the Share dialog you can change the options, which we'll see shortly. Depending on the settings you're using when you click the **Next** button, a drop down sheet will appear letting you name the digital file and assign its location. If you're sharing a bundle, all the items will have the same name tagged with the name of the export option that's in the bundle. When each encode is finished a notification will appear on your screen to let you know it's completed, which you can either close or click the **Show** button to take you to the file.

One of the nice features in FCP is that exporting or sharing does not seize control of the application. The export process is a background process, and you can monitor the progress in the dial in the top bar in the upper left of the screen or by clicking on the dial to bring up the Background Task window, which can also be opened with the shortcut **Command-9**. You can continue to edit while this is going on. This allows you to queue up multiple files to export, different projects or portions of projects, or different clips, just add them to the Background Process window and they will be done sequentially. However, there is no true batch processing, no ability to select multiple clips and send them off to export with one setting. For this you need Compressor.

TIP

Notifications: If you find the notification popups that appear on your screen annoying, these can be switched off or amended in the **System Preferences>Notifications**.

NOTE

Proxy Project: If you're working with proxy files in your project, do not export the project unless you want a proxy quality file. Exporting a project full of proxy files and settings ProRes 422 (HQ) as the output, will give you a very large, very poor quality export file. If you want to export a real master file make sure you switch the Viewer setting back from **Proxy** media to **Optimized/Original**. There is no warning in the export operation when you are exporting a project of proxy clips. You just have to do it.

Master File

This function allows you to export high resolution as well as compressed versions of your project. I would suggest that creating a high resolution version of your completed project should be standard procedure. When you have finished a project you use the **Share** button and select **Master File**. This gives you the opportunity to produce a high quality master that you can use to reproduce your project or recompress to other formats with minimal degradation of your image. The **Format** popup has three categories, **Mastering**, **Publishing**, and **Broadcast** (see Figure 13.9). Mastering simply gives

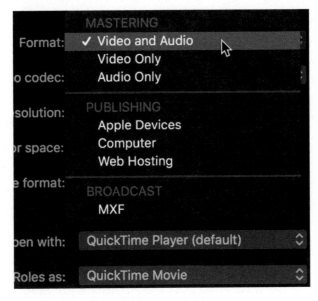

Figure 13.9 Format Popup

you options to output **Video and Audio, Video only,** or **Audio only.** Devices gives you access to **Apple Devices,** which is a basic setup for mobile devices and Apple TV and produces an Apple MPEG-4 file; **Computer,** which let's you output an MPEG-4 file that's PC and Mac compatible; and **Web Hosting,** which creates a QuickTime movie for the web. Broadcast allows you to export to **MXF,** which is a professional format that can now be encoded in a ProRes codec as well as other high resolution codecs depending on the project you're sharing.

If you export to an option in the Publishing category all the formats use the same H.264 codec with some variation in data rate and file size. The MPEG-4 Computer setting is a little larger, while the Web Hosting QuickTime is a little smaller. If you select a video format from Mastering or Broadcast the **Video codec** popup will let you choose from a number of available codecs (see Figure 13.10). You will normally see the ProRes codecs from ProRes 4444 XQ to ProRes

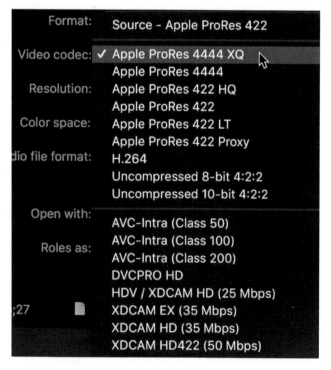

Figure 13.10 Available HD Codecs

Proxy together with H.264. Below that are codecs like AVC-Intra and XDCAM. This will vary depending on whether the export is UHD, HD, or standard definition. For SD export, in addition to the ProRes codecs you have **DV** and **DVC50** codecs, as well as **IMX** options. For creating an SD master of your project, I would recommend using **DVC50**, though the file sizes are twice that of standard DV. It is a robust 422 codec that stands up very well to duplication and creates good quality output when compressed.

Which codec to use? Though H.264 is an option here, it really should never be used as a master file, which should always be a high resolution format. Use **Apple ProRes 422 (Proxy)** if you want to export a low resolution proxy file; it is good for training videos that require heavily compressed media to fit onto a disc, otherwise it's probably not something you're going to use.

In my view **Apple ProRes 422 LT** (LT meaning Light) is an outstanding codec. I wish FCP would allow transcoding to this codec for Optimized Media as it is an excellent compromise of high quality with moderately high data rate. For AVCHD originals, this would be an excellent codec for importing. Unfortunately it's not available for that. If you're going to continue editing on another platform, this may be a good export choice for you. For most purposes the **Apple ProRes 422** codec, the standard current settings for render output, should be your choice for creating a high resolution master file of your project. Anything edited in HD that's 1080p or smaller should be exported to this codec. If you are working in larger formats that are 2K in size, then you would be best served exporting to the **Apple ProRes 422 (HQ)** codec (HQ meaning High Quality). Be warned, though, that these are very large, very high data rate files and require very fast drives to support them for proper playback. If you need to export a file with transparency then you should use **Apple ProRes 4444**. If you need a pristine file, of the highest quality as a digital intermediate, with transparency, you can now export to **ProRes 4444 (XQ)** Extreme Quality.

In Master File export the resolution is fixed to whatever the project resolution is. In the case of the project in our library, it's 1920 × 1080.

When you're exporting a video and audio file, you have no real control over the audio format. However, if you are exporting audio only you get different audio export codec options (see Figure 13.11). These allow for compressed versions of your audio output: AAC and MP3, which are suitable for iPods, AC3, which is used for DVD production, CAF for 5.1 Surround audio, and AIFF and WAV for uncompressed audio, which should always be your first choice if you're making an audio master or exporting your audio for use in another production application.

Figure 13.11 Audio Codecs

Notice the **When done** popup that lets you select an application to open the file, including the default QuickTime player or Compressor, which will load the file directly into that application. If you don't want anything to happen—no application to open, no sending to iTunes—select the first option: **Do Nothing**.

NOTE

Interlacing: If you shoot interlaced video, when you export to the Share options that compress the video, such as Apple devices and H.264, the material is deinterlaced. However, when you export, and want to make a full size file without interlacing you have to set that up manually. While you can change the project properties, this is not always reliable. It's best to make a new project and use a custom setting. Select a resolution that matches your media, and in the drop down sheet change the format to a **p** for progressive format and change the frame rate to a **p** frame rate, such as **29.97p**. Select everything in edited project and use **Command-C** to copy it all. Then paste everything into the new custom project. This deinterlaces the content and allows you to output a deinterlaced version.

Blu-ray and DVD

While it's Apple's view that discs, CDs, DVDs, and Blu-ray discs, are, if not actually dead, fast dying out as a delivery mechanism, nonetheless many people still want to make them, play them, buy them, and sell them. Apple has provided a very minimal mechanism for doing this within FCP. If you want fuller features for standard definition DVD creation you would need to use iDVD. For more complete Blu-ray features you would need Roxio's Toast or Adobe's Encore, which is also end of life. If you are going to one of these applications, it's best to export at high resolution and allow the disc creation software to encode the media for you. If you're delivering content to clients, you should be actively steering them as rapidly as possible away from discs to delivering online or on cheap thumb drives.

While the Blu-ray option can be added to Destinations, the **DVD** option is available by default. We'll look at the Blu-ray option as it has more features and includes everything that's available in DVD (see Figure 13.12). The first popup lets you select whether to record directly to a connected disc burner, create a disk image on your hard drive for burning later using the Finder, or to burn an AVCHD red laser burned disc, which burns onto a standard DVD.

The second popup lets you select whether to create a single layer or dual layer disc, while the third sets whether to build into a file (disk image) or into a folder. The popup below for **Disc template** allows you to choose from one of five basic menus (see Figure 13.13). The DVD option only has the black or white templates. Below that is the title option, which is the name that appears at the top of the player, and the disc name option, which is the name that appears on your desktop if you mount the disc. It's also the name of the disk image or folder. For DVD the name has to be in the correct format such as *UNTITLED_DISC*. You can set also whether the disc displays a menu first, or is what's called a first play disc, in which the program begins playing as soon as the disc is loaded into the player. There's also a check box to allow you to include a button for looped playback in your menu. Chapter markers created in the FCP project can

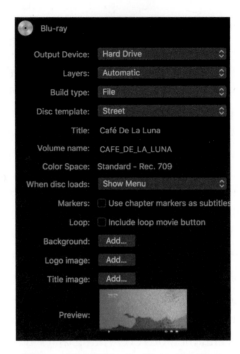

Figure 13.12 Blu-ray Share Options

Figure 13.13 Disc Template Options

be included and appear in a separate chapter menu, or the chapter markers can be converted to use as subtitles with a checkbox.

If you have pre-built graphical elements created in an application like Affinity Photo you can choose to load those as a background image, a logo image, or as title text.

When you click the **Burn** button the files are encoded into the correct formats and, when completed, a prompt will appear asking you to insert a disc. If you're creating a disk image rather than burning directly to disc, the **Next** button will ask for the location and name of the file. Remember the name that will appear on the Blu-ray or DVD player is the name entered in the Settings pane. I think it's generally good practice to create the disk image first, saving it to your hard drive, and burning the necessary discs from that using the Finder or third party software.

> **NOTE**
>
> **Still Images for Menu Backgrounds:** Be careful with background images. They should be made into the standard format size for your video, 1920 x 1080 for HD, and 720 x 540 for 4:3 standard definition or 853 x 480 for 16:9 anamorphic DVD. Do not use high megapixel camera images for background images when burning discs. The encoding process will most likely fail.

Apple Devices, Vimeo, and Others

The remaining groups are either for preparing media for use with Apple Devices, primarily, of course, TV, and for web-based output options such as YouTube, Vimeo, and Facebook. Other account options, such as Youku and sending via email, are available in **Add Destinations**.

I am not sure why there are three Apple Devices presets as they are all the same, except that **720p** uses the 1280 × 720 preset, **1080p** uses the 1920 × 1080, and **4K** uses the 3840 × 2160 preset. All of the available resolutions are found in each popup (see Figure 13.14).

Figure 13.14 Apple Devices Resolutions

Though the 4K option is available you cannot output a project larger than its project properties. So if you want to output 4K but your material is 1080p, you have to put your 1080p media into a 4K project to have the 4K option available.

You have very little choice in the compression options, either **Faster encode** or **Better quality (multi-pass)**. If you need better control over your exporting options you really need to look to Compressor.

ROLES

One of the features of exporting a Master File is the ability to use Roles to create what are called *stems*, separating tracks of audio based on the content, for instance separate stems for dialogue, effects, and music for professional audio mixing. In addition to exporting as separate tracks in a QuickTime file, they can also each be exported as separate audio files. You can export the Roles as a **Multitrack QuickTime Movie** (see Figure 13.15), which will create a QuickTime file using any of the available video codecs, with each Role laid on a separate track. When you export to Multitrack QuickTime Movie, you will have the option in the Video popup to switch off the titles if you wish, which can be handy if supers or subtitles are being added elsewhere (see Figure 13.16). Notice in the popup menu that you can save presets for different combinations of role outputs.

In addition to multitrack QuickTime movies, you can also export as **Separate Files**, which will give you QuickTime files, one for video

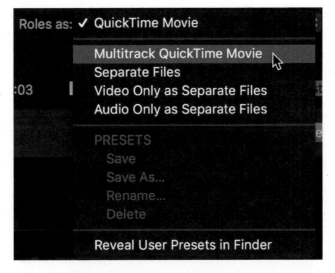

Figure 13.15 Roles Export Options

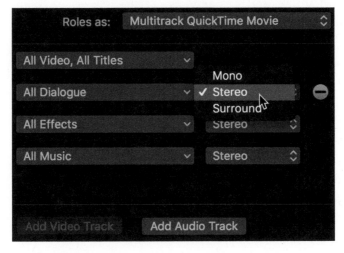

Figure 13.16 Multitrack QuickTime Movie

and one for titles, as well as separate AIFF or WAV files for the audio stems (see Figure 13.17). You should be aware, however, that if you're exporting separate tracks for video and titles you must export using a ProRes 4444 codec, otherwise you will lose title transparency. This is also true, of course, of the **Video Only As Separate Files** option.

You can switch on and off individual roles with the **minus** button. You can also add a role back in with the buttons at the bottom. Being able to remove roles is really useful if you need to output an M&E version (Music and Effects) for language replacement.

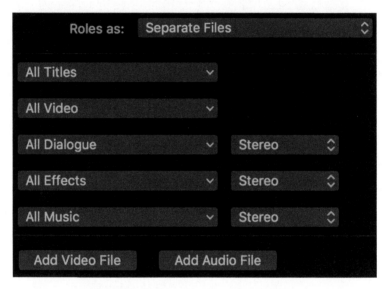

Figure 13.17 Roles As Separate Files

> **NOTE**
>
> **Export AAF/OMF:** While FCP cannot export directly to AAF or OMF for use in ProTools, you can get X2Pro (www.x2pro.net), which is available from the Mac App Store. This is a really well done tool that brings compatibility with ProTools to FCP.

Still Image Export

There are two types of still image exports available in Destinations, either **Save Current Frame** or **Export Image Sequence**. You can export a frame from either the Browser or the Timeline. In the Current Frame export dialog notice the checkbox for **Scale image to preserve aspect ratio** (see Figure 13.18). This should be used if

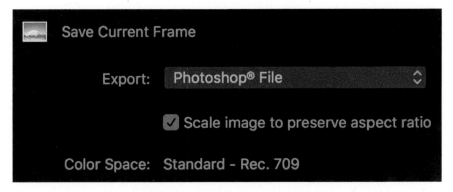

Figure 13.18 Still Export Dialog

you're exporting a format that does not use square pixels, such as standard definition DV or some HD formats that record sizes that are 1440 × 1080, but display as 1920 × 1080. When you check the box with NTSC DV media the exported file becomes 640 × 480 to preserve the aspect ratio, while the HD media becomes its display size of 1920 × 1080. If you want to keep the original size and aspect ratio, leave the checkbox empty.

You can export in a number of different still formats, common ones such as the default PNG, TIFF, JPEG, or Photoshop, or more exotic ones like DPX and OpenEXR.

If you're going to export stills for web or print work that come from video, especially video with a lot of motion in it, you'll probably want to deinterlace it. You should do this in a graphics application after you've exported. In Affinity Photo it's in the **Filters>Noise>Deinterlace**. There are some tools, such as the excellent PhotoZoom Pro from BenVista (www.benvista.com), which can enhance your still exports to convert them from the standard screen size of 72dpi to higher dpi for print.

You can also export image sequences, which are useful for rotoscoping, frame-by-frame painting on the video image, and other animation work. Image sequences provide high-quality output without loss. The frame rate used for this will be the same frame rate as your project properties.

> **TIP**
>
> **Saving and Sharing Destinations:** Destinations are stored in the user's Library in *Application Support/ProApps/Shared Destinations*. The files can be copied from here and put in the same folder on other users or on other computers. Of course, if you're using Compressor settings those will have to be available as presets on the other machine, and account-based destinations may not have relevant sign-ins for another user.

Compressor

The **Send to Compressor** function has been greatly improved in recent versions and if you have the application you should seriously consider using the **Send to** function or export using Compressor settings function. The way **Send to Compressor** works is you select the function, Compressor launches, you get to choose whatever options—either Apple presets or custom presets you've created—and you set off the compression.

When you create the **Export Using Compressor Settings** destination you have to apply a setting. Pick one that you commonly use. The destination will take its name from the setting in Compressor. You don't have to create a separate destination for each Compressor setting. You simply apply the Compressor setting and if you want a different one, click the **Change** button to select another. When you change the setting to another preset, the destination name will be changed as well. Compressor and its settings give you access to all the QuickTime options available, about 70 formats, using about two dozen codecs. In addition, you can customize your data rates for many of the formats to suit your delivery needs.

Exporting using Compressor settings does not launch Compressor at all; FCP simply uses its setting presets. This is an excellent way to make custom export formats and custom sizes using cropping. Compressor's well worth the price of the application in my view.

ARCHIVING

Now that you've finished your project, you should think about archiving your material. Before doing so, consider exporting a high resolution QuickTime master file of your edited program.

The original memory cards, or disks, or tapes on which you shot the project should have been correctly backed up already and should be your primary archive.

To archive the project you need the project file and the associated media. One good way to do this is to make a new library on an archive drive. Make sure the library properties are set to use managed media; that is store the media inside the library bundle. Rename the empty event with the name of your project and drag your project into it. This will copy all the used clips, but only the used clips, into the new library. When you drag the project into the new library you'll get a dialog asking if you want to copy optimized and proxy media. Generally you can leave these out of your archive as they can be rebuilt in FCP at any time. In addition to the media, all the metadata such as Keyword Collections, Favorites, and Smart Collections, will also be transferred.

In addition to the archive library you can also export an XML of the original library. This is a quite small file, but it has all the information for the production, all the clip, project, and other information, together with all the timecode data. Should your archive drive fail you can import the XML into a new empty library and then inside FCP use the **Import>Reimport from Camera/Archive** function to bring the video back from the camera archives into the library. Once that's done the project will reconnect automatically to the material in the event, and you will have brought back all your work.

It's important that, in addition to archiving your camera originals, you also properly secure backups of your graphics and audio files, including your FCP audio recordings, in separate locations outside of the events. Digital media redundancy is the future of production,

whether it's on disc, on LTO, on hard drives, or SSDs, or servers in the cloud; redundancy in your digital life is essential.

> **TIP**
>
> **iMovie Theater:** While there is no direct way to get to iMovie Theater to put your project on iCloud, it's easy enough to do going through iMovie. Export a file to Apple Devices and instead of setting the iTunes Library as the default location, set **Add to Playlist** to **Do Nothing**. You will then be prompted to save the file somewhere. Once the export is complete, bring the file into iMovie. Select the movie in the Browser and click the **Share** button to choose **iMovie Theater**. If you have iCloud turned on for iMovie the file automatically gets uploaded to the iCloud servers.

SUMMARY

We've now gone through the whole cycle of work in Final Cut Pro X, starting with some if the basic differences between iMovie and FCP, working with the new interface, importing your raw material, editing, transitions, titling, special effects, motion effects, color correction, and compositing. Now, finally, we have output our finished work, shared and exported it, for everyone to see and enjoy. It's been a long road, but I hope you found it an exciting, interesting, and rewarding one. Good luck with all your future video projects and with your work in Final Cut Pro X!

Keyboard Shortcuts

Add Default Audio Effect	Option-Command-E
Add Default Transition	Command-T
Add Default Video Effect	Option-E
Add Marker	M
Add Marker and Modify	Option-M
Adjust Volume Absolute	Control-Option-L
Adjust Volume Relative	Control-L
All Clips	Control-C
Append to Storyline	E
Application Switcher	Command-Tab
Audio Skimmer	Shift-S
Audition: Add to Audition	Shift-Option-Y
Audition: Duplicate as Audition	Option-Y
Audition: Duplicate from Original	Shift-Command-Y
Audition: Preview	Control-Command-Y
Background Tasks HUD	Command-9
Blade	Command-B
Blade All	Shift-Command-B
Blade Speed	Shift-B
Blade Tool	B
Break Apart Clip Items	Shift-Command-G
Clip Skimmer	Option-Command-S
Color & Effects Workspace	Shift-Control-2
Command Editor	Option-Command-K
Connect Default Lower Third	Shift-Control-T
Connect Default Title	Control-T
Connect to Primary Storyline	Q
Connect to Primary Storyline - Backtime	Shift-Q
Copy	Command-C
Create Audition	Command-Y
Create Storyline	Command-G

Crop Tool	Shift-C
Custom Speed	Control-Option-R
Cut and Switch to Viewer Angle 1	1
Cut and Switch to Viewer Angle 2	2
Cut and Switch to Viewer Angle 3	3
Cut and Switch to Viewer Angle 4	4
Cut and Switch to Viewer Angle 5	5
Cut and Switch to Viewer Angle 6	6
Cut and Switch to Viewer Angle 7	7
Cut and Switch to Viewer Angle 8	8
Cut and Switch to Viewer Angle 9	9
Cut Keyframes	Shift-Option-X
Cut/Switch Multicam Audio & Video	Shift-Option-1
Cut/Switch Multicam Audio Only	Shift-Option-3
Cut/Switch Multicam Video Only	Shift-Option-2
Default Workspace	Command-0
Delete	Delete
Delete Keyframe	Shift-Option-Delete
Delete Marker	Control-M
Delete Markers in Selection	Control-Shift-M
Deselect All	Shift-Command-A
Distort Tool	Option-D
Duplicate	Command-D
Duration	Control-D
Edit Audio and Video	Shift-1
Edit Audio Only	Shift-3
Edit Video Only	Shift-2
Enable/Disable Balance Color	Option-Command-B
Enable/Disable Clip	V
Enhance Audio	Option-Command-A
Expand/Collapse Audio/Video	Control-S
Expand/Collapse Audio Components	Control-Option-S
Export with Default Settings	Command-E
Extend Edit	Shift-X

Favorite	F
Favorites	Control-F
Find	Command-F
Go to Beginning	Home
Go to Color Board	Command-6
Go to End	End
Go to Library Browser	Command-1
Go to Photos and Audio	Shift-Command-1
Go to Range End	Shift-O
Go to Range Start	Shift-I
Go to Timeline	Command-2
Go to Viewer	Command-3
Hand Tool	H
Hide Rejected	Control-H
Import Media	Command-I
Insert Gap	Option-W
Insert to Storyline	W
Insert/Connect Freeze Frame	Option-F
Lift from Storyline	Option-Command-Up arrow
Loop Playback	Command-L
Match Audio	Shift-Command-M
Match Color	Option-Command-M
Move to Trash	Command-Delete
New Compound Clip	Option-G
New Folder	Shift-Command-N
New Keyword Collection	Shift-Command-K
New Project	Command-N
New Smart Collection	Option-Command-N
Next Edit	Down
Next Edit	'
Next Frame	Right

Next Marker	Control-'
Nudge Left	,
Nudge Right	.
Nudge Left 10	Shift-,
Nudge Right 10	Shift-.
Open Audition	Y
Organize Workspace	Shift-Control-1
Override Connections	`
Overwrite	D
Overwrite to Primary Storyline	Option-Command-Down
Paste	Command-V
Paste Attributes	Shift-Command-V
Paste Effects	Option-Command-V
Paste Keyframes	Shift-Option-V
Pause	K
Playhead Position	Control-P
Play Forward	L
Play Full Screen	Shift-Command-F
Play Backwards	J
Play Selection	/
Position Tool	P
Previous Edit	Up
Previous Edit	;
Previous Frame	Left
Previous Marker	Control-;
Project Properties	Command-J
Range Selection Tool	R
Record Voiceover	Option-Command-8
Redo Changes	Shift-Command-Z
Rejected	Control-Delete
Remove Attributes	Shift-Command-X
Remove Effects	Option-Command-X
Render All	Shift-Control-R
Render Selection	Control-R
Replace	Shift-R

Replace from Start	Option-R
Replace with Gap	Forward Delete
Retime: Editor	Command-R
Retime: Hold	Shift-H
Retime: Reset	Option-Command-R
Retime: Set Normal Speed Segment	Shift-N
Reveal in Finder	Shift-Command-R
Select All	Command-A
Select Clip	C
Select Clip Range	X
Select Left and Right Edit Edges	\
Select Left and Right Audio Edges	Shift-\
Select Left Audio Edge	Shift-[
Select Left Edge	[
Select Right Audio Edge	Shift-]
Select Right Edge]
Select Tool	A
Set Additional Range End	Shift-Command-O
Set Additional Range Start	Shift-Command-I
Set Range End	O
Set Range Start	I
Show/Hide Angles	Shift-Command-7
Show/Hide Audio Meters	Shift-Command-8
Show/Hide Browser	Control-Command-1
Show/Hide Effects Browser	Command-5
Show/Hide Inspector	Command-4
Show/Hide Libraries Sidebar	Command-'
Show/Hide Keyword Editor	Command-K
Show/Hide Precision Editor	Control-E
Show/Hide Timeline	Control-Command-2
Show/Hide Timeline Index	Shift-Command-2
Show/Hide Video Animation	Control-V
Show/Hide Video Scopes	Command-7
Skimmer	S
Snapping	N
Solo	Option-S
Switch to Viewer Angle 1	Option-1

Switch to Viewer Angle 2	Option-2
Switch to Viewer Angle 3	Option-3
Switch to Viewer Angle 4	Option-4
Switch to Viewer Angle 5	Option-5
Switch to Viewer Angle 6	Option-6
Switch to Viewer Angle 7	Option-7
Switch to Viewer Angle 8	Option-8
Switch to Viewer Angle 9	Option-9
Synchronize Clips	Option-Command-G
Timeline History Back	Command-[
Timeline History Forward	Command-]
Toggle Filmstrip/List View	Option-Command-2
Transform Tool	Shift-T
Trim End	Option-]
Trim to Selection	Option-\
Trim Tool	T
Trim Start	Option-[
Undo	Command-Z
Unrate	U
Zoom In	Command- =
Zoom Out	Command- –
Zoom to Fit	Shift-Z
Zoom Tool	Z

Index